ANATOMY

and

DRAWING

by VICTOR PERARD

Lecturer on Anatomy. Painter and Illustrator. Formerly Art Instructor Traphagen Art School and Cooper Union, New York City. Graduate Ecole des Beaux-Arts, Paris; the National Academy of Design; and Art Students' League, New York City

BARNES
&NOBLE
BOOKS
NEW YORK

This edition published by Barnes & Noble, Inc.

1995 Barnes & Noble Books

ISBN 1-56619-787-2

Printed and bound in the United States of America

M 9 8 7 6 5 4 3

Dedicated to my wife
Ernestine Perard

CONTENTS

PREFACE TO THE FOURTH EDITION

It has long been known that the study of anatomy leads to the appreciation of form and beauty in art. The human figure is particularly rewarding for study. It has simplicity and beauty of form. It is so balanced and proportioned that it can do much with little effort.

For these reasons, human anatomy is taught in schools of fine arts throughout the world.

The student who buys a book on drawing anatomy needs to have this important subject explained to him as simply as possible.

This *Fourth Edition* of ANATOMY AND DRAWING, including new material on the muscles, has been prepared from this point of view. The human figure is presented in a series of simple diagrams from which all but the necessary naming of parts and

actions has been stripped. The wording is printed in clear juxta-position to the identified body parts. Skeleton figures or quick body sketches demonstrate actions.

Throughout the book, I have kept the text to the essential minimum and have adhered to the wisdom of the saying, "One picture is worth a thousand words."

SEPTEMBER 1955 VICTOR PERARD

PREFACE TO THE THIRD EDITION

The purpose of this book is to present in a simple and direct manner the subject of anatomy as it is applied to Art. As little text as possible has been used, and much dependence has been placed on pictorial representations because the latter are a more direct means of impressing the artist with construction and form. For this reason this work has been copiously illustrated, often showing various views of the same structures and actions.

To the beginner the study of anatomy is too often dull, prosaic and difficult and this is due, in large part, to the fact that many text books on the subject contain insufficient descriptive drawings. Even though the student plows through many pages of text, he often fails to visualize the subject properly. Therefore it has been endeavored to substitute illustrations for descriptive text whenever practical. The drawings have been arranged in groups for the purpose of comparison, and in this way the eye becomes accustomed to observe much which otherwise might escape attention.

Preface

To express outward form correctly requires a knowledge of the internal structure, that is, of the bones which compose the framework and define its proportions and of the muscles and tendons which direct its action.

Every figure artist finds sooner or later, as he advances in his artistic career, that his work needs strengthening through a well grounded knowledge of anatomy. The great masters of the past realized this and their grasp on the fundamentals of anatomy is reflected not only in their finished works, but in such of their preliminary sketches as are still preserved.

The ability to construct figures correctly from the imagination rather than to depend entirely on models is a distinct aid to the draftsman and to the sculptor. The student of anatomy should therefore test his skill by making memory drawings and by applying his knowledge to compositions of his own fancy.

When working from living models, the artist will find that his knowledge of anatomy will enable him to analyze and interpret the forms before him in a more understanding way than he could without such information. It will develop in him greater powers of observation. An understanding of anatomy is an instrument in the mechanics of Art: a means to be employed to assist but never allowed to dominate. The artist must learn properly to evaluate his anatomical information and to know the part it is to play in the development of his art. The studies he makes will then be done more intelligently and with better draftsmanship as an inevitable result.

Victor Perard

NOTES ON PROPORTION

Since proportion is the comparative relation of one thing to an-
other, some standard or unit of measure must arbitrarily be estab-
lished. In Art, this unit is known as the "head" which is the distance
from the top of the skull to the tip of the chin. The illustrations in
this book are based on the proportion of seven and a half "heads"
to the height of an erect figure. The use of this standard will obviate
much descriptive text. It is well, however, to bear in mind that this
standard of proportion is modified by such elements as race, sex,

age and physical differences peculiar to the individual. For this reason the following notes on proportion are grouped under the heads: Male, Female, Children and General Observations.

Proportions of the Male. The greatest width of the male figure is at the deltoids, a little below the shoulders and the width here is about two heads.

The width between the hips should equal one and one half heads, and the width between the nipples one head.

The height of the figure, seven and one-half heads, should approximate one "head" for the head, two and three-quarter heads for the neck and trunk, and three and three-quarter heads for the lower extremities.

From the finger tips to the elbow should measure two heads.

Proportions of the Female. The bones of the female are shorter and have less rough surfaces than those of the male. The sternum or breast bone is shorter and more curved and the pelvis is broader and shallower which gives a greater width to the hips. The sacrum is wider and projects at an angle backward.

The posterior superior iliac spines and the anterior iliac spines are further apart than those of the male. The distance from the rib cage to the pelvis is greater due to the shallower and broader pelvis.

There is less distance from the crest of the iliacs to the great trochanters of the hips, because the anterior iliac spines are spread out and lower, and further apart. In the female figure the Poupart's ligaments and the furrow of the groin are more horizontal.

The shoulders are narrower and the collar bones (clavicles) straighter and shorter thus giving a more graceful and longer neck and more sloping shoulders in comparison with the square shoulders of the male.

Notes on Proportion

The arms are shorter in proportion to the trunk which is due to the shorter humerus bone of the female, and because the humerus bone is shorter, the elbow is higher.

Variations in the length of the female leg are more frequent than those of the trunk and so it is more difficult to judge the height of the female figure when seated. But the length of the torso is proportionately longer than in the other sex. The legs are shorter and the skull smaller.

The center of the female figure is above the pubic bone while in the male, the center is about at the pubic bone. The width of the female hips is about the width of the chest wall plus that of one arm and is greater than that of the male of the same height. The fact that the female sacrum is at a greater angle than that of the male and that there is more fat on the buttocks gives these a greater diameter.

The female abdomen, is more rounded and the thighs are thicker from the back to the front than in the other sex.

Proportions of Children. The child of three is about one half the height of the adult, and at ten, about three-quarters the height of the adult. As the child grows older the relative sizes of the head and the trunk change. At twenty-five the figure is full grown.

At birth the center of the figure is a little above the navel, at two years at the navel and at three years the center is level with the iliac bone.

With advancing age this point gradually lowers depending to a great extent on the length of the legs.

General Observations. The clavicle bone continues to grow for a considerable period after the other bones of the body have attained

their full development and therefore the shoulders are said to broaden.

Only very tall people have a height of eight heads. Short people are seven heads or less. The muscles of the adult account for about one half the weight of the body.

The skeleton always provides the proportions of the figure with slight allowances for the padding between the joints, between each vertebra, and under the heel and foot. In old age the figure shortens due to the hardening and shrinking of the cartilages between the bones.

PART ONE
PROPORTION and DRAWING

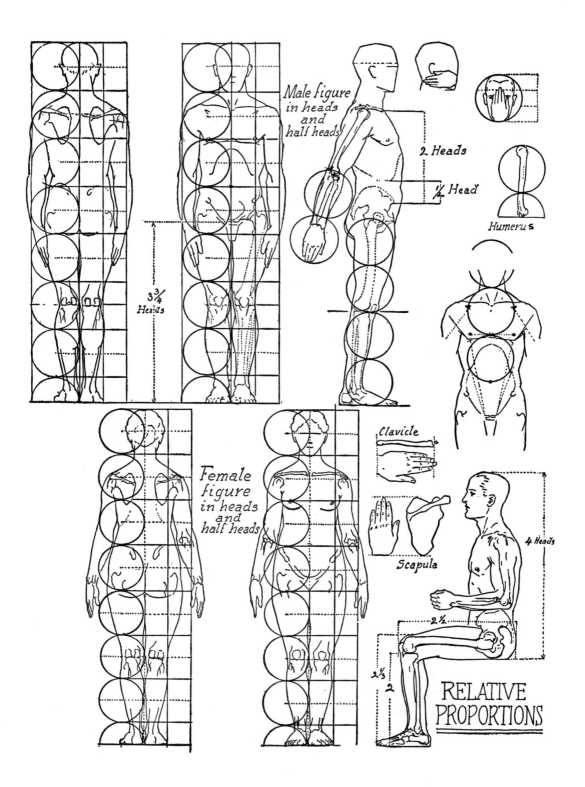

Male figure
in heads
and
half heads

2 Heads

½ Head

Humerus

3¾
Heads

Female
figure
in heads
and
half heads

Clavicle

Scapula

4 Heads

2½

2⅓

2

RELATIVE
PROPORTIONS

Some of the mechanical principles of the human frame.

Weight of head 12 to 15 lbs.

Weight

Force

Fulcrum

Lever

Fulcrum

Force

Supine Position

Prone Position

1¾ Heads

Heads 3¾

Female pelvis wider and shallower than the male

Height of pelvis 1 head. The sacrum performs the function of a keystone in the arch of the pelvis.

7½ Heads

The feet placed together form an arch.

The heavy line indicates how shocks are deflected in walking, running and jumping.

The bones of the foot are so arranged as to form a springy arch.

Heads 3¾

The astragalis bone acts as a keystone to the arch of the foot.

Line of gravity

The skeleton in simplified form to illustrate curves which deflect shocks and give springiness to the frame.

Relative proportion of bones by heads

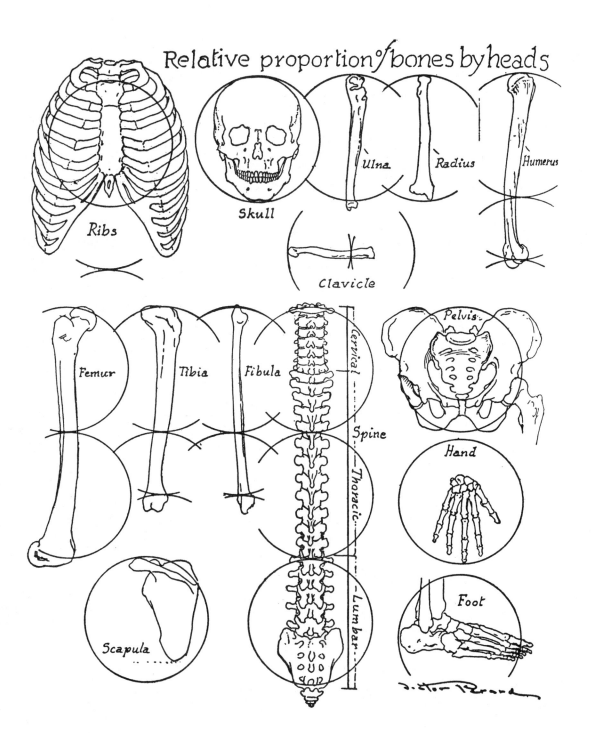

Ribs

Skull

Ulna

Radius

Humerus

Clavicle

Femur

Tibia

Fibula

Cervical

Spine

Thoracic

Lumbar

Pelvis

Hand

Foot

Scapula

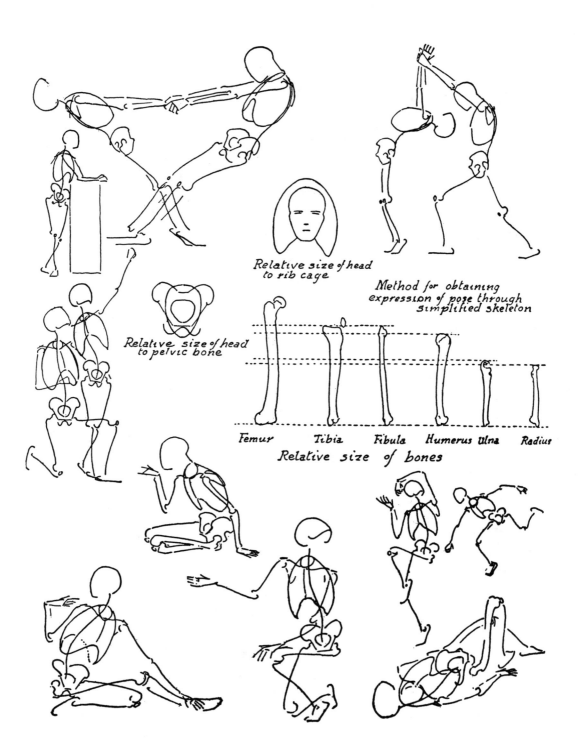

Relative size of head
to rib cage

Relative size of head
to pelvic bone

Method for obtaining
expression of pose through
simplified skeleton

| Femur | Tibia | Fibula | Humerus | Ulna | Radius |

Relative size of bones

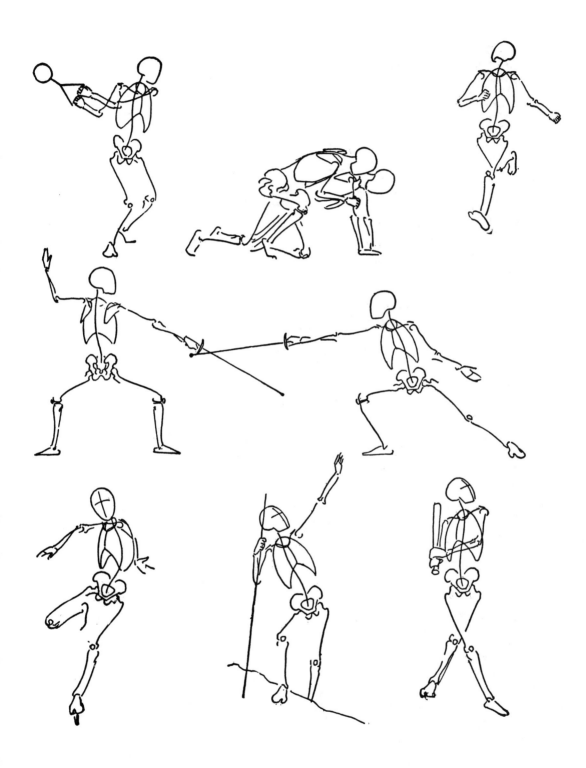

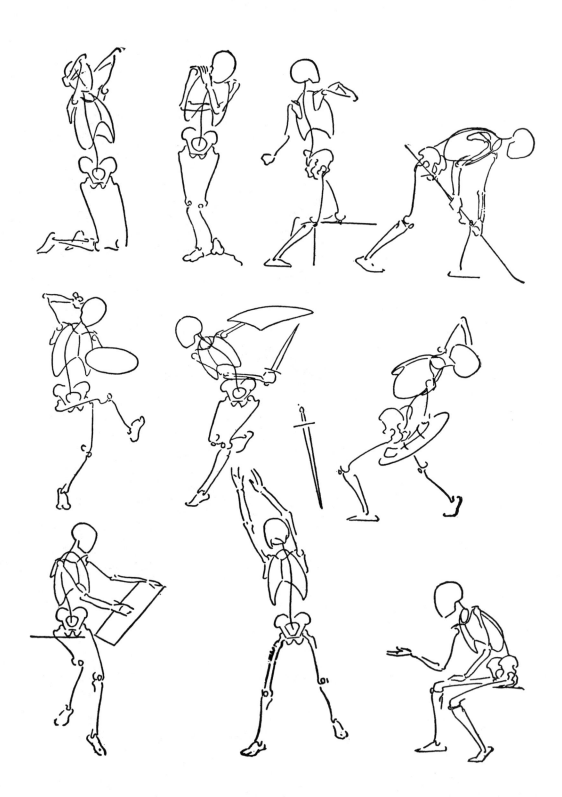

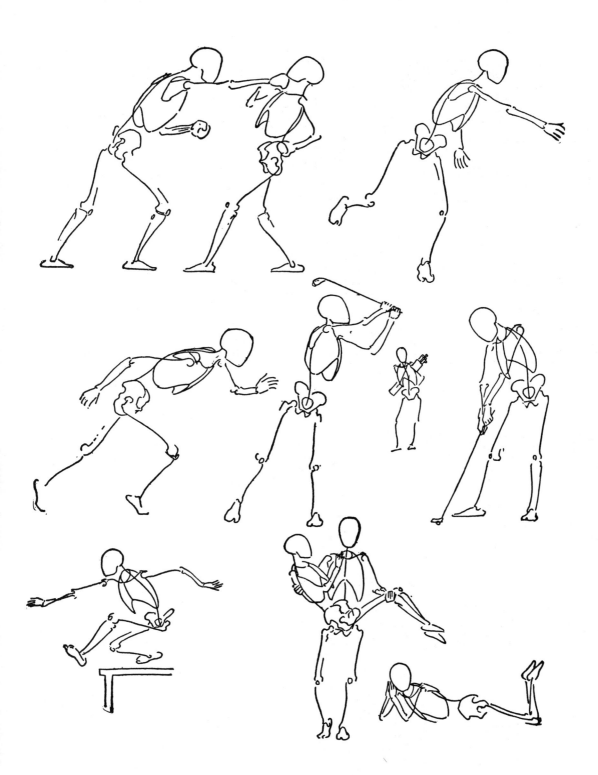

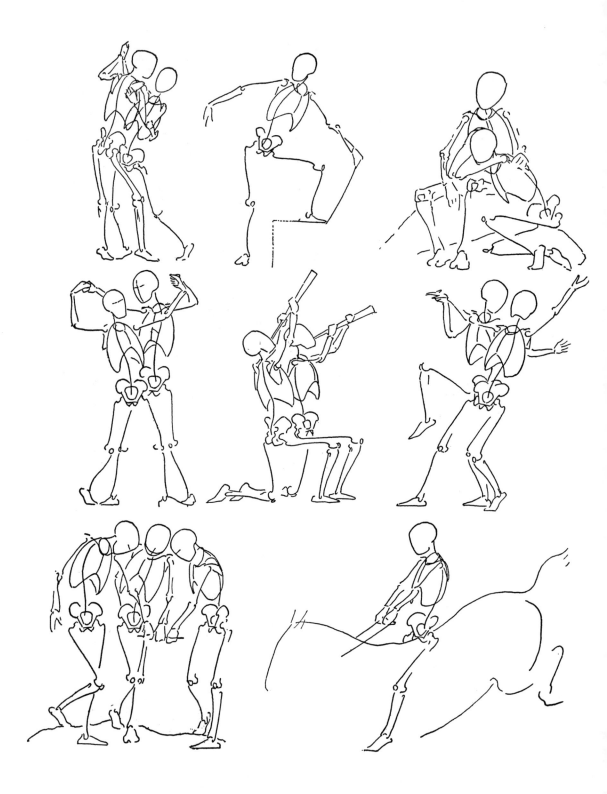

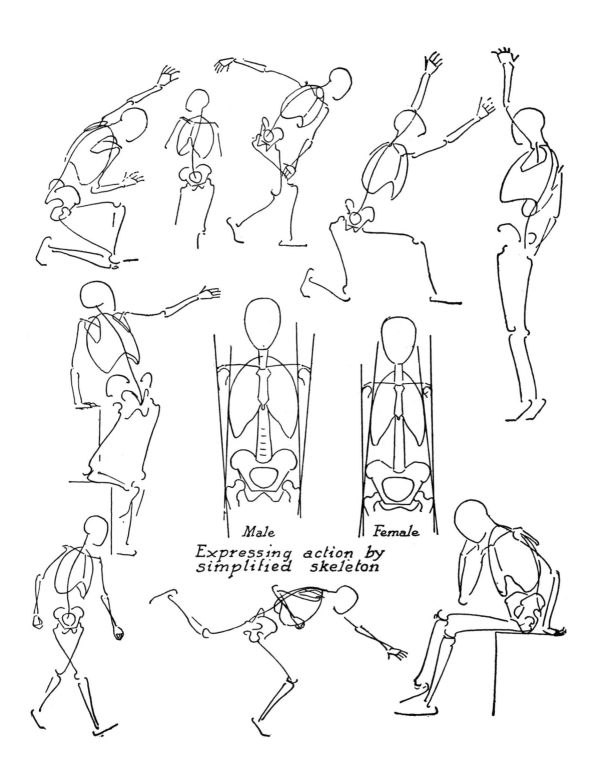

Male Female

Expressing action by simplified skeleton

METHOD OF DRAWING
From Life or from the Cast

1. Find the center of the paper by drawing lines from corner to corner. This is done to help center the study.
2. Measure with the eye or pencil to find the center of the subject and make a line at that point as related to the center of the paper.
 Draw a line at the head and another at the feet.
 With free lines search for the rhythm of the pose, to help visualize the figure and to place it on the paper the size intended.
 Draw lightly so that the mental impression of the figure is not obliterated by a heavy drawing, and corrections can be easily made.
3. Decide where the pit of the neck should be placed and draw a perpendicular line from this point (if a front view) to the feet. If a back view, draw the perpendicular line from the seventh cervical vertebra to the feet.
 Find the line of the shoulders, giving the angle of their positions.
 If a standing figure, first draw the leg on which there is most weight, to obtain the proper balance of the figure.
4. Give the line showing the angle of the position of the pelvis.
 Indicate a line through the knee-caps. Draw the torso, indicating its bulk, marking the width of shoulders, hips, neck and head.
 Block with straight lines going beyond the intersections to obtain a better idea of the direction of line and to avoid a cramped feeling.
5. Sketch within the lines a simplified skeleton, to check up on position of joints and bulk of chest. (Refer to pages on proportion.)
 See that the pit of the neck, the pubic bone, the navel, the pelvis, the knee-caps and the inner ankles are in proper relation to each other.
 Compare relative sizes of head to bulk of torso, hands to face, feet to hands, arms to legs, and thickness of the neck to that of the head, leg and arm.
6. Go over the outline, perfecting it, searching for character and for grace of line.
7. Indicate the outline of the planes and of the principal shadows.
8. Fill in the planes in large surfaces, and connect the shadows as much as possible.
9. Without losing their mass, model the planes keeping well in mind the direction of light.
 In drawing the head, decide on the bulk and draw in the planes of the face (see Part III), then the eyes, the mouth and the nose last.
 It is easier to fit a head on a figure, than to fit a figure to a head.

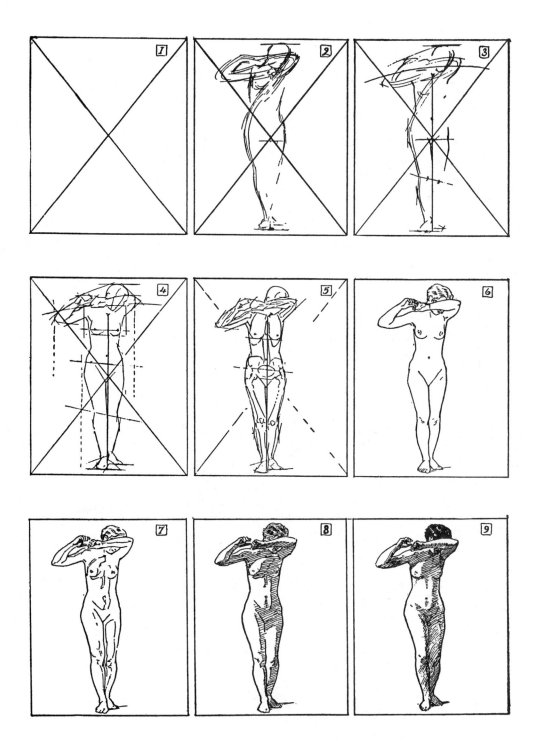

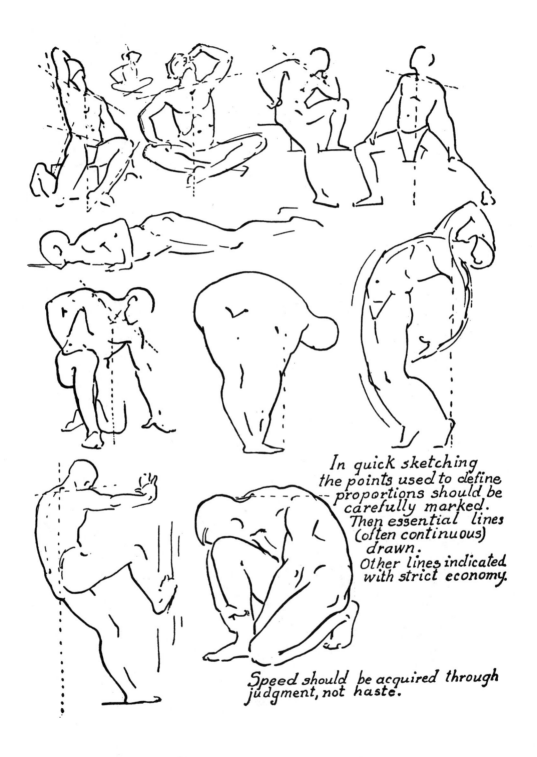

*In quick sketching
the points used to define
proportions should be
carefully marked.
Then essential lines
(often continuous)
drawn.
Other lines indicated
with strict economy.*

*Speed should be acquired through
judgment, not haste.*

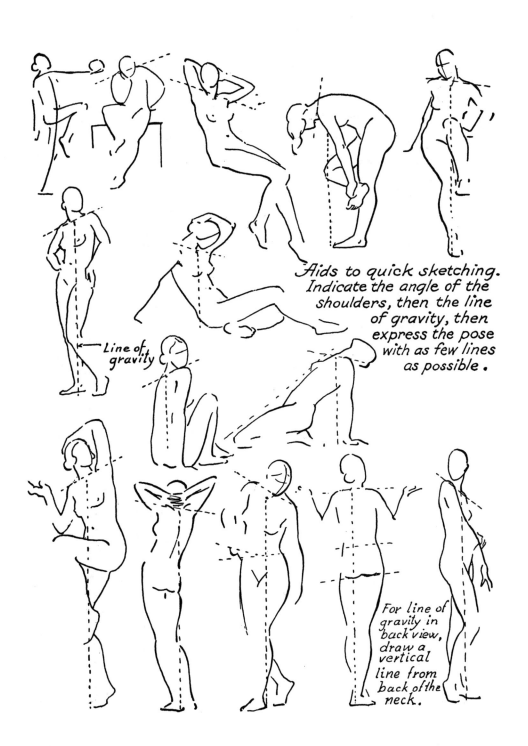

Aids to quick sketching. Indicate the angle of the shoulders, then the line of gravity, then express the pose with as few lines as possible.

Line of gravity

For line of gravity in back view, draw a vertical line from back of the neck.

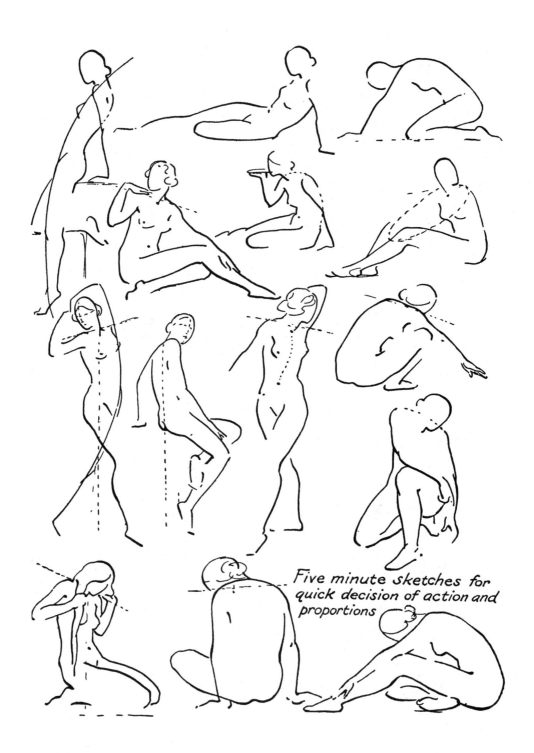

Five minute sketches for quick decision of action and proportions

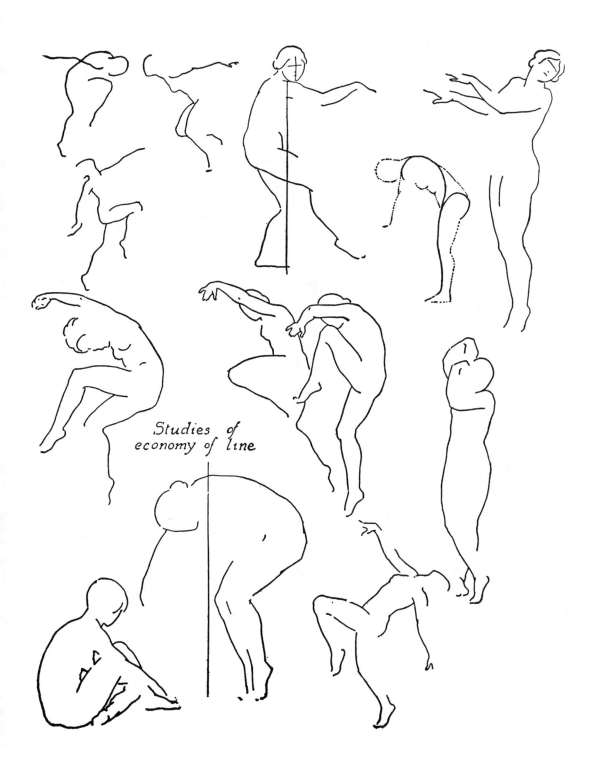

Studies of
economy of line

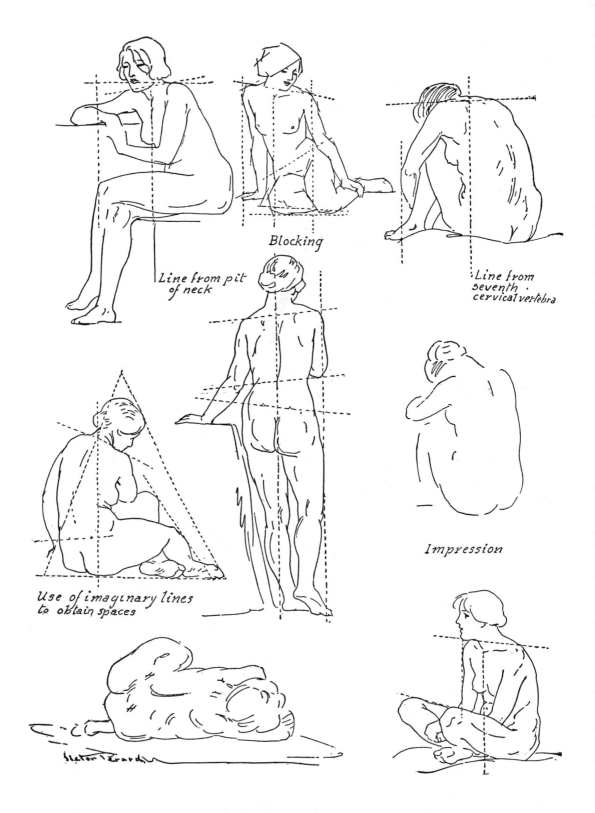

Blocking

Line from pit
of neck

Line from
seventh
cervical vertebra

Use of imaginary lines
to obtain spaces

Impression

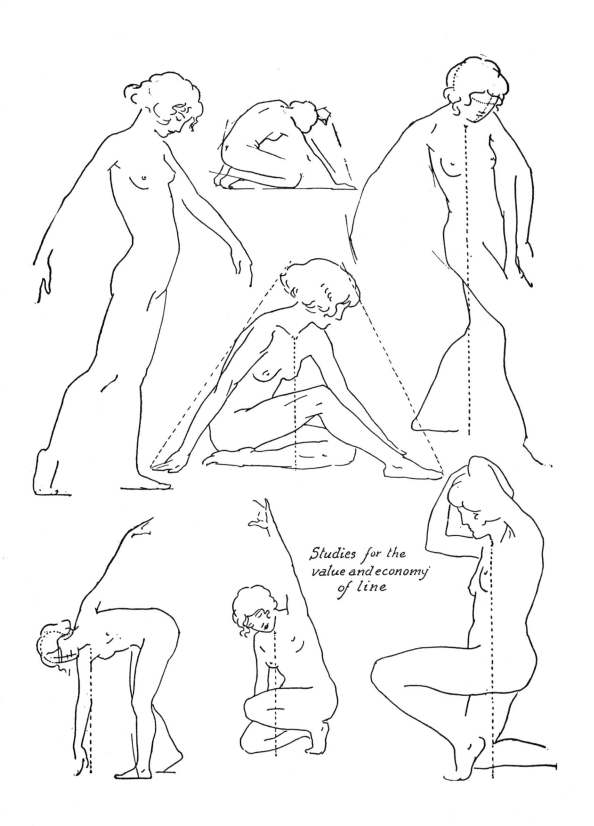

Studies for the
value and economy
of line

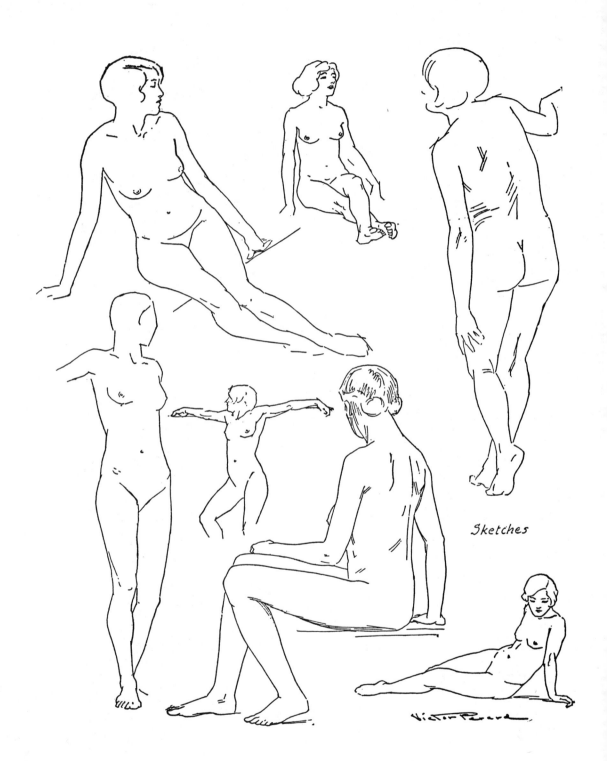

Sketches

Victor Perard

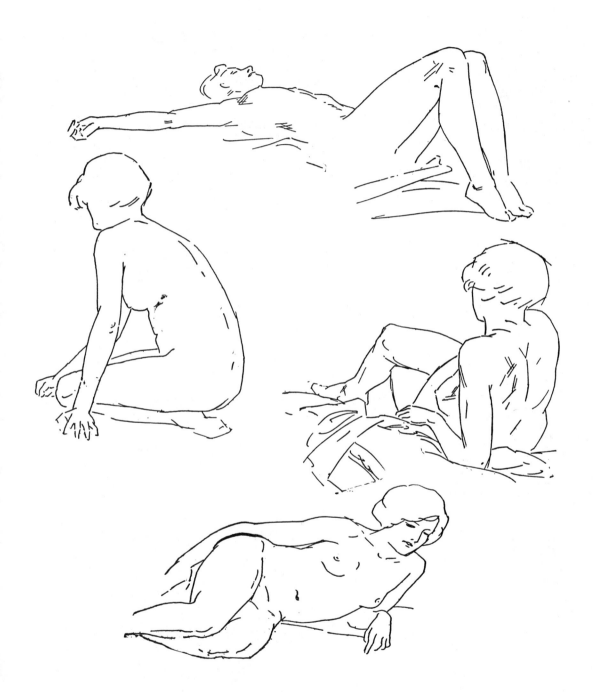

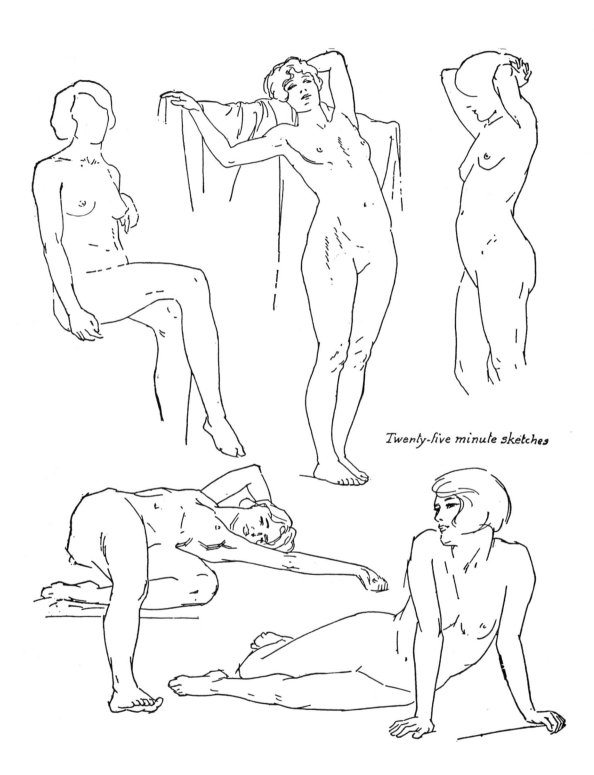

Twenty-five minute sketches

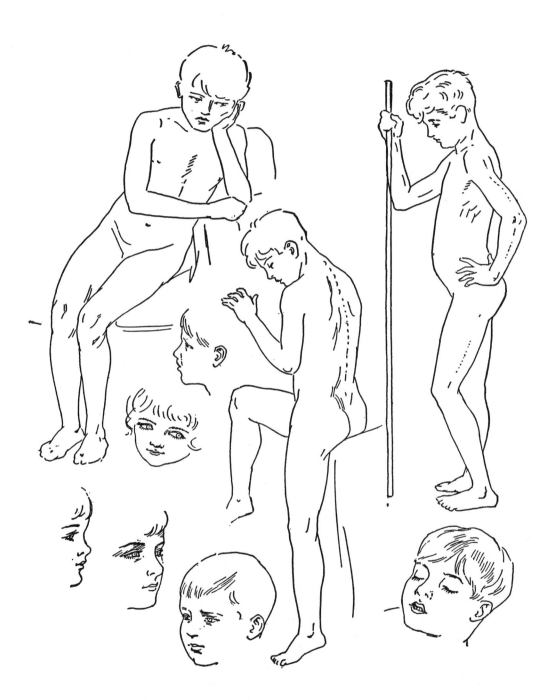

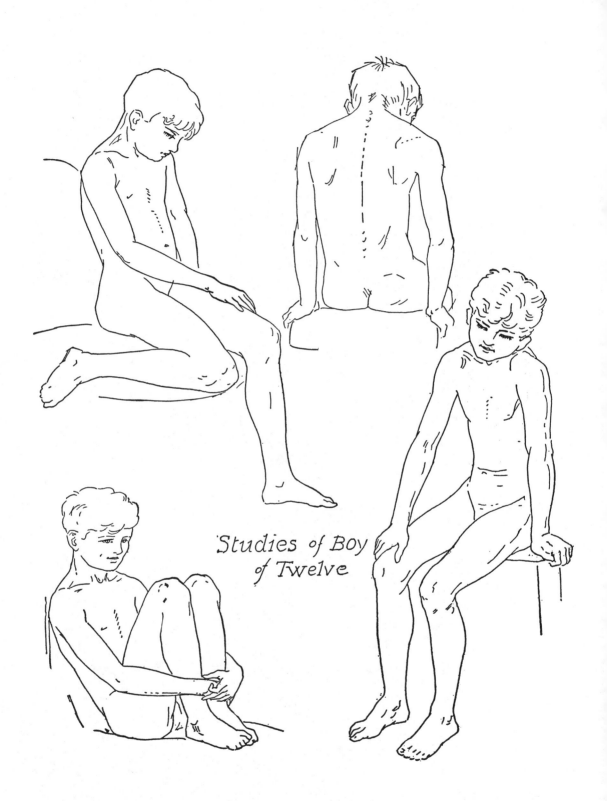

Studies of Boy of Twelve

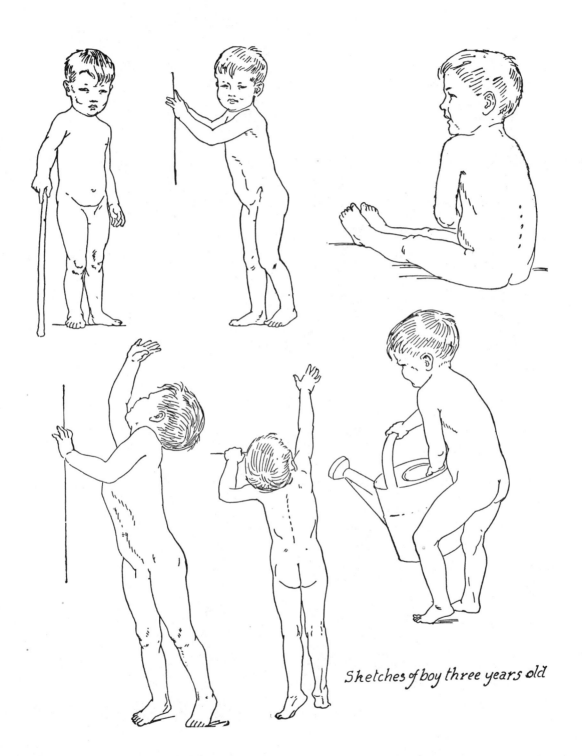

Sketches of boy three years old

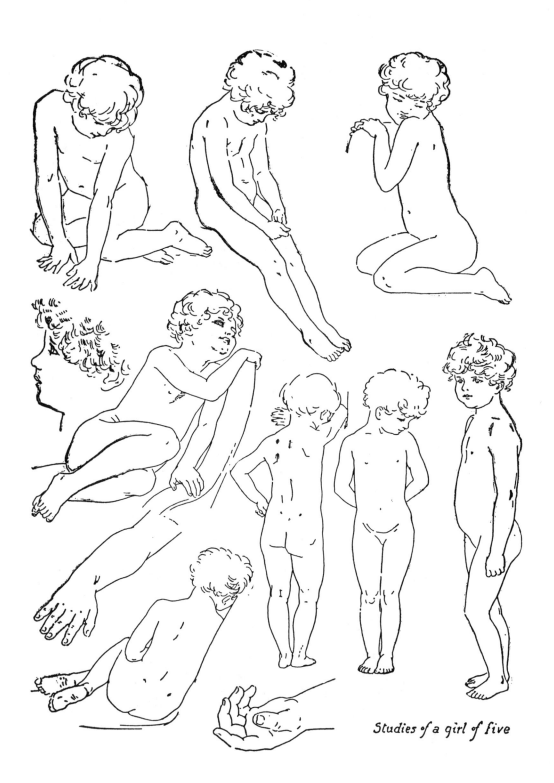

Studies of a girl of five

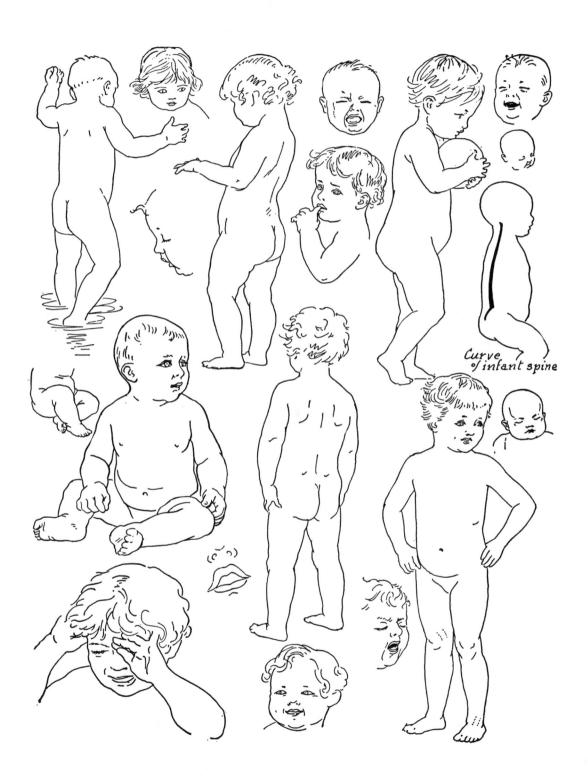

Curve of infant spine

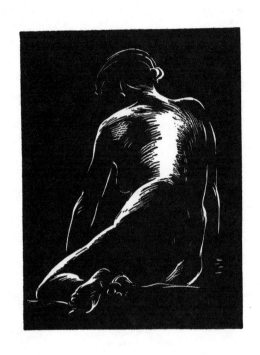

PART TWO

THE SKELETON

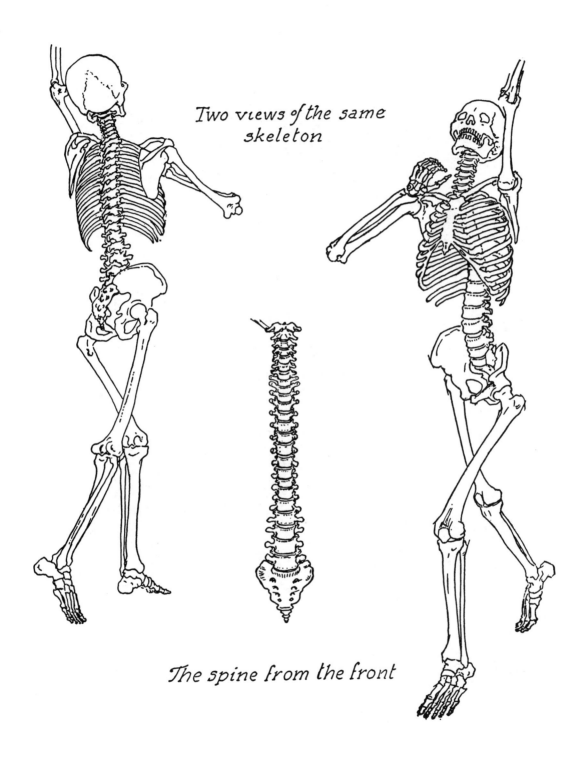

Two views of the same
skeleton

The spine from the front

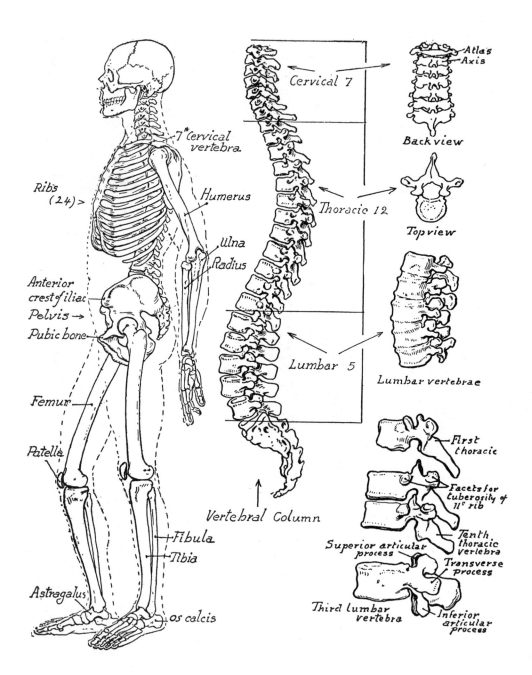

7thCervical vertebra.

Ribs (24) >

Humerus

Ulna

Radius

Anterior crest of iliac

Pelvis →

Pubic bone

Femur

Patella

Fibula

Tibia

Astragalus

os calcis

Cervical 7

Thoracic 12

Lumbar 5

Vertebral Column

Atlas
Axis

Back view

Top view

Lumbar vertebrae

First thoracic

Facets for tuberosity of 11th rib

Tenth thoracic vertebra

Superior articular process

Transverse process

Third lumbar vertebra

Inferior articular process

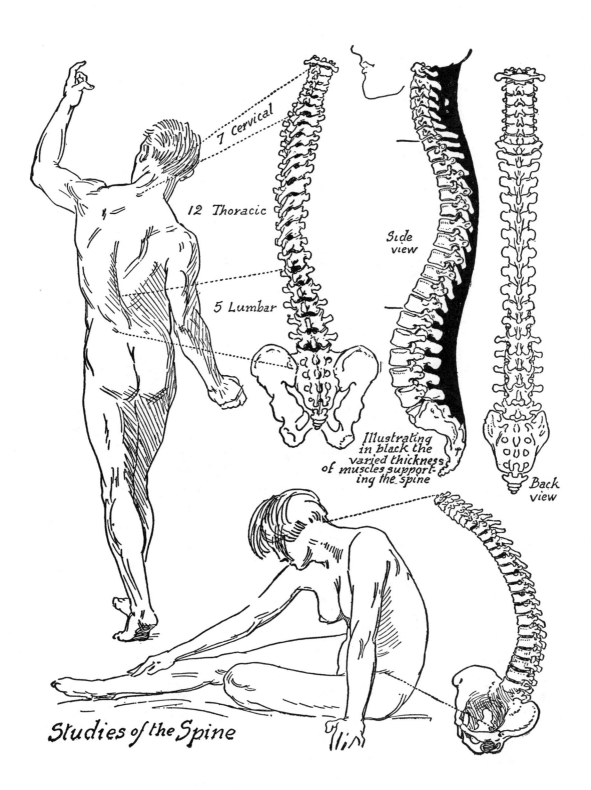

7 Cervical

12 Thoracic

5 Lumbar

Side
view

Illustrating
in black the
varied thickness
of muscles support-
ing the spine

Back
view

Studies of the Spine

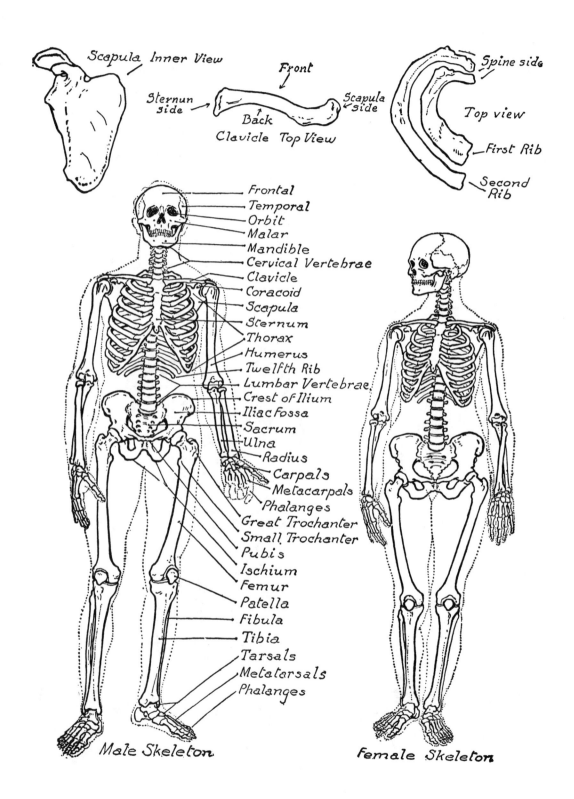

Scapula Inner View

Sternun side → Front ← Scapula side
Back
Clavicle Top View

Spine side
Top view
First Rib
Second Rib

Frontal
Temporal
Orbit
Malar
Mandible
Cervical Vertebrae
Clavicle
Coracoid
Scapula
Sternum
Thorax
Humerus
Twelfth Rib
Lumbar Vertebrae
Crest of Ilium
Iliac Fossa
Sacrum
Ulna
Radius
Carpals
Metacarpals
Phalanges
Great Trochanter
Small Trochanter
Pubis
Ischium
Femur
Patella
Fibula
Tibia
Tarsals
Metatarsals
Phalanges

Male Skeleton

Female Skeleton

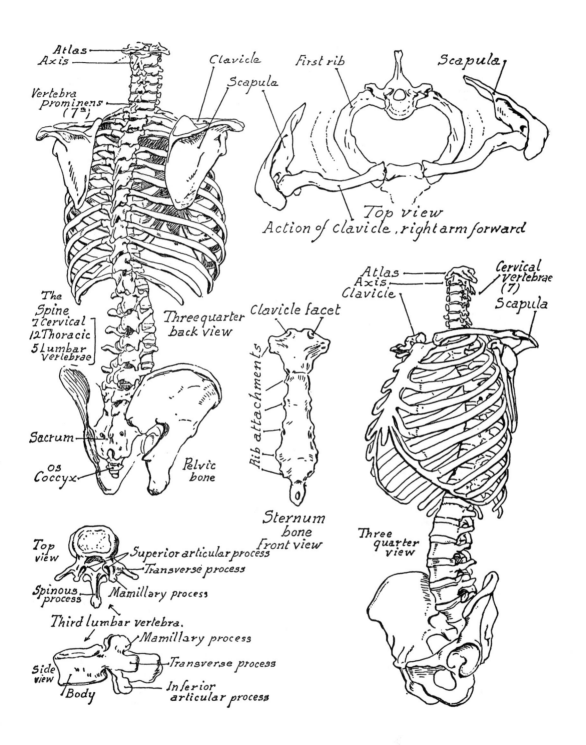

Atlas

Axis

Vertebra
Prominens
(7th)

Clavicle

Scapula

First rib

Scapula

Top view
Action of clavicle, right arm forward

The
Spine
7 Cervical
12 Thoracic
5 Lumbar
vertebrae

Three quarter
back view

Clavicle facet

Atlas

Axis

Clavicle

Cervical
vertebrae
(7)

Scapula

Rib attachments

Sacrum

Os
Coccyx

Pelvic
bone

Sternum
bone
Front view

Three
quarter
view

Top
view

Superior articular process

Transverse process

Spinous
process

Mamillary process

Third lumbar vertebra.

Mamillary process

Side
view

Transverse process

Body

Inferior
articular process

PART THREE
THE HEAD and NECK

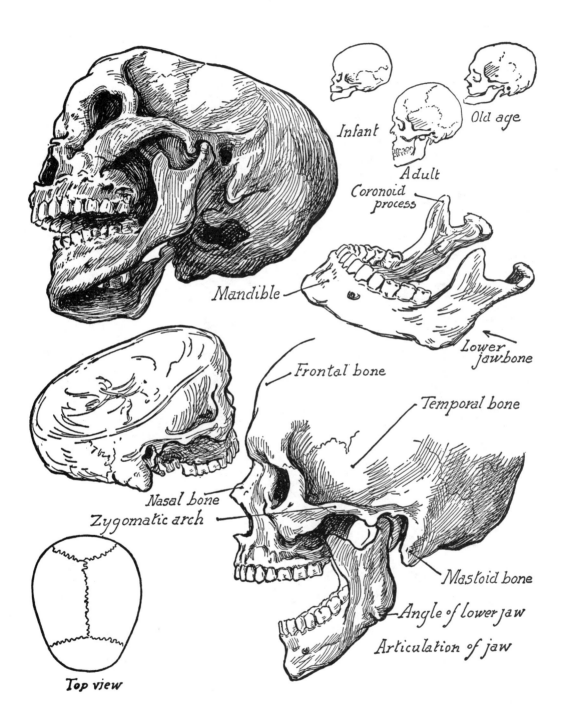

Infant

Old age

Adult

Coronoid process

Mandible

Lower jawbone

Frontal bone

Temporal bone

Nasal bone

Zygomatic arch

Mastoid bone

Angle of lower jaw

Articulation of jaw

Top view

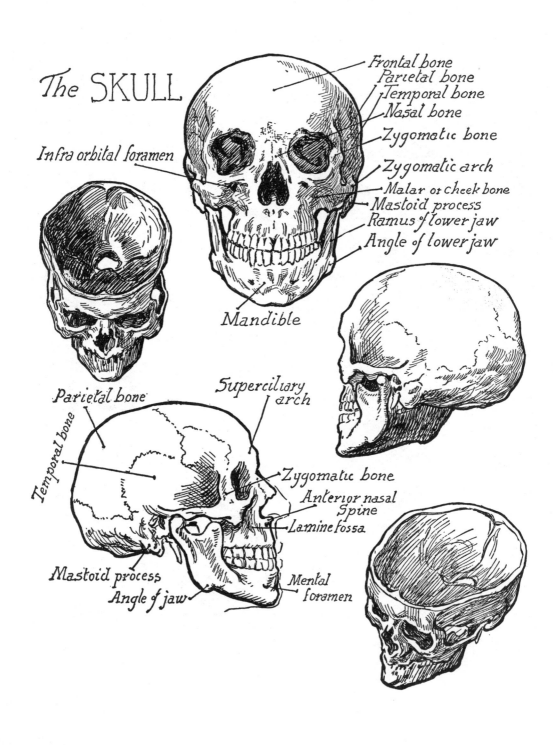

The SKULL

Frontal bone
Parietal bone
Temporal bone
Nasal bone
Zygomatic bone

Zygomatic arch
Malar or cheek bone
Mastoid process
Ramus of lower jaw
Angle of lower jaw

Infra orbital foramen

Mandible

Superciliary arch

Parietal bone

Temporal bone

Zygomatic bone
Anterior nasal Spine
Lamine fossa

Mastoid process
Angle of jaw
Mental foramen

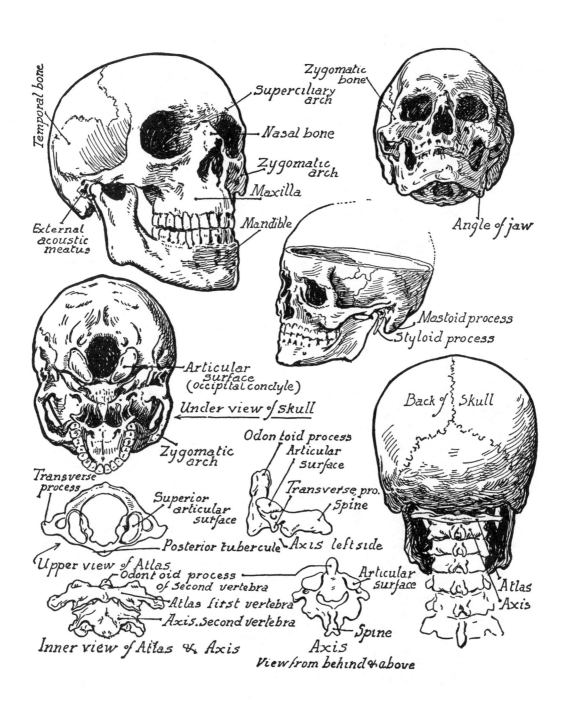

Temporal bone

Superciliary arch

Nasal bone

Zygomatic arch

Maxilla

Mandible

External acoustic meatus

Zygomatic bone

Angle of jaw

Mastoid process
Styloid process

Articular surface (occipital condyle)

Under view of skull

Back of Skull

Zygomatic arch

Odontoid process
Articular surface

Transverse pro.
Spine

Axis left side

Transverse process

Superior articular surface

Posterior tubercule

Upper view of Atlas

Odontoid process of Second vertebra

Atlas first vertebra

Axis.Second vertebra

Inner view of Atlas & Axis

Articular surface

Spine

Axis

View from behind & above

Articular surface

Atlas
Axis

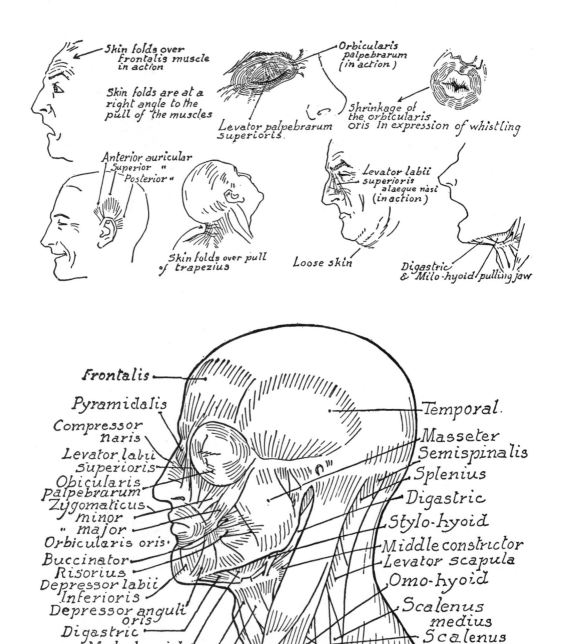

Skin folds over
frontalis muscle
in action

Skin folds are at a
right angle to the
pull of the muscles

Orbicularis
palpebrarum
(in action)

Levator palpebrarum
superioris.

Shrinkage of
the orbicularis
oris in expression of whistling

Anterior auricular
Superior "
Posterior "

Skin folds over pull
of trapezius

Levator labii
superioris
alaeque nasi
(in action)

Loose skin

Digastric
& Milo-hyoid pulling jaw

Frontalis

Pyramidalis

Compressor
naris

Levator labii
Superioris

Obicularis
palpebrarum

Zygomaticus
minor

" major

Orbicularis oris

Buccinator

Risorius

Depressor labii
Inferioris

Depressor anguli
oris

Digastric

Mylo-hyoid

Sterno-hyoid

Omo-hyoid

Sterno-mastoid

Temporal.

Masseter

Semispinalis

Splenius

Digastric

Stylo-hyoid

Middle constrictor

Levator scapula

Omo-hyoid

Scalenus
medius

Scalenus
anterior

Trapezius

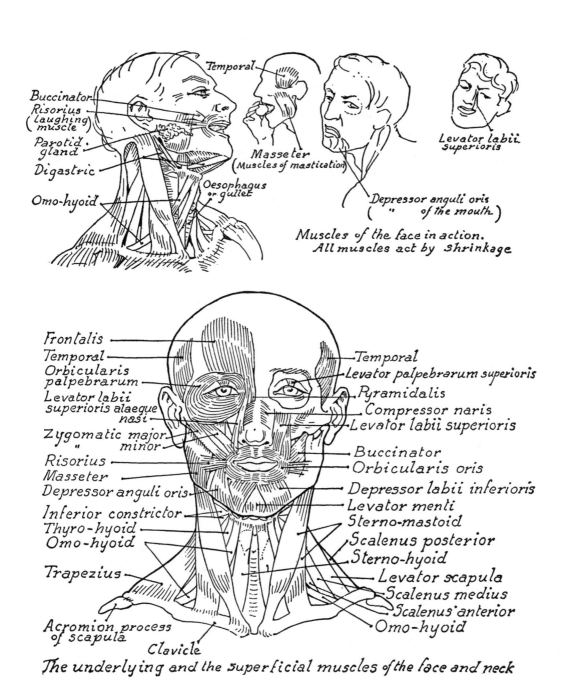

Temporal

Buccinator
Risorius
(laughing
muscle)
Parotid
gland
Digastric

Omo-hyoid

Oesophagus
or gullet

Masseter
(Muscles of mastication)

Levator labii
superioris

Depressor anguli oris
(" of the mouth)

Muscles of the face in action.
All muscles act by shrinkage

Frontalis
Temporal
Orbicularis
palpebrarum
Levator labii
superioris alaeque
nasi
Zygomatic major
 " minor
Risorius
Masseter
Depressor anguli oris
Inferior constrictor
Thyro-hyoid
Omo-hyoid
Trapezius
Acromion process
of scapula
Clavicle

Temporal
Levator palpebrarum superioris
Pyramidalis
Compressor naris
Levator labii superioris
Buccinator
Orbicularis oris
Depressor labii inferioris
Levator menti
Sterno-mastoid
Scalenus posterior
Sterno-hyoid
Levator scapula
Scalenus medius
Scalenus anterior
Omo-hyoid

The underlying and the superficial muscles of the face and neck

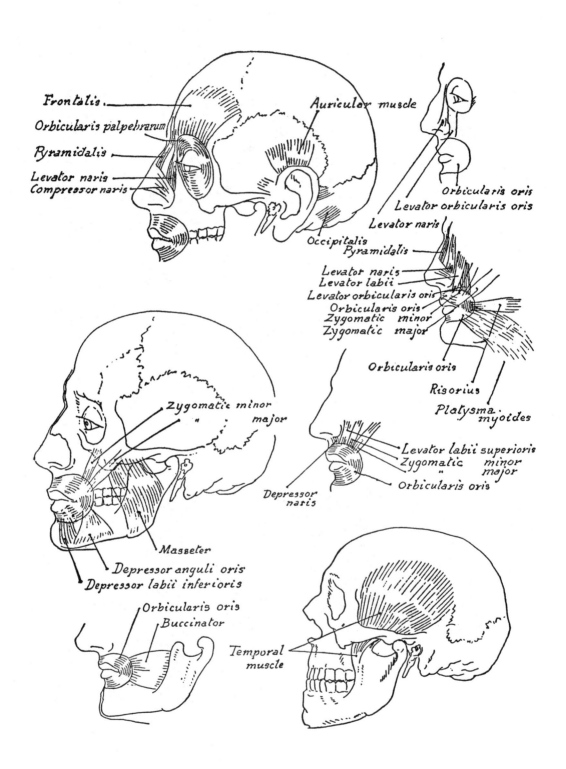

Frontalis.

Orbicularis palpebrarum

Pyramidalis

Levator naris
Compressor naris

Auricular muscle

Orbicularis oris
Levator orbicularis oris

Levator naris

Occipitalis
Pyramidalis

Levator naris
Levator labii
Levator orbicularis oris
Orbicularis oris
Zygomatic minor
Zygomatic major

Orbicularis oris

Risorius

Platysma
myoides

Zygomatic minor
" major

Levator labii superioris
Zygomatic minor
" major
Orbicularis oris

Depressor
naris

Masseter

Depressor anguli oris
Depressor labii inferioris

Orbicularis oris
Buccinator

Temporal
muscle

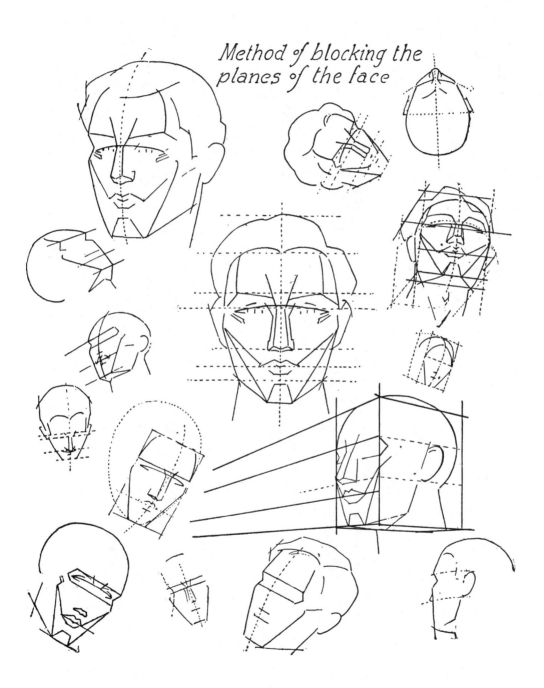

Method of blocking the
planes of the face

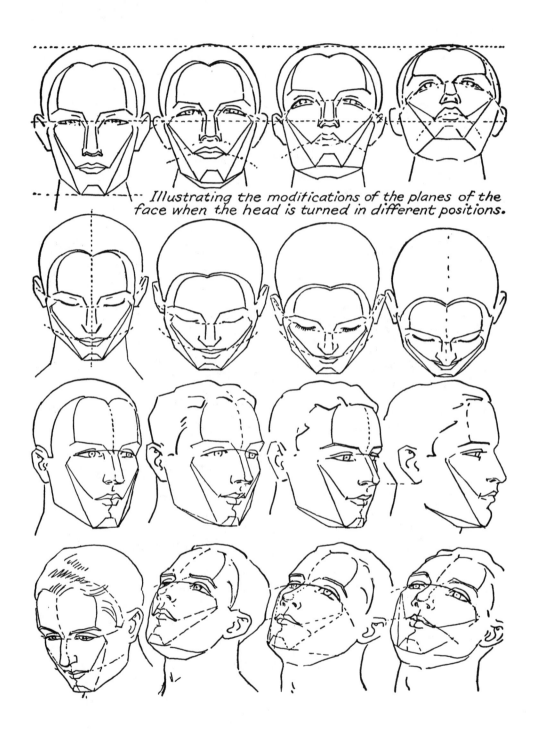

Illustrating the modifications of the planes of the face when the head is turned in different positions.

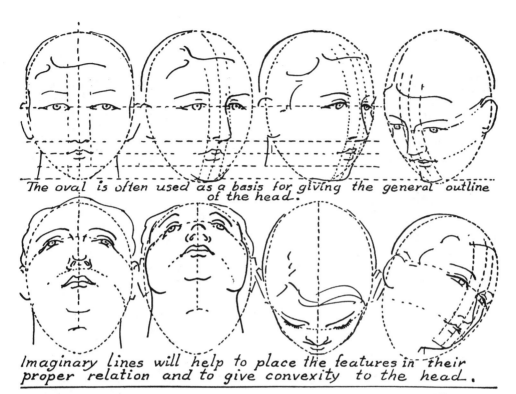

The oval is often used as a basis for giving the general outline
of the head.

Imaginary lines will help to place the features in their
proper relation and to give convexity to the head.

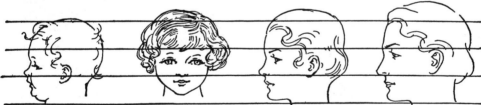

Showing changes in the relative proportions of features
and skull at different ages. The nose gradually straightens,
then lengthens, the ears lengthen, the eyes are placed higher.

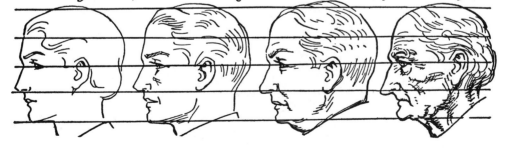

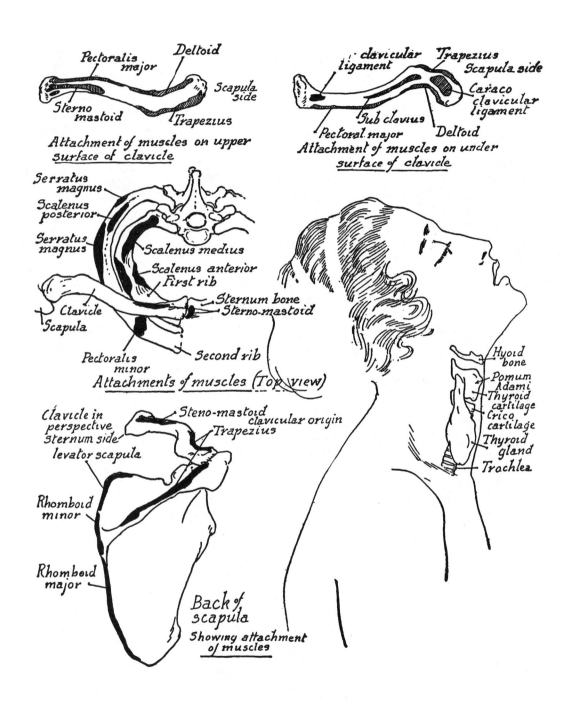

Pectoralis major Deltoid
Sterno mastoid Scapula side Trapezius

Attachment of muscles on upper surface of clavicle

clavicular ligament Trapezius Scapula side
Sub clavius Caraco clavicular ligament
Pectoral major Deltoid

Attachment of muscles on under surface of clavicle

Serratus magnus
Scalenus posterior
Serratus magnus
Scalenus medius
Scalenus anterior
First rib
Sternum bone
Sterno-mastoid
Clavicle
Scapula
Second rib
Pectoralis minor

Attachments of muscles (Top view)

Clavicle in perspective
Sternum side
levator scapula
Steno-mastoid
clavicular origin
Trapezius
Rhomboid minor
Rhomboid major

Back of scapula
Showing attachment of muscles

Hyoid bone
Pomum Adami
Thyroid cartilage
Crico cartilage
Thyroid gland
Trachea

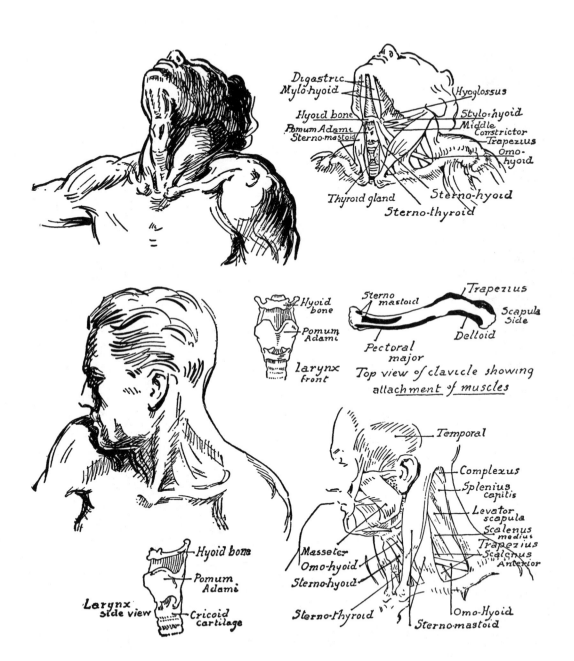

Digastric
Mylo-hyoid
Hyoglossus
Hyoid bone
Stylo-hyoid
Pomum Adami
Middle
Constrictor
Sterno-mastoid
Trapezius
Omo-
hyoid
Thyroid gland
Sterno-hyoid
Sterno-thyroid

Hyoid
bone
Sterno
mastoid
Trapezius
Pomum
Adami
Scapula
Side
larynx
front
Deltoid
Pectoral
major
Top view of clavicle showing
attachment of muscles

Temporal
Complexus
Splenius
capitis
Levator
scapula
Scalenus
medius
Masseter
Trapezius
Omo-hyoid
Scalenus
Anterior
Sterno-hyoid
Sterno-thyroid
Omo-Hyoid
Sterno-mastoid

Hyoid bone
Pomum
Adami
Larynx
side view
Cricoid
cartilage

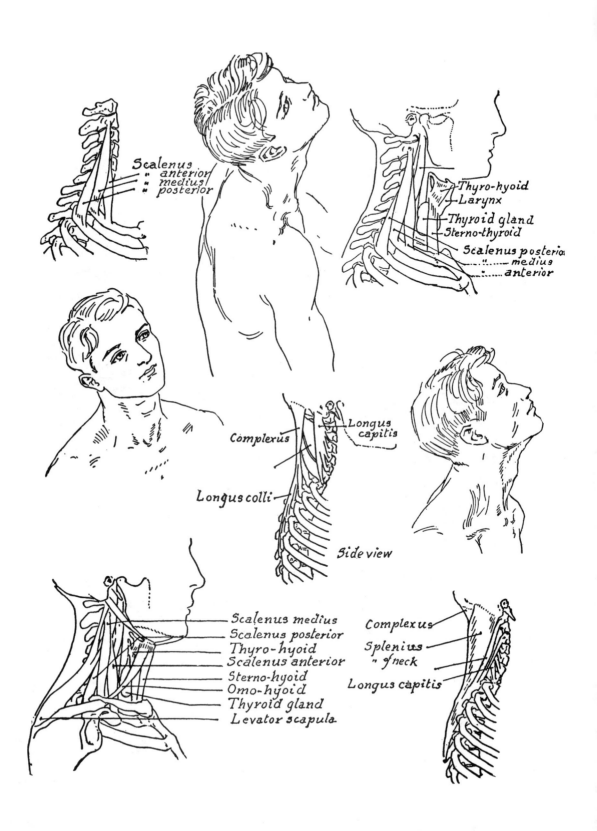

Scalenus
" anterior
" medius
" posterior

Thyro-hyoid
Larynx
Thyroid gland
Sterno-thyroid
Scalenus posteria
" medius
" anterior

Complexus

Longus capitis

Longus colli

Side view

Scalenus medius
Scalenus posterior
Thyro-hyoid
Scalenus anterior
Sterno-hyoid
Omo-hyoid
Thyroid gland
Levator scapula

Complexus
Splenius
" of neck
Longus capitis

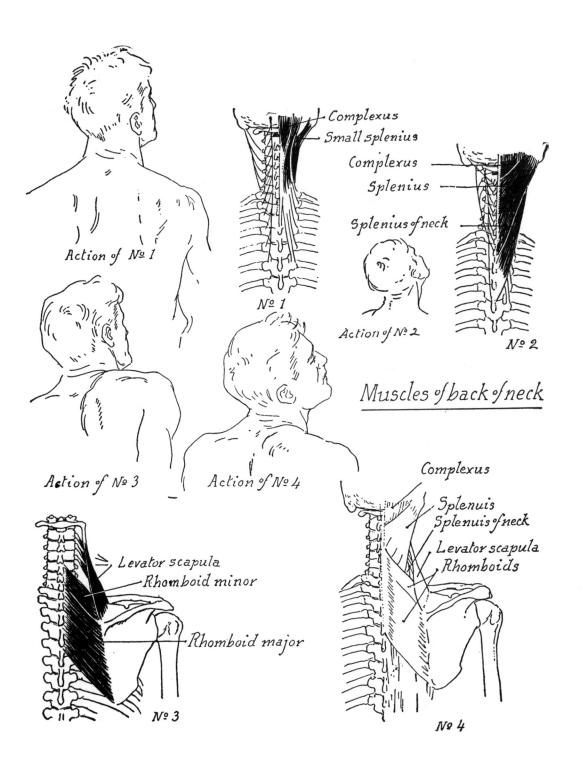

Action of Nº 1

Complexus
Small splenius
Complexus
Splenius
Splenius of neck

Nº 1

Action of Nº 2

Nº 2

Action of Nº 3

Action of Nº 4

Muscles of back of neck

Levator scapula
Rhomboid minor

Rhomboid major

Nº 3

Complexus
Splenuis
Splenuis of neck
Levator scapula
Rhomboids

Nº 4

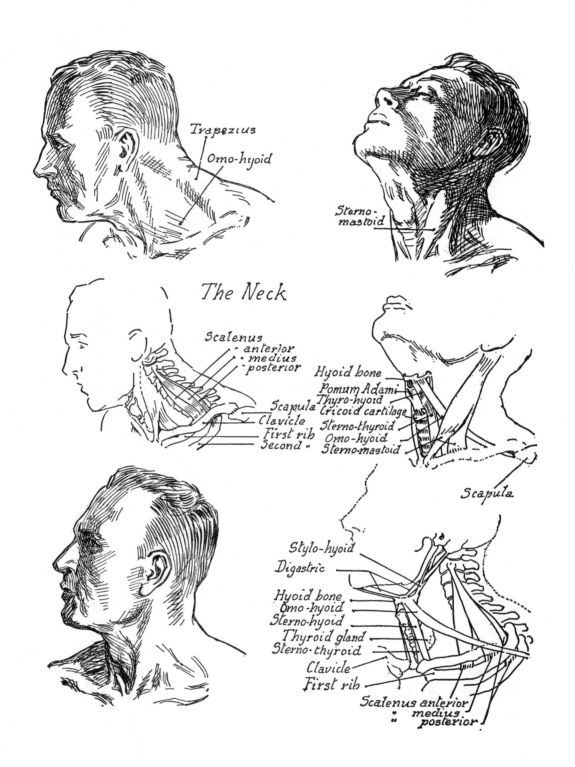

Trapezius

Omo-hyoid

Sterno-mastoid

The Neck

Scalenus
- anterior
- medius
- posterior

Scapula
Clavicle
First rib
Second "

Hyoid bone
Pomum Adami
Thyro-hyoid
Cricoid cartilage
Sterno-thyroid
Omo-hyoid
Sterno-mastoid

Scapula

Stylo-hyoid
Digastric

Hyoid bone
Omo-hyoid
Sterno-hyoid
Thyroid gland
Sterno-thyroid
Clavicle
First rib

Scalenus anterior
" medius
" posterior

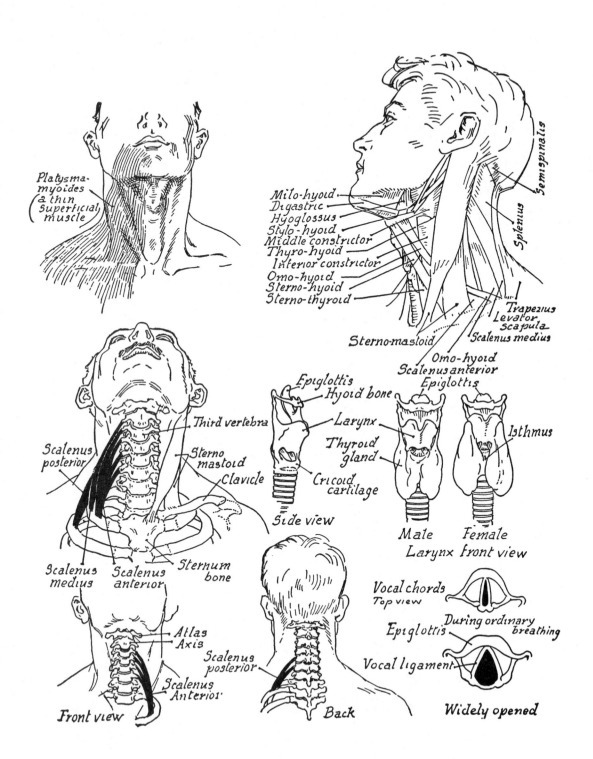

Platysma-
myoides
(a thin
Superficial
muscle)

Milo-hyoid
Digastric
Hyoglossus
Stylo-hyoid
Middle constrictor
Thyro-hyoid
Inferior constrictor
Omo-hyoid
Sterno-hyoid
Sterno-thyroid

Semispinalis
Splenius
Trapezius
Levator
scapula
Scalenus medius

Sterno-mastoid

Omo-hyoid
Scalenus anterior
Epiglottis

Scalenus
posterior

Third vertebra

Sterno
mastoid
Clavicle

Scalenus
medius

Scalenus
anterior

Sternum
bone

Epiglottis
Hyoid bone

Larynx

Thyroid
gland

Cricoid
cartilage

Side view

Isthmus

Male
Larynx

Female
front view

Atlas
Axis

Scalenus
Anterior

Scalenus
posterior

Vocal chords
Top view

Epiglottis

During ordinary
breathing

Vocal ligament

Front view

Back

Widely opened

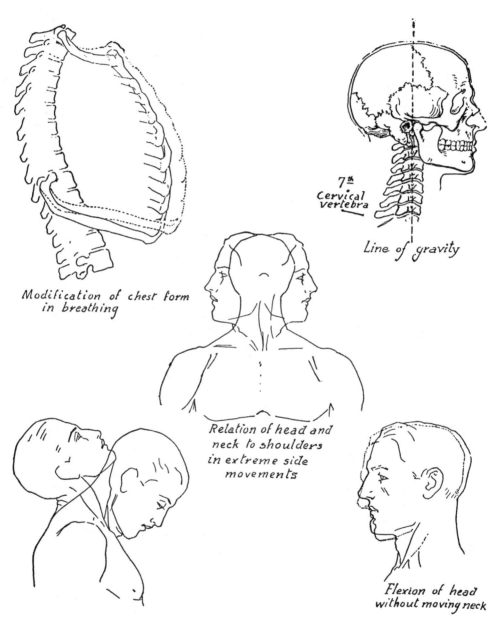

Modification of chest form
in breathing

7th
Cervical
vertebra

Line of gravity

Relation of head and
neck to shoulders
in extreme side
movements

Extent of bending forward and back

Flexion of head
without moving neck

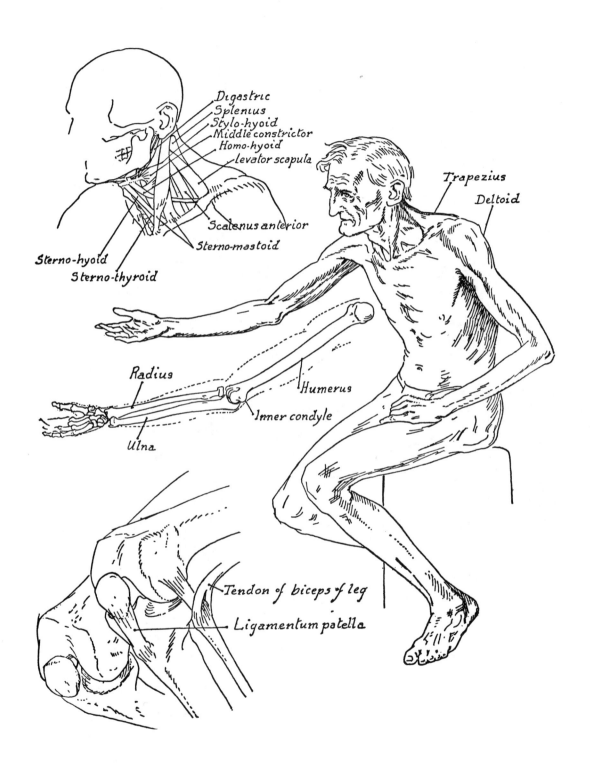

Digastric
Splenius
Stylo-hyoid
Middle constrictor
Homo-hyoid
levator scapula

Trapezius

Deltoid

Scalenus anterior

Sterno-mastoid

Sterno-hyoid
Sterno-thyroid

Radius

Humerus

Inner condyle

Ulna

Tendon of biceps of leg

Ligamentum patella

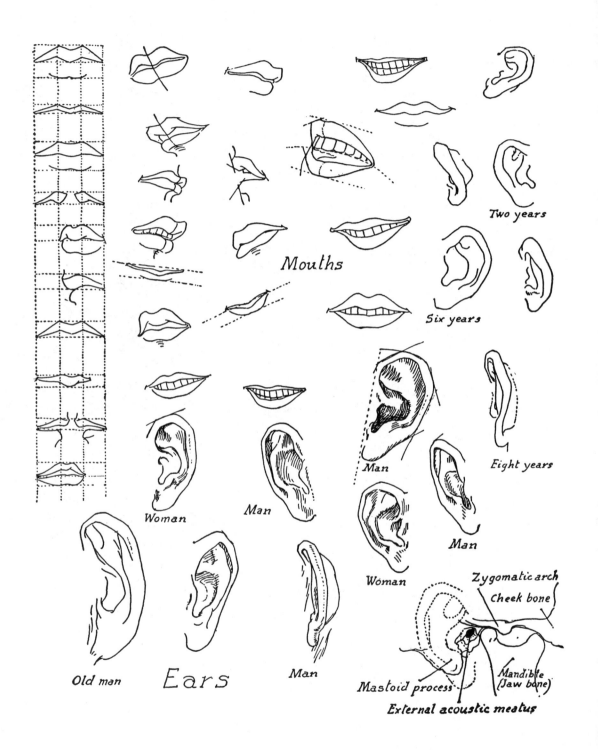

Mouths

Two years

Six years

Eight years

Man

Woman

Man

Man

Woman

Old man

Ears

Man

Zygomatic arch

Cheek bone

Mandible
(Jaw bone)

Mastoid process

External acoustic meatus

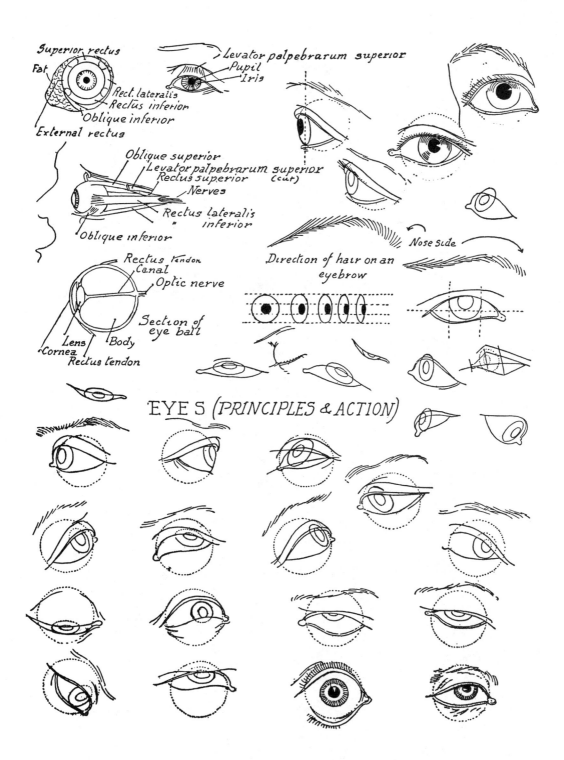

Superior rectus

Fat

Rect. lateralis
Rectus inferior
Oblique inferior

External rectus

Levator palpebrarum superior
Pupil
Iris

Oblique superior
Levator palpebrarum superior (cut)
Rectus superior
Nerves
Rectus lateralis
inferior
"

Oblique inferior

Rectus tendon
Canal
Optic nerve

Section of
eye ball

Lens
Cornea
Body
Rectus tendon

Direction of hair on an
eyebrow

Nose side

EYES (PRINCIPLES & ACTION)

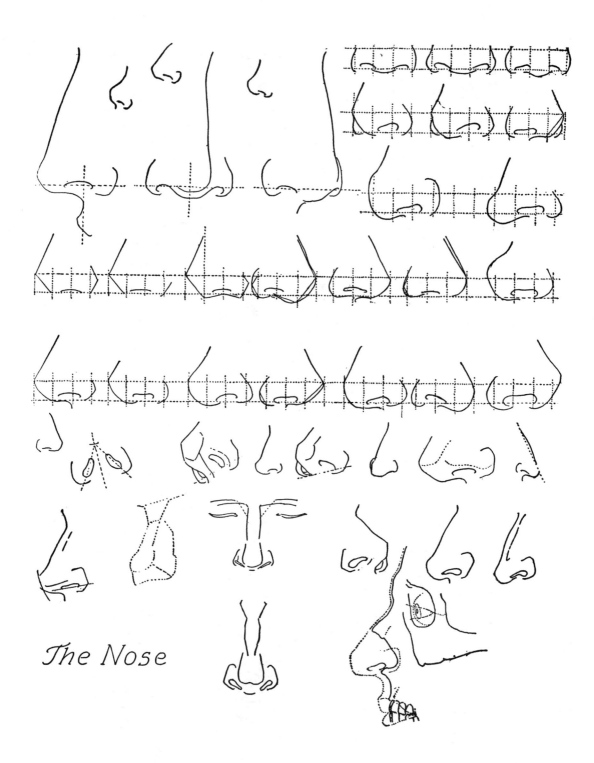

The Nose

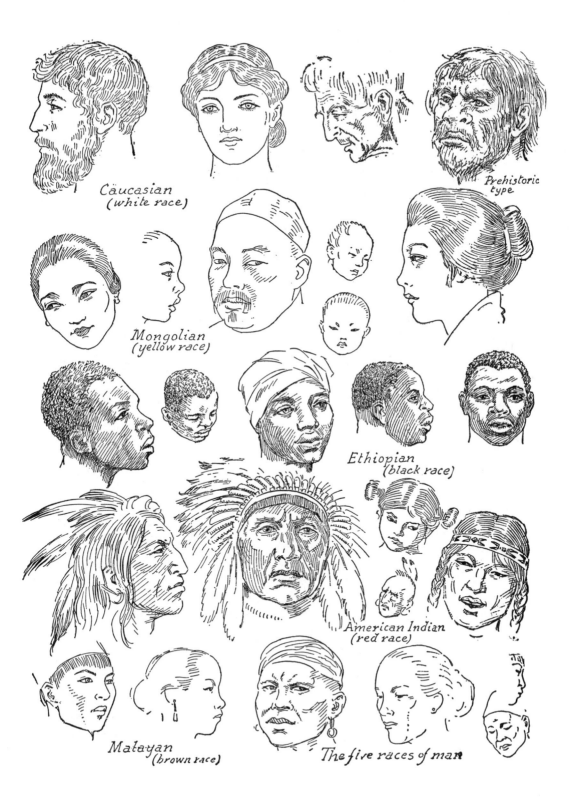

Caucasian
(white race)

Prehistoric
type

Mongolian
(yellow race)

Ethiopian
(black race)

American Indian
(red race)

Malayan
(brown race)

The five races of man

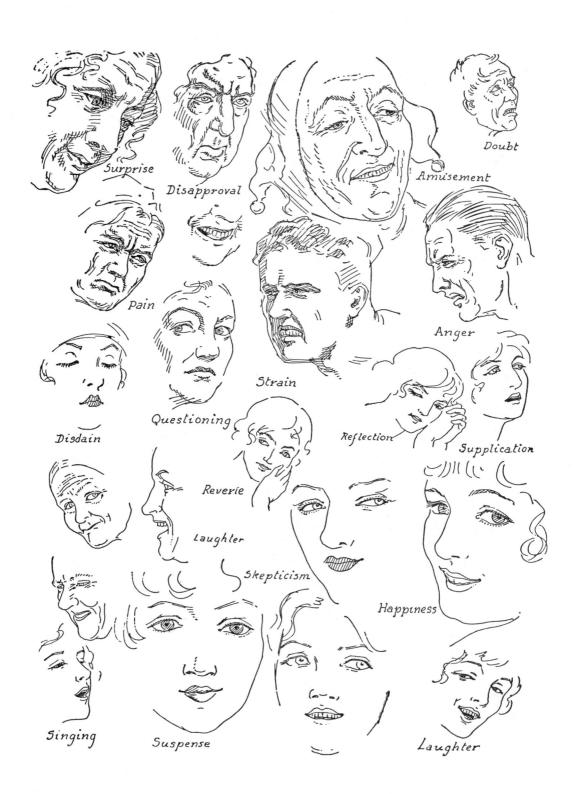

Surprise

Disapproval

Amusement

Doubt

Pain

Anger

Strain

Disdain

Questioning

Reflection

Supplication

Reverie

Laughter

Skepticism

Happiness

Singing

Suspense

Laughter

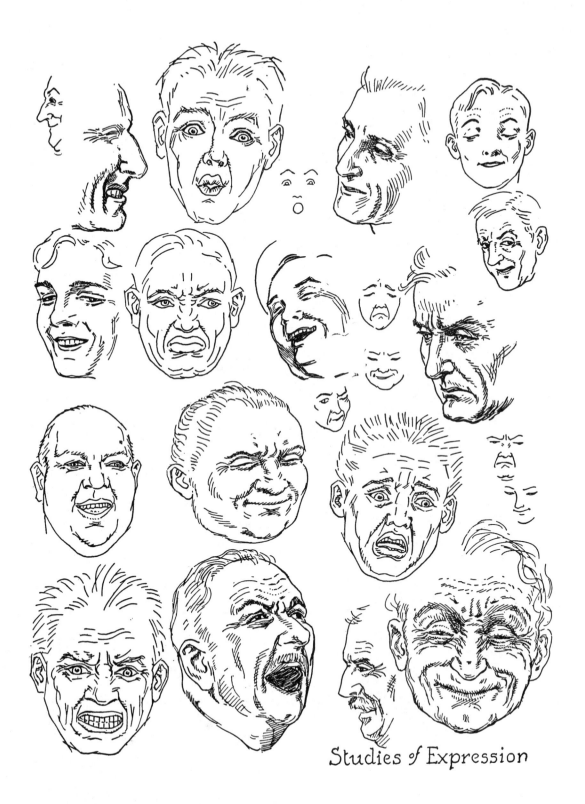

Studies of Expression

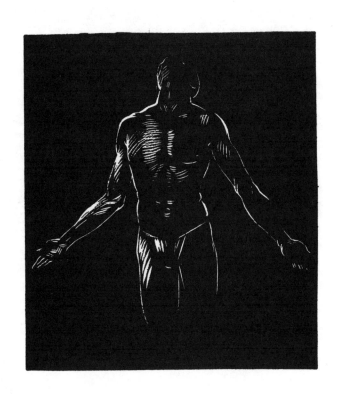

PART FOUR

THE TORSO

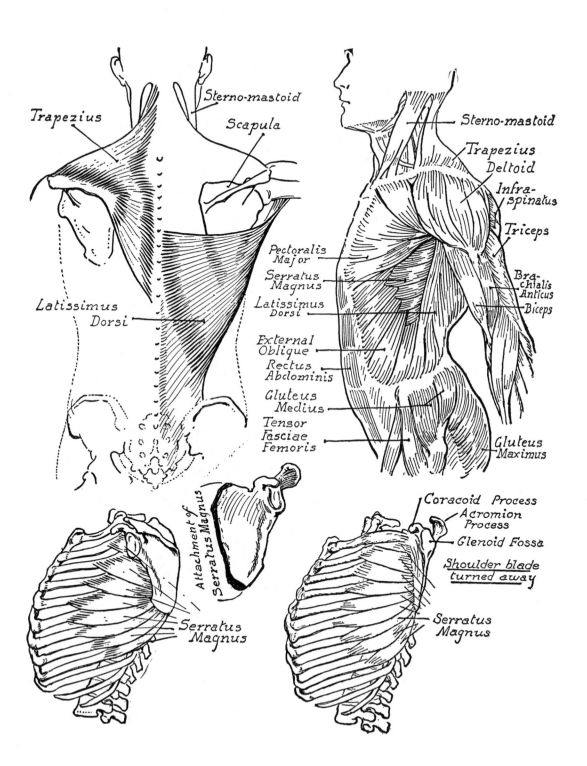

Trapezius

Sterno-mastoid

Scapula

Latissimus Dorsi

Pectoralis Major

Serratus Magnus

Latissimus Dorsi

External Oblique

Rectus Abdominis

Gluteus Medius

Tensor Fasciae Femoris

Sterno-mastoid

Trapezius

Deltoid

Infra-spinatus

Triceps

Brachialis Anticus

Biceps

Gluteus Maximus

Attachment of Serratus Magnus

Serratus Magnus

Coracoid Process

Acromion Process

Glenoid Fossa

Shoulder blade turned away

Serratus Magnus

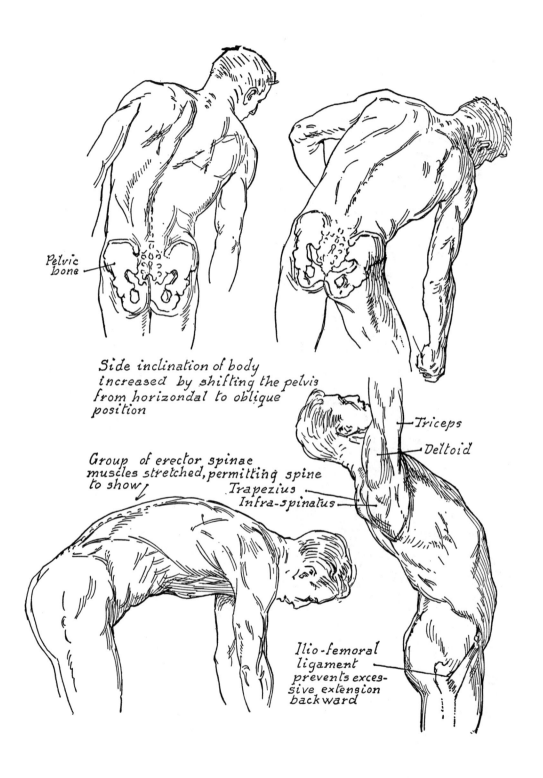

Pelvic
bone

Side inclination of body
increased by shifting the pelvis
from horizondal to oblique
position

Group of erector spinae
muscles stretched, permitting spine
to show

Triceps

Deltoid

Trapezius

Infra-spinatus

Ilio-femoral
ligament
prevents exces-
sive extension
backward

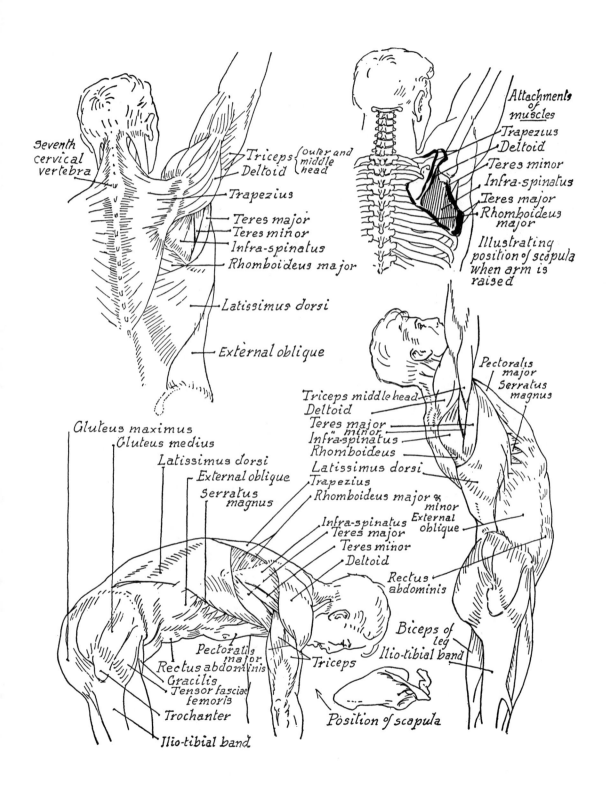

Seventh cervical vertebra

Triceps {outer and middle head

Deltoid

Trapezius

Teres major
Teres minor
Infra-spinatus
Rhomboideus major

Latissimus dorsi

External oblique

Attachments of muscles
Trapezius
Deltoid
Teres minor
Infra-spinatus
Teres major
Rhomboideus major

Illustrating position of scapula when arm is raised

Pectoralis major
Serratus magnus

Triceps middle head
Deltoid
Teres major
" minor
Infra-spinatus
Rhomboideus
Latissimus dorsi
Trapezius
Rhomboideus major & minor
External oblique

Infra-spinatus
Teres major
Teres minor
Deltoid

Rectus abdominis

Biceps of leg
Ilio-tibial band

Gluteus maximus
Gluteus medius
Latissimus dorsi
External oblique
Serratus magnus

Pectoralis major
Rectus abdominis
Gracilis
Tensor fasciae femoris
Trochanter

Ilio-tibial band

Triceps

Position of scapula

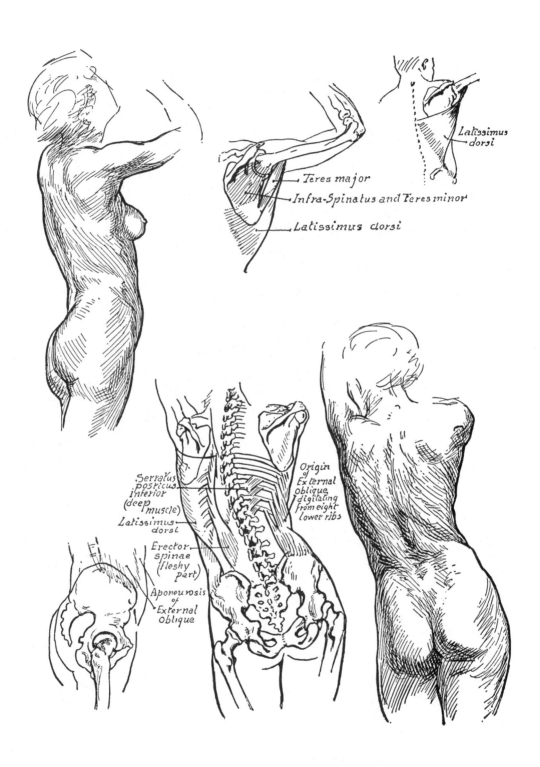

Teres major

Infra-Spinatus and Teres minor

Latissimus dorsi

Latissimus dorsi

Serratus
posticus
inferior
(deep
muscle)

Latissimus
dorsi

Erector
spinae
(fleshy
part)

Aponeurosis
of
External
Oblique

Origin
of
External
oblique
digitating
from eight
lower ribs

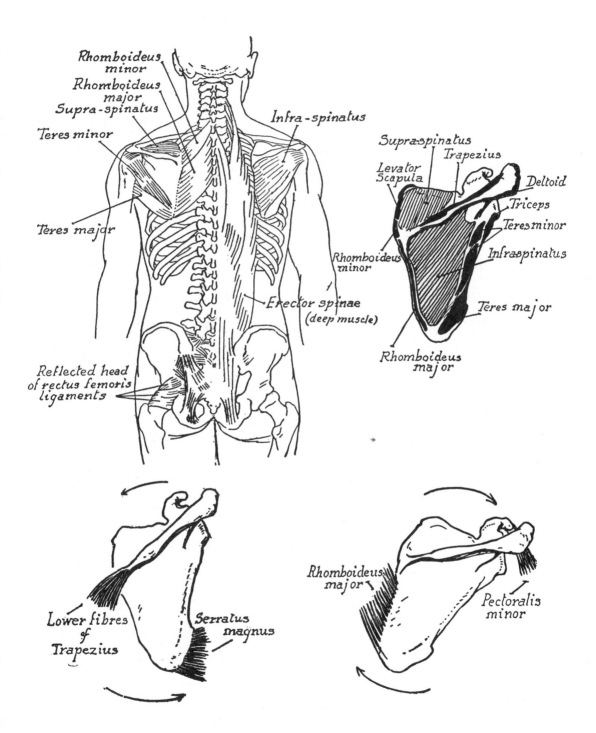

Rhomboideus minor
Rhomboideus major
Supra-spinatus
Teres minor
Teres major
Infra-spinatus
Reflected head of rectus femoris ligaments
Erector spinae (deep muscle)

Suprospinatus
Levator Scapula
Trapezius
Deltoid
Triceps
Teres minor
Infraspinatus
Teres major
Rhomboideus minor
Rhomboideus major

Lower fibres of Trapezius
Serratus magnus

Rhomboideus major
Pectoralis minor

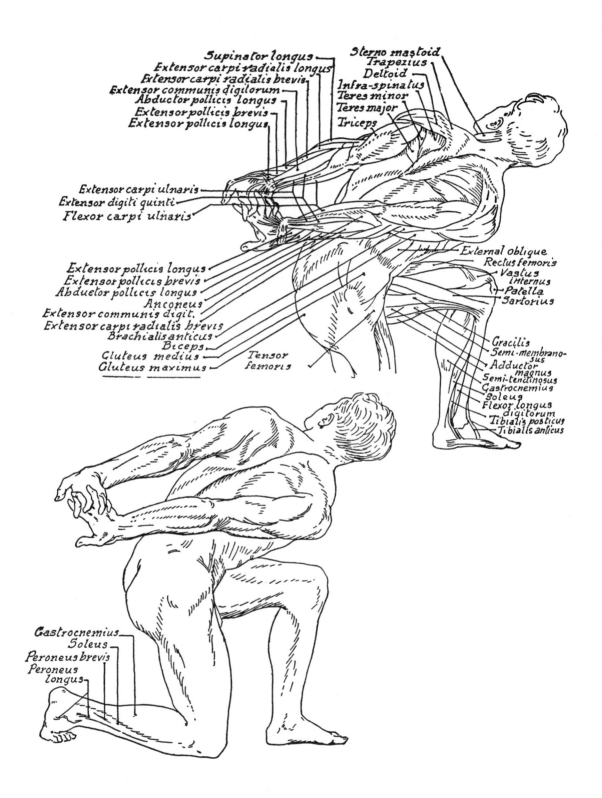

Supinator longus
Extensor carpi radialis longus
Extensor carpi radialis brevis
Extensor communis digitorum
Abductor pollicis longus
Extensor pollicis brevis
Extensor pollicis longus

Sterno mastoid
Trapezius
Deltoid
Infra-spinatus
Teres minor
Teres major
Triceps

Extensor carpi ulnaris
Extensor digiti quinti
Flexor carpi ulnaris

External oblique
Rectus femoris
Vastus internus
Patella
Sartorius

Extensor pollicis longus
Extensor pollicis brevis
Abductor pollicis longus
Anconeus
Extensor communis digit.
Extensor carpi radialis brevis
Brachialis anticus
Biceps
Gluteus medius
Gluteus maximus

Tensor femoris

Gracilis
Semi-membranosus
Adductor magnus
Semi-tendinosus
Gastrocnemius
Soleus
Flexor longus digitorum
Tibialis posticus
Tibialis anticus

Gastrocnemius
Soleus
Peroneus brevis
Peroneus longus

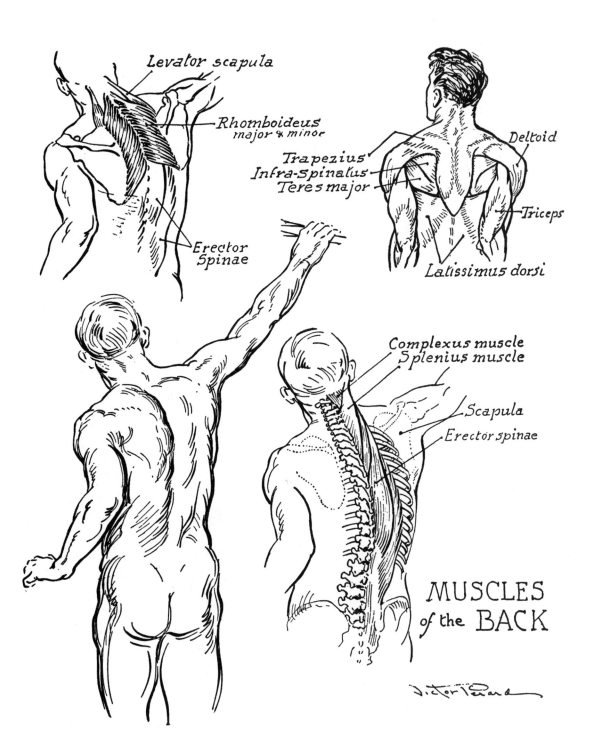

Levator scapula

Rhomboideus
major & minor

Trapezius
Infra-spinatus
Teres major

Deltoid

Triceps

Erector
Spinae

Latissimus dorsi

Complexus muscle
Splenius muscle

Scapula
Erector spinae

MUSCLES
of the BACK

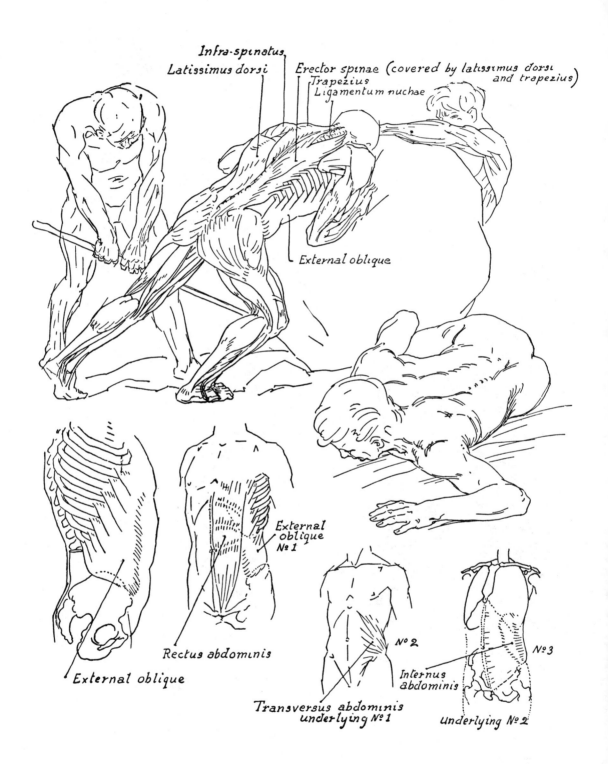

Infra-spinatus

Latissimus dorsi

Erector spinae (covered by latissimus dorsi and trapezius)

Trapezius

Ligamentum nuchae

External oblique

External oblique №1

Rectus abdominis

External oblique

№2

Internus abdominis

№3

Transversus abdominis underlying №1

Underlying №2

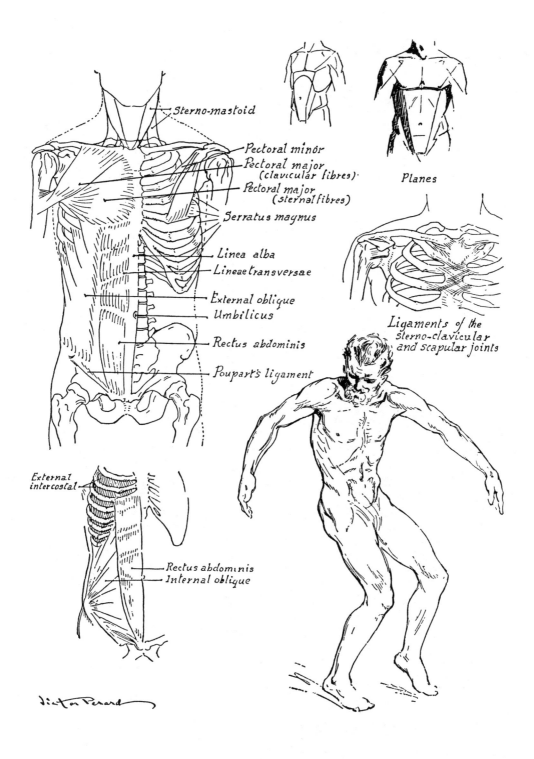

Sterno-mastoid

Pectoral minor
Pectoral major
(clavicular fibres)
Pectoral major
(sternal fibres)
Serratus magnus

Linea alba
Lineae transversae

External oblique
Umbilicus

Rectus abdominis

Poupart's ligament

Planes

Ligaments of the
Sterno-clavicular
and scapular joints

External
intercostal

Rectus abdominis
Internal oblique

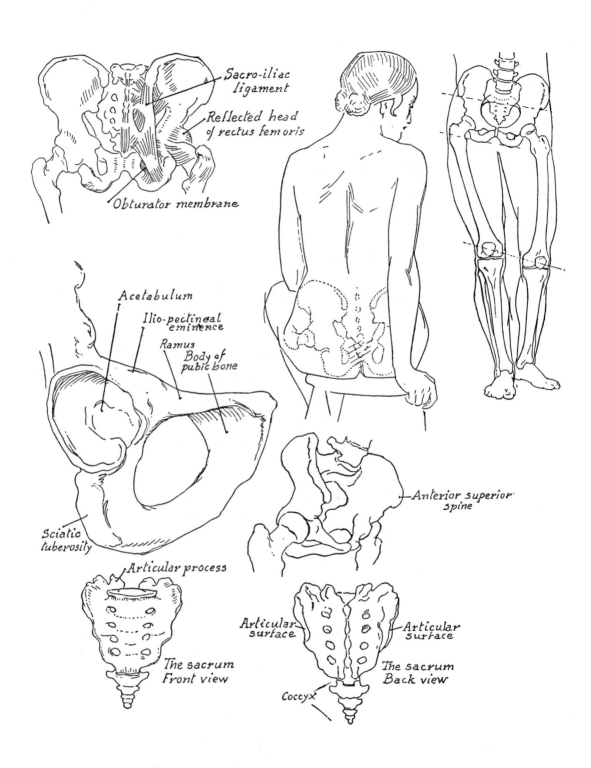

Sacro-iliac
ligament

Reflected head
of rectus femoris

Obturator membrane

Acetabulum

Ilio-pectineal
eminence

Ramus
Body of
pubic bone

Sciatic
tuberosity

Anterior superior
spine

Articular process

Articular
surface

Articular
surface

The sacrum
Front view

The sacrum
Back view

Coccyx

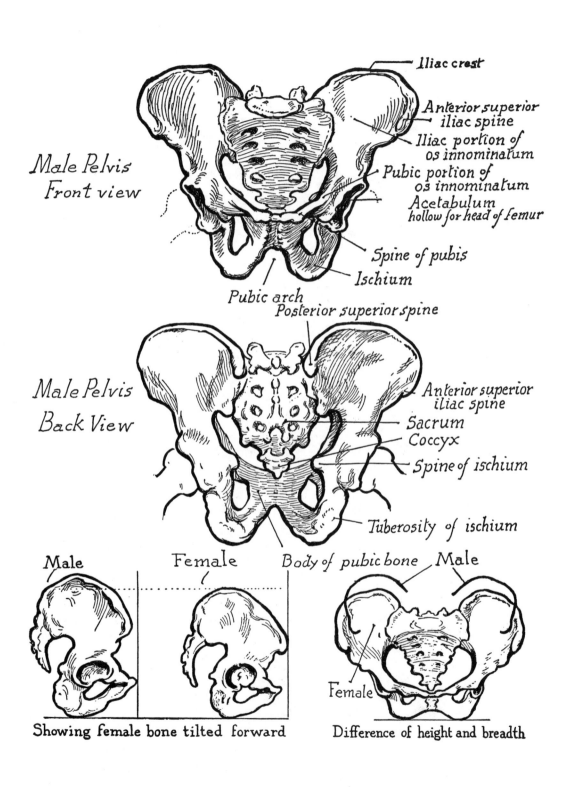

Iliac crest

Anterior superior
iliac spine

Iliac portion of
os innominatum

Pubic portion of
os innominatum

Acetabulum
hollow for head of femur

Male Pelvis
Front view

Spine of pubis

Ischium

Pubic arch

Posterior superior spine

Male Pelvis
Back View

Anterior superior
iliac spine

Sacrum

Coccyx

Spine of ischium

Tuberosity of ischium

Male Female Body of pubic bone Male

Female

Showing female bone tilted forward

Difference of height and breadth

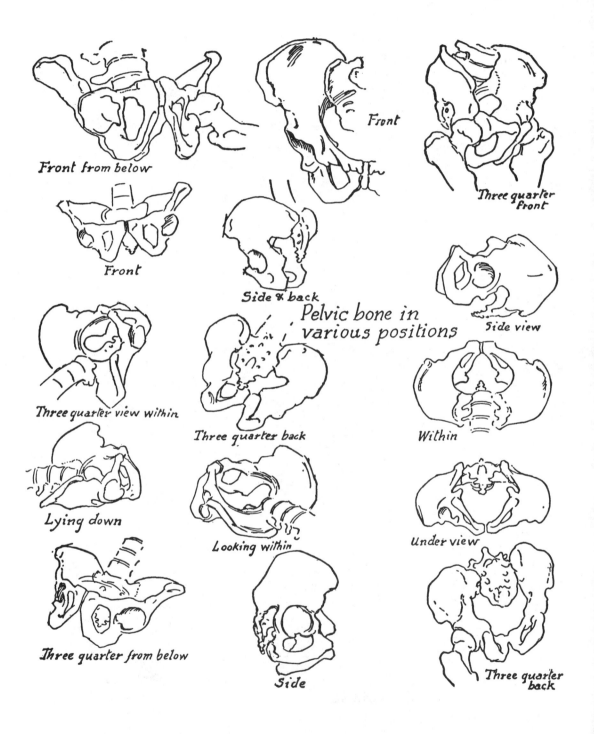

Front from below

Front

Three quarter front

Front

Side & back

Side view

Pelvic bone in various positions

Three quarter view within

Three quarter back

Within

Lying down

Looking within

Under view

Three quarter from below

Side

Three quarter back

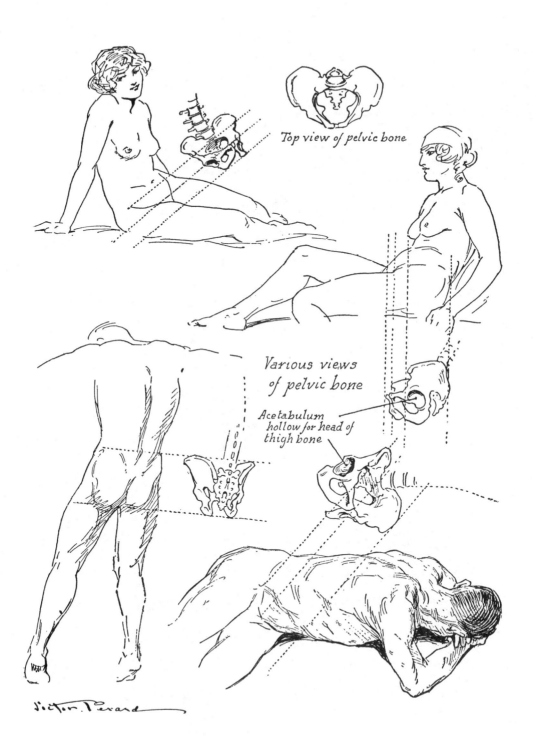

Top view of pelvic bone

Various views of pelvic bone

Acetabulum hollow for head of thigh bone

Victor Perard

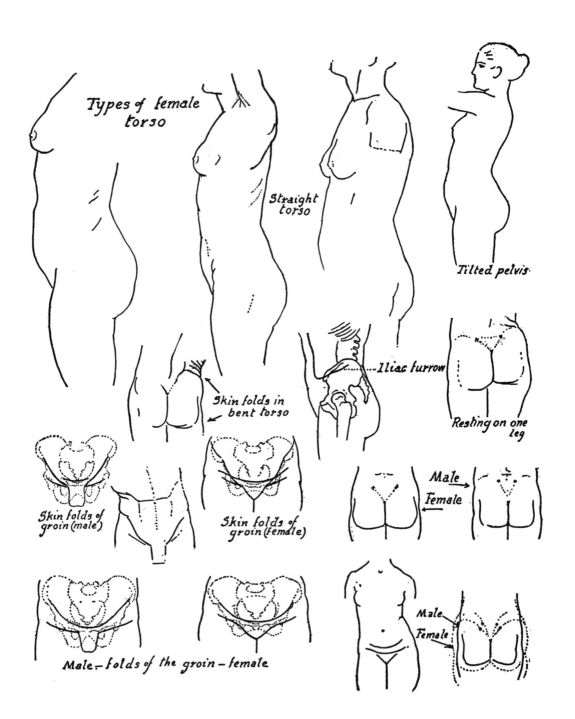

Types of female torso

Straight torso

Tilted pelvis

Skin folds in bent torso

Iliac furrow

Resting on one leg

Skin folds of groin (male)

Skin folds of groin (female)

Male
Female

Male — folds of the groin — female

Male
Female

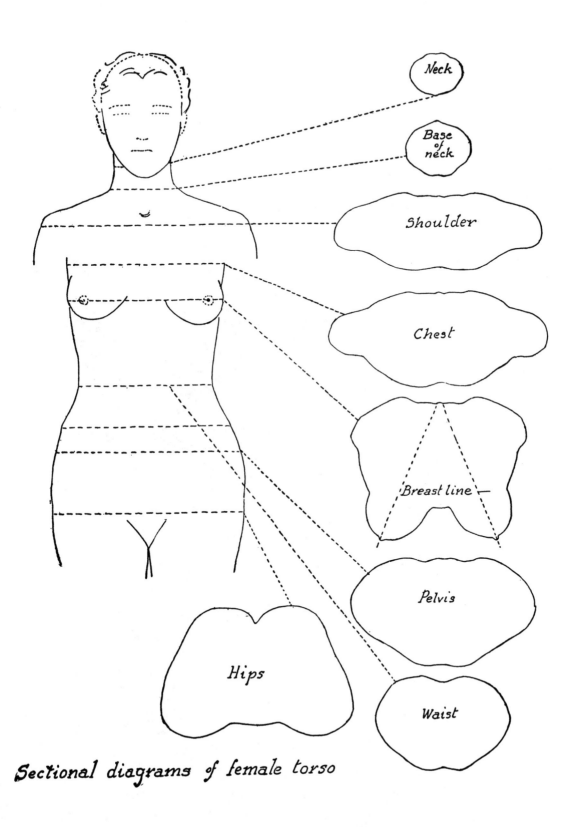

Neck

Base of neck

Shoulder

Chest

Breast line

Pelvis

Hips

Waist

Sectional diagrams of female torso

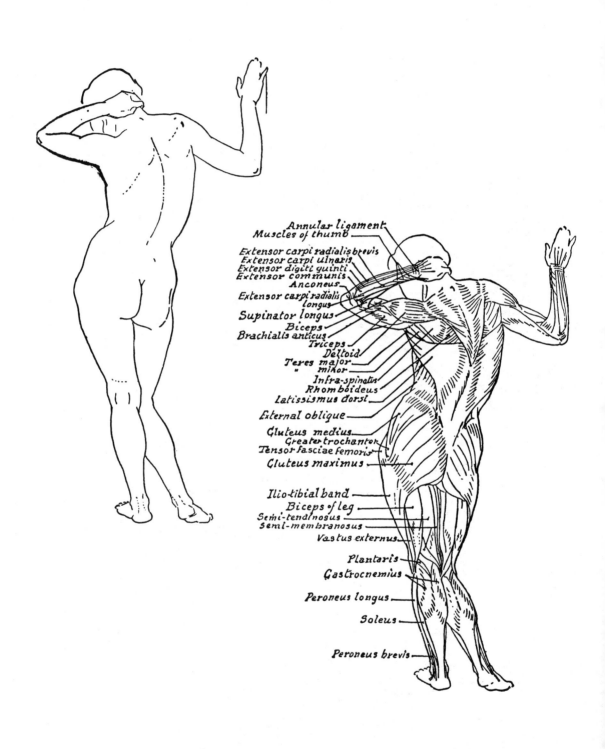

Annular ligament
Muscles of thumb
Extensor carpi radialis brevis
Extensor carpi ulnaris
Extensor digiti quinti
Extensor communis
Anconeus
Extensor carpi radialis
longus
Supinator longus
Biceps
Brachialis anticus
Triceps
Deltoid
Teres major
" minor
Infra-spinatus
Rhomboideus
Latissismus dorsi
External oblique
Gluteus medius
Greater trochanter
Tensor fasciae femoris
Gluteus maximus

Ilio-tibial band
Biceps of leg
Semi-tendinosus
Semi-membranosus
Vastus externus

Plantaris
Gastrocnemius

Peroneus longus

Soleus

Peroneus brevis

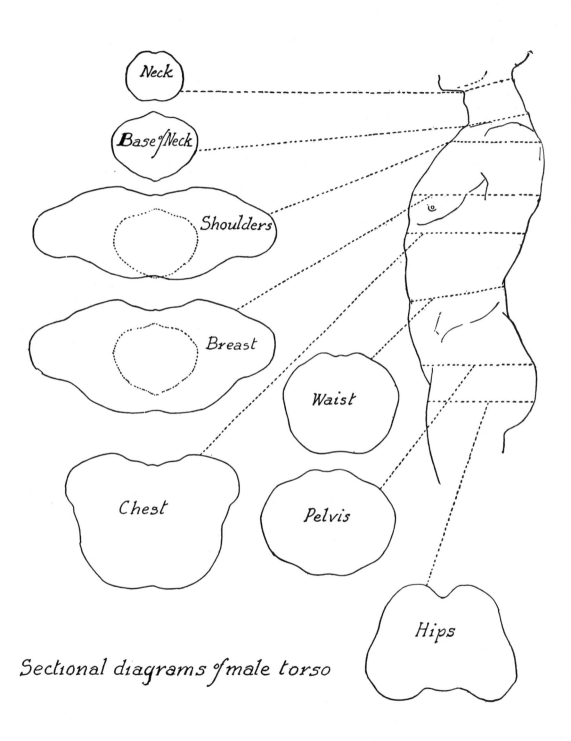

Neck

Base of Neck

Shoulders

Breast

Waist

Chest

Pelvis

Hips

Sectional diagrams of male torso

PART FIVE

THE ARM

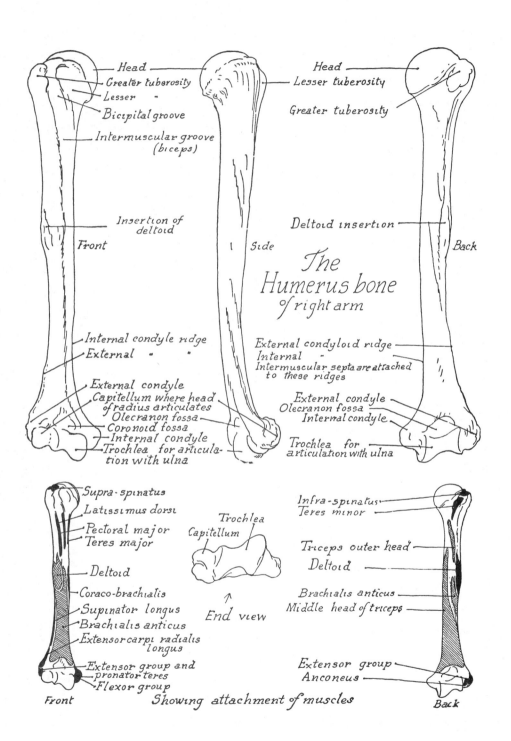

Head
Greater tuberosity
Lesser -
Bicipital groove
Intermuscular groove
(biceps)

Head
Lesser tuberosity
Greater tuberosity

Insertion of
deltoid

Deltoid insertion

Front

Side

Back

*The
Humerus bone
of right arm*

Internal condyle ridge
External - -

External condyloid ridge
Internal -
Intermuscular septa are attached
to these ridges

External condyle
Capitellum where head
of radius articulates
Olecranon fossa
Coronoid fossa
Internal condyle
Trochlea for articula-
tion with ulna

External condyle
Olecranon fossa
Internal condyle

Trochlea for
articulation with ulna

Supra-spinatus
Latissimus dorsi
Pectoral major
Teres major

Deltoid
Coraco-brachialis
Supinator longus
Brachialis anticus
Extensor carpi radialis
longus
Extensor group and
pronator teres
Flexor group

Trochlea
Capitellum

End view

Infra-spinatus
Teres minor

Triceps outer head
Deltoid

Brachialis anticus
Middle head of triceps

Extensor group
Anconeus

Front

Showing attachment of muscles

Back

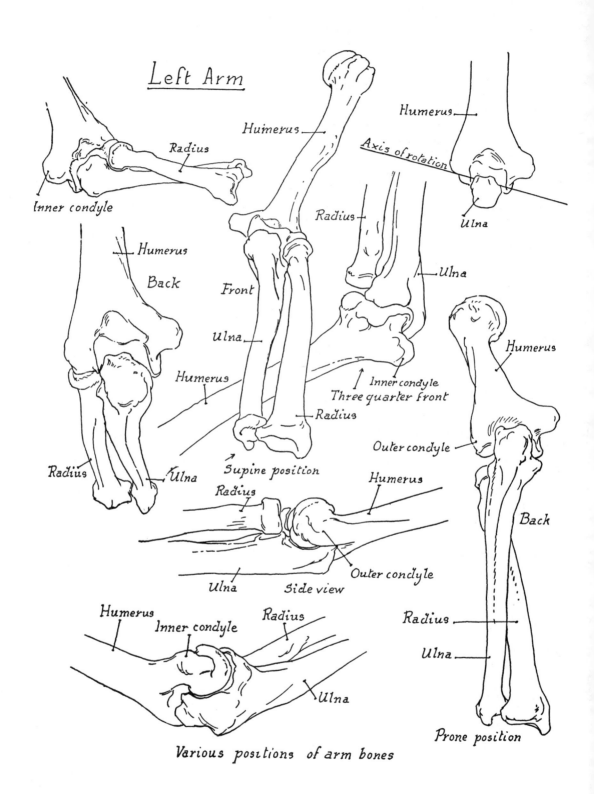

Left Arm

Radius

Humerus

Humerus

Axis of rotation

Inner condyle

Radius

Ulna

Humerus

Back

Front

Radius

Humerus

Ulna

Ulna

Radius

Humerus

Inner condyle

Three quarter front

Outer condyle

Radius

Ulna

Supine position

Back

Radius

Humerus

Ulna

Outer condyle

Side view

Humerus

Inner condyle

Radius

Radius

Ulna

Ulna

Prone position

Various positions of arm bones

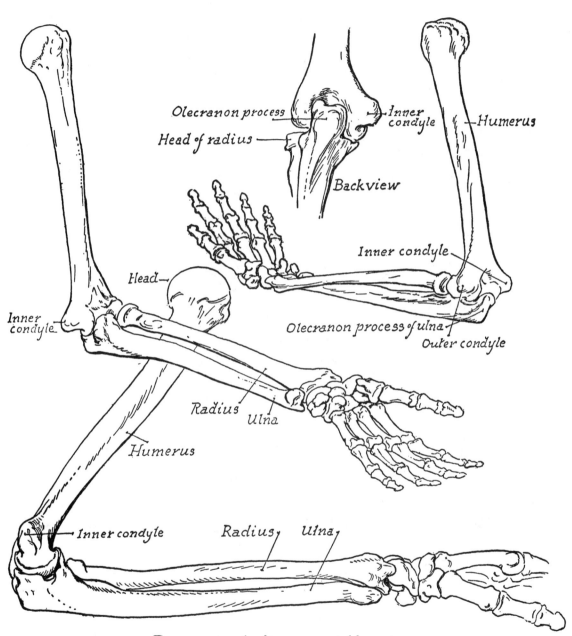

Olecranon process

Head of radius

Inner condyle

Humerus

Backview

Inner condyle

Olecranon process of ulna

Outer condyle

Head

Inner condyle

Radius

Ulna

Humerus

Inner condyle

Radius

Ulna

Bones of Arm and Hand

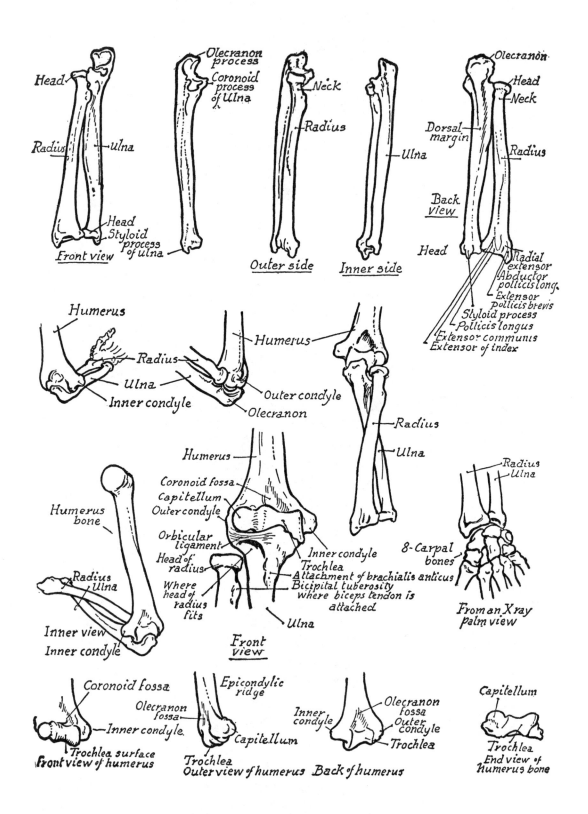

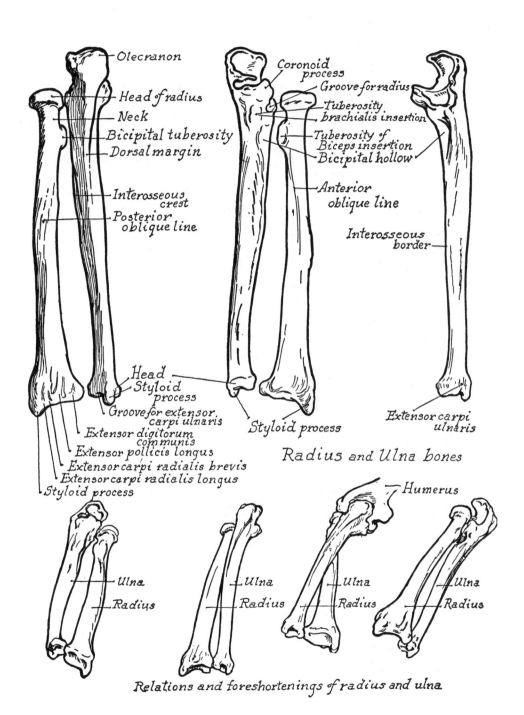

Olecranon

Head of radius

Neck

Bicipital tuberosity

Dorsal margin

Interosseous crest

Posterior oblique line

Coronoid process

Groove for radius

Tuberosity brachialis insertion

Tuberosity of Biceps insertion

Bicipital hollow

Anterior oblique line

Interosseous border

Head

Styloid process

Groove for extensor carpi ulnaris

Extensor digitorum communis

Extensor pollicis longus

Extensor carpi radialis brevis

Extensor carpi radialis longus

Styloid process

Styloid process

Extensor carpi ulnaris

Radius and Ulna bones

Humerus

Ulna

Radius

Ulna

Radius

Ulna

Radius

Ulna

Radius

Relations and foreshortenings of radius and ulna

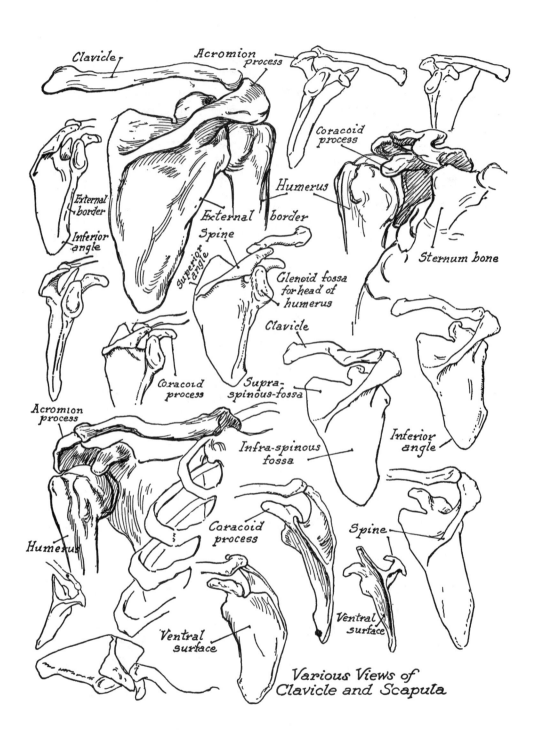

Various Views of
Clavicle and Scapula

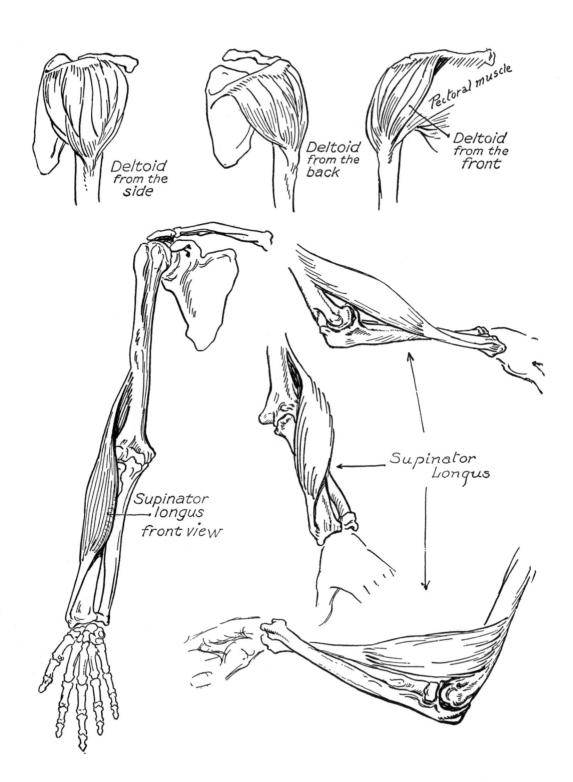

Deltoid from the side

Deltoid from the back

Pectoral muscle

Deltoid from the front

Supinator longus front view

Supinator Longus

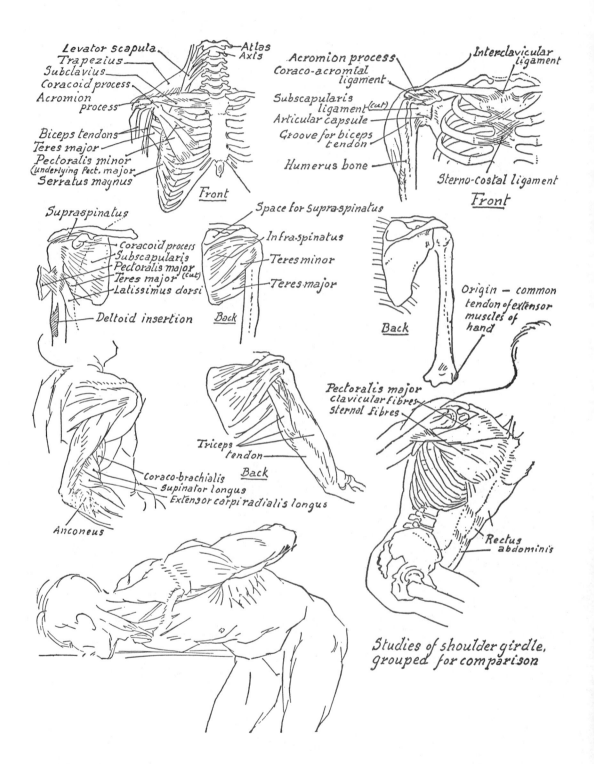

Levator scapula
Trapezius
Subclavius
Coracoid process
Acromion process

Atlas
Axis

Biceps tendons
Teres major
Pectoralis minor
(underlying Pect. major)
Serratus magnus

Front

Acromion process
Coraco-acromial ligament

Interclavicular ligament

Subscapularis ligament (cut)
Articular capsule
Groove for biceps tendon

Humerus bone

Sterno-costal ligament

Front

Supraspinatus

Coracoid process
Subscapularis
Pectoralis major
Teres major (cut)
Latissimus dorsi

Deltoid insertion

Space for Supra-spinatus

Infra-spinatus

Teres minor

Teres major

Back

Back

Origin — common tendon of extensor muscles of hand

Back

Triceps tendon

Back

Coraco-brachialis
supinator longus
Extensor carpi radialis longus

Anconeus

Pectoralis major
clavicular fibres
sternal fibres

Rectus abdominis

Studies of shoulder girdle, grouped for comparison

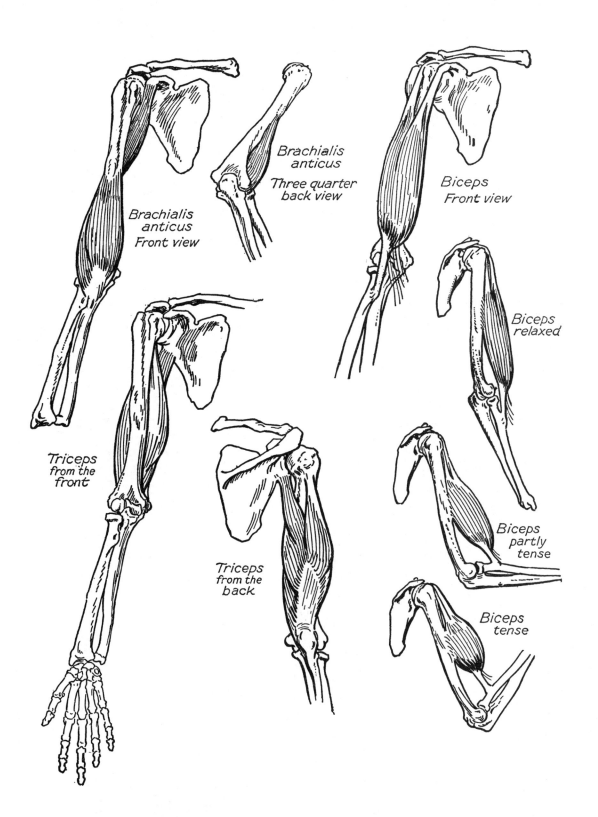

Brachialis anticus
Three quarter back view

Brachialis anticus Front view

Biceps Front view

Biceps relaxed

Triceps from the front

Triceps from the back

Biceps partly tense

Biceps tense

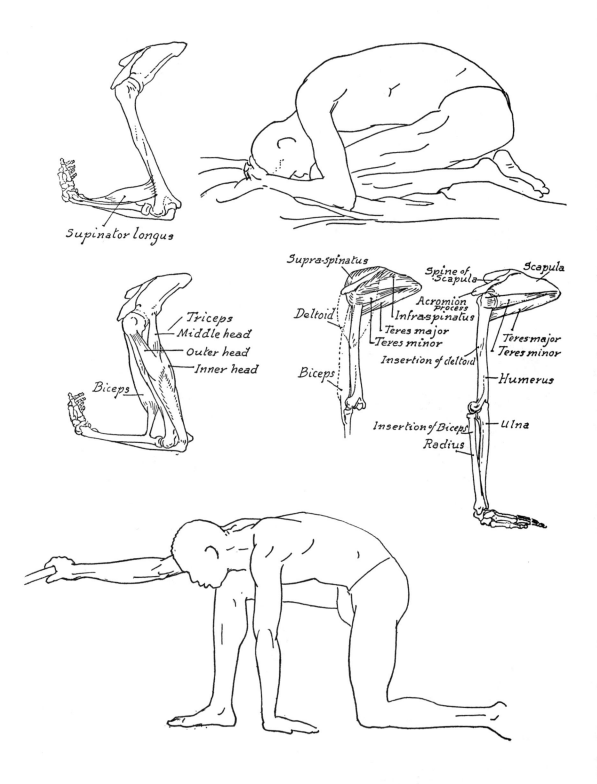

Supinator longus

Triceps
Middle head
Outer head
Inner head

Biceps

Supra-spinatus

Spine of
Scapula

Scapula

Deltoid

Acromion
process

Infra-spinatus

Teres major

Teres minor

Teres major
Teres minor

Biceps

Insertion of deltoid

Humerus

Insertion of Biceps

Ulna

Radius

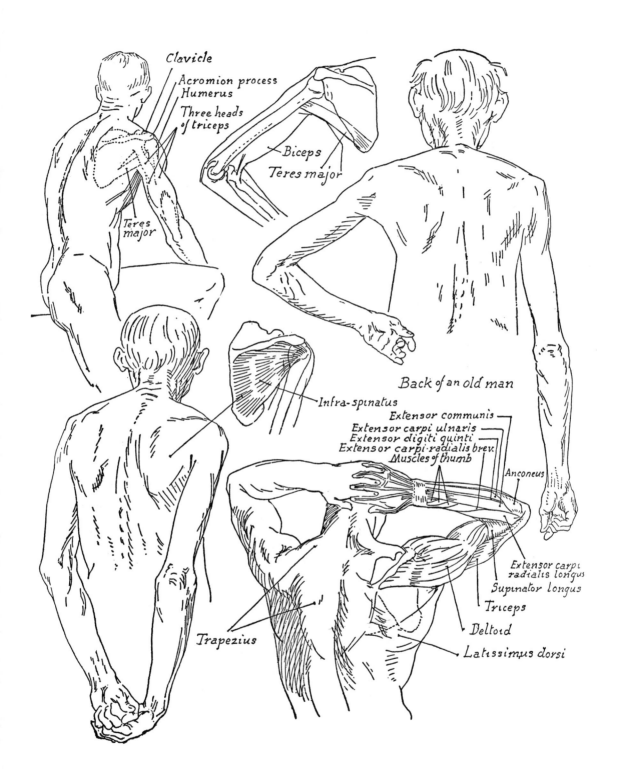

Clavicle

Acromion process
Humerus

Three heads
of triceps

Biceps
Teres major

Teres
major

Infra-spinatus

Back of an old man

Extensor communis
Extensor carpi ulnaris
Extensor digiti quinti
Extensor carpi-radialis brev.
Muscles of thumb

Anconeus

Extensor carpi
radialis longus

Supinator longus

Triceps

Deltoid

Latissimus dorsi

Trapezius

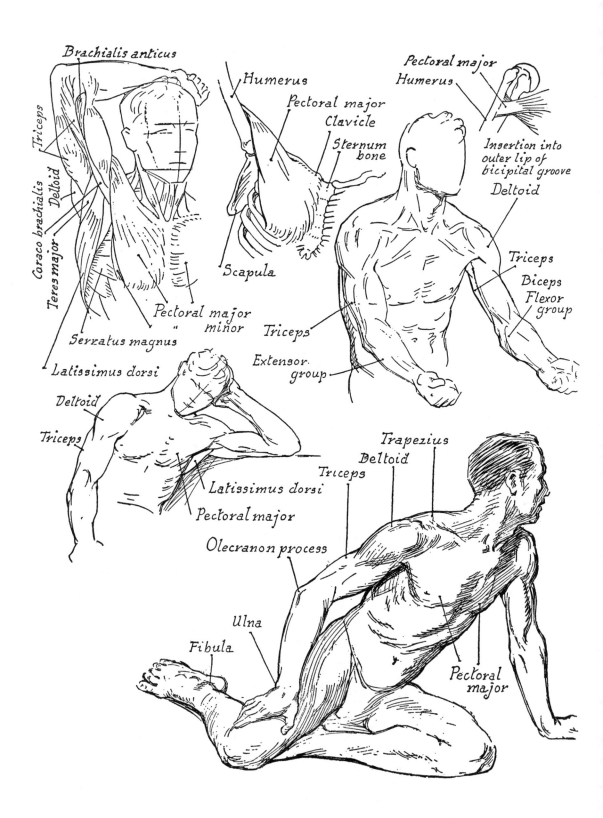

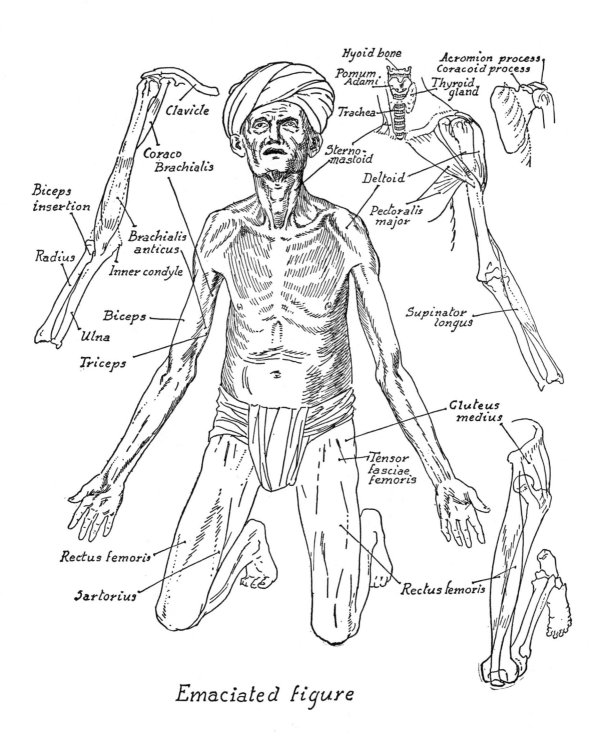

Hyoid bone

Pomum Adami

Acromion process
Coracoid process

Thyroid gland

Trachea

Clavicle

Coraco Brachialis

Sterno-mastoid

Deltoid

Pectoralis major

Biceps insertion

Radius

Brachialis anticus

Inner condyle

Biceps

Ulna

Triceps

Supinator longus

Gluteus medius

Tensor fasciae femoris

Rectus femoris

Sartorius

Rectus femoris

Emaciated figure

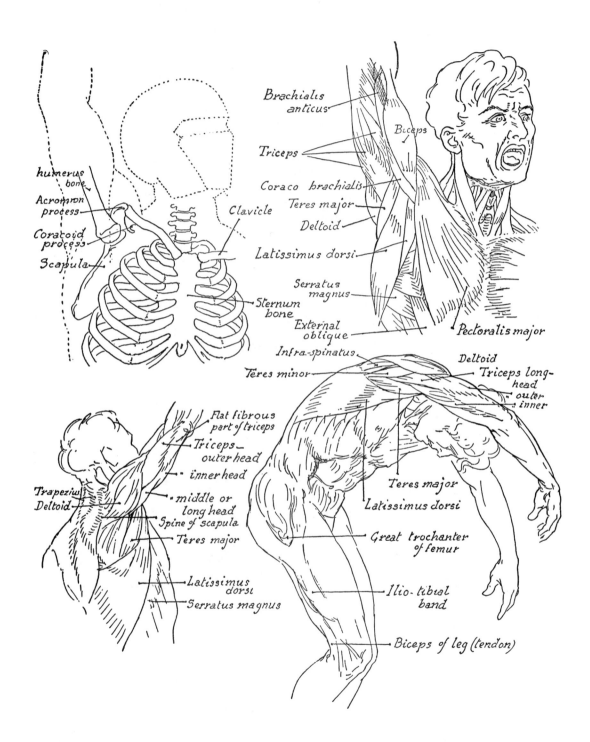

Brachialis anticus

Biceps

Triceps

Coraco brachialis

Teres major

Deltoid

Latissimus dorsi

Serratus magnus

External oblique

Pectoralis major

humerus bone

Acromion process

Coracoid process

Scapula

Clavicle

Sternum bone

Infra-spinatus

Teres minor

Deltoid

Triceps long head
outer
inner

Flat fibrous part of triceps

Triceps outer head

inner head

middle or long head

Spine of scapula

Teres major

Trapezius

Deltoid

Latissimus dorsi

Serratus magnus

Teres major

Latissimus dorsi

Great trochanter of femur

Ilio-tibial band

Biceps of leg (tendon)

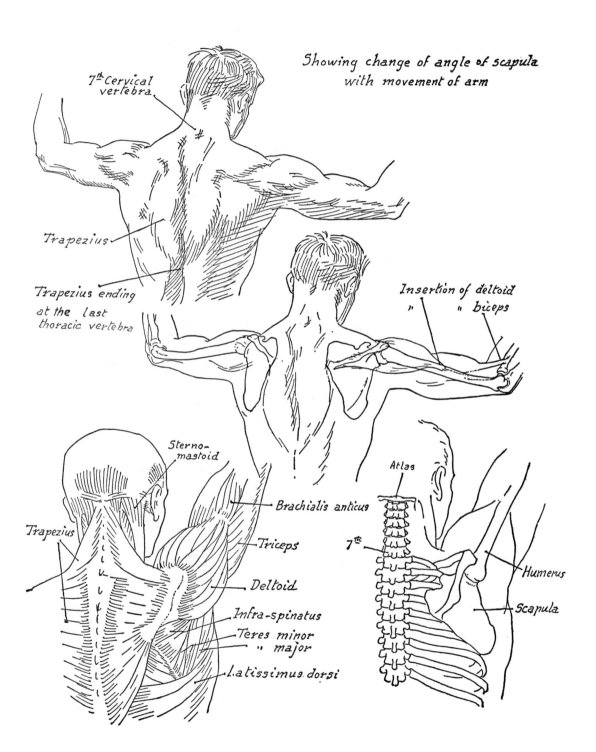

Showing change of angle of scapula
with movement of arm

7th Cervical
vertebra.

Trapezius

Trapezius ending
at the last
thoracic vertebra

Insertion of deltoid
" " biceps

Sterno-
mastoid

Atlas

Trapezius

Brachialis anticus

Triceps

Deltoid

7th

Infra-spinatus

Teres minor
" major

Latissimus dorsi

Humerus

Scapula

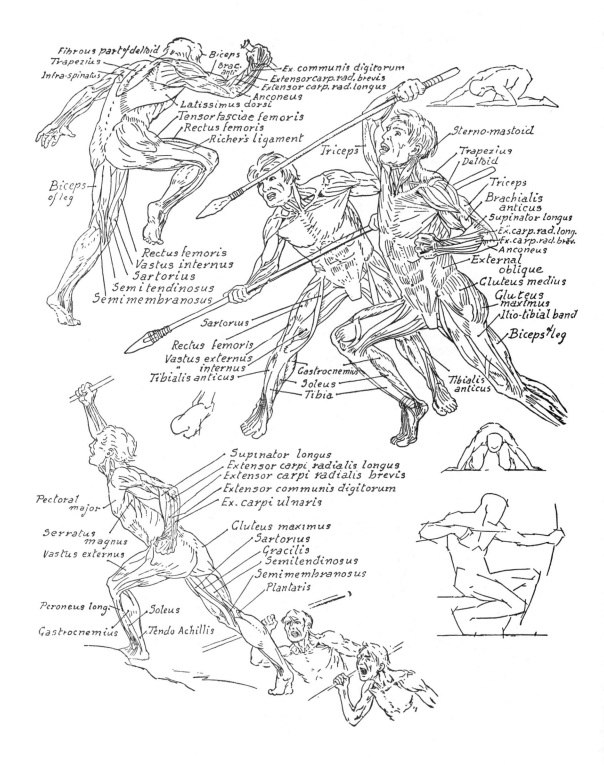

Fibrous part of deltoid
Trapezius
Infra-spinatus
Biceps
Brac.
anti.
Ex. communis digitorum
Extensor carp. rad. brevis
Extensor carp. rad. longus
Anconeus
Latissimus dorsi
Tensor fasciae femoris
Rectus femoris
Richer's ligament
Triceps

Biceps
of leg

Sterno-mastoid
Trapezius
Deltoid
Triceps
Brachialis
anticus
Supinator longus
Ex. carp. rad. long.
Ex. carp. rad. brev.
Anconeus
External
oblique
Gluteus medius
Gluteus
maximus
Ilio-tibial band
Biceps of leg

Rectus femoris
Vastus internus
Sartorius
Semitendinosus
Semimembranosus

Sartorius

Rectus femoris
Vastus externus
" internus
Tibialis anticus
Gastrocnemius
Soleus
Tibia
Tibialis
anticus

Supinator longus
Extensor carpi radialis longus
Extensor carpi radialis brevis
Extensor communis digitorum
Ex. carpi ulnaris

Pectoral
major

Serratus
magnus
Vastus externus

Gluteus maximus
Sartorius
Gracilis
Semitendinosus
Semimembranosus
Plantaris

Peroneus long.
Soleus
Gastrocnemius
Tendo Achillis

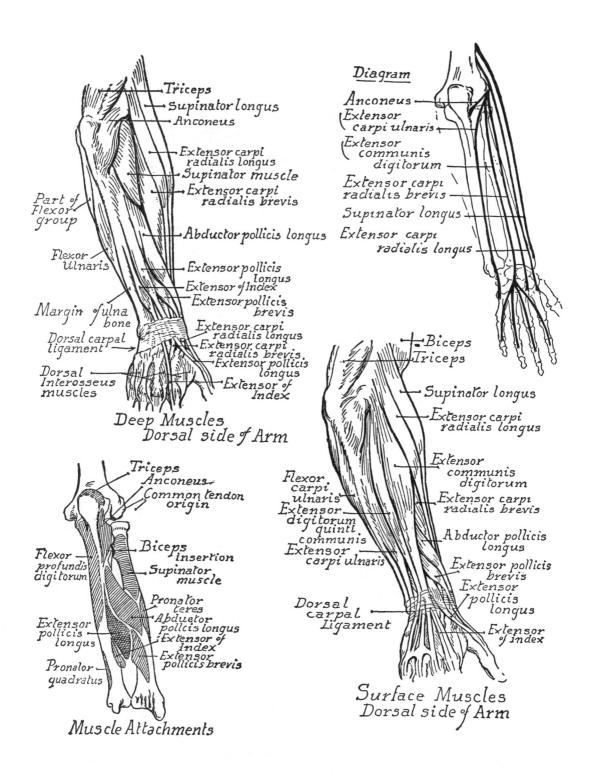

Triceps
Supinator longus
Anconeus
Extensor carpi radialis longus
Supinator muscle
Extensor carpi radialis brevis
Part of Flexor group
Abductor pollicis longus
Flexor ulnaris
Extensor pollicis longus
Extensor of Index
Extensor pollicis brevis
Margin of ulna bone
Dorsal carpal ligament
Extensor carpi radialis longus
Extensor carpi radialis brevis
Extensor pollicis longus
Dorsal Interosseus muscles
Extensor of Index

Deep Muscles
Dorsal side of Arm

Diagram
Anconeus
Extensor carpi ulnaris
Extensor communis digitorum
Extensor carpi radialis brevis
Supinator longus
Extensor carpi radialis longus

Triceps
Anconeus
Common tendon origin
Biceps insertion
Flexor profundis digitorum
Supinator muscle
Pronator teres
Abductor pollicis longus
Extensor of Index
Extensor pollicis longus
Extensor pollicis brevis
Pronator quadratus

Muscle Attachments

Biceps
Triceps
Supinator longus
Extensor carpi radialis longus
Flexor carpi ulnaris
Extensor communis digitorum
Extensor digitorum quinti communis
Extensor carpi radialis brevis
Extensor carpi ulnaris
Abductor pollicis longus
Extensor pollicis brevis
Extensor pollicis longus
Dorsal carpal ligament
Extensor of index

Surface Muscles
Dorsal side of Arm

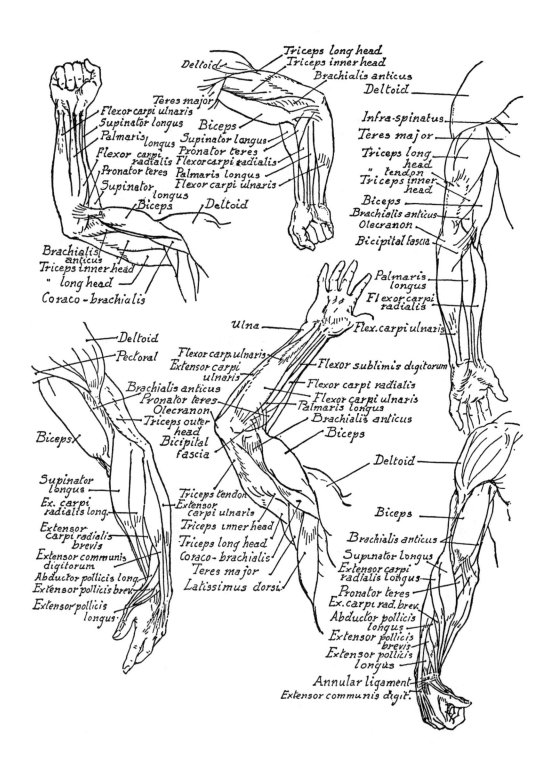

Triceps long head
Triceps inner head
Brachialis anticus
Deltoid
Deltoid

Infra-spinatus
Teres major
Triceps long head
" tendon
Triceps inner head
Biceps
Brachialis anticus
Olecranon
Bicipital fascia

Teres major
Flexor carpi ulnaris
Supinator longus
Palmaris longus
Flexor carpi radialis
Pronator teres
Supinator longus

Biceps
Supinator longus
Pronator teres
Flexor carpi radialis
Palmaris longus
Flexor carpi ulnaris
Deltoid

Brachialis anticus
Triceps inner head
" long head
Coraco-brachialis

Palmaris longus
Flexor carpi radialis
Flex. carpi ulnaris

Ulna

Deltoid
Pectoral
Brachialis anticus
Pronator teres
Olecranon
Triceps outer head
Bicipital fascia

Flexor carpi ulnaris
Extensor carpi ulnaris

Flexor sublimis digitorum
Flexor carpi radialis
Flexor carpi ulnaris
Palmaris longus
Brachialis anticus
Biceps

Biceps

Supinator longus
Ex. carpi radialis long.
Extensor carpi radialis brevis
Extensor communis digitorum
Abductor pollicis long.
Extensor pollicis brev.
Extensor pollicis longus

Triceps tendon
Extensor carpi ulnaris
Triceps inner head
Triceps long head
Coraco-brachialis
Teres major
Latissimus dorsi

Deltoid

Biceps

Brachialis anticus
Supinator longus
Extensor carpi radialis longus
Pronator teres
Ex. carpi rad. brev.
Abductor pollicis longus
Extensor pollicis brevis
Extensor pollicis longus
Annular ligament
Extensor communis digit.

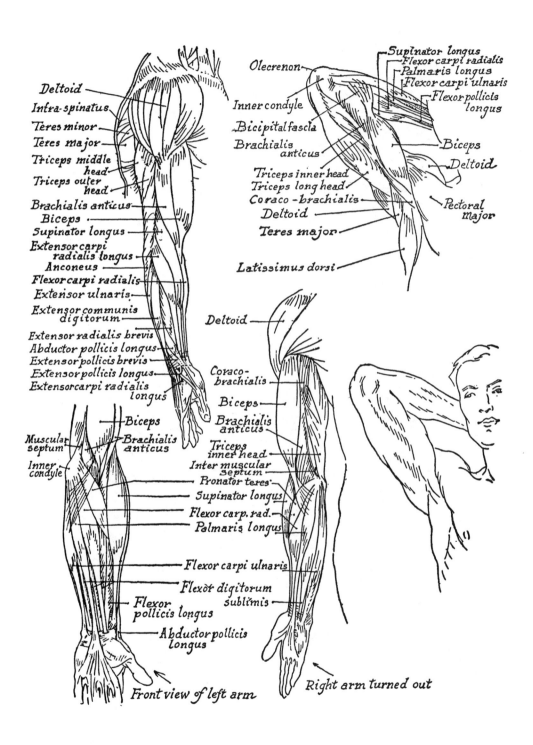

Deltoid
Infra-spinatus
Teres minor
Teres major
Triceps middle head
Triceps outer head
Brachialis anticus
Biceps
Supinator longus
Extensor carpi radialis longus
Anconeus
Flexor carpi radialis
Extensor ulnaris
Extensor communis digitorum
Extensor radialis brevis
Abductor pollicis longus
Extensor pollicis brevis
Extensor pollicis longus
Extensor carpi radialis longus

Olecrenon
Inner condyle
Bicipital fascia
Brachialis anticus
Triceps inner head
Triceps long head
Coraco-brachialis
Deltoid
Teres major
Latissimus dorsi

Supinator longus
Flexor carpi radialis
Palmaris longus
Flexor carpi ulnaris
Flexor pollicis longus
Biceps
Deltoid
Pectoral major

Deltoid
Coraco-brachialis
Biceps
Brachialis anticus
Triceps inner head
Inter muscular septum
Pronator teres
Supinator longus
Flexor carp. rad.
Palmaris longus
Flexor carpi ulnaris
Flexor digitorum sublimis

Biceps
Brachialis anticus
Muscular septum
Inner condyle
Flexor carpi ulnaris
Flexor digitorum sublimis
Flexor pollicis longus
Abductor pollicis longus

Front view of left arm

Right arm turned out

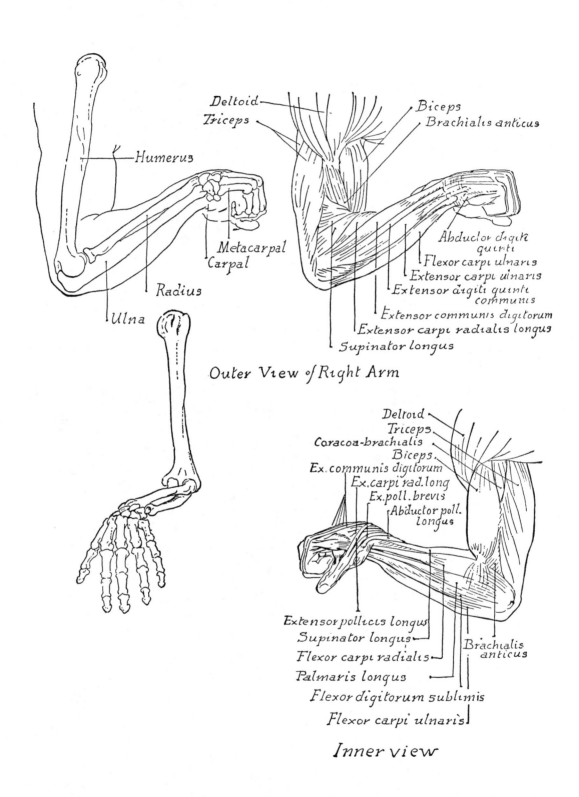

Deltoid

Triceps

Humerus

Biceps

Brachialis anticus

Metacarpal

Carpal

Abductor digiti quinti

Flexor carpi ulnaris

Extensor carpi ulnaris

Extensor digiti quinti communis

Radius

Extensor communis digitorum

Extensor carpi radialis longus

Ulna

Supinator longus

Outer View of Right Arm

Deltoid

Triceps

Coracoa-brachialis

Biceps.

Ex. communis digitorum

Ex. carpi rad. long

Ex. poll. brevis

Abductor poll. longus

Extensor pollicis longus

Supinator longus

Flexor carpi radialis

Brachialis anticus

Palmaris longus

Flexor digitorum sublimis

Flexor carpi ulnaris

Inner view

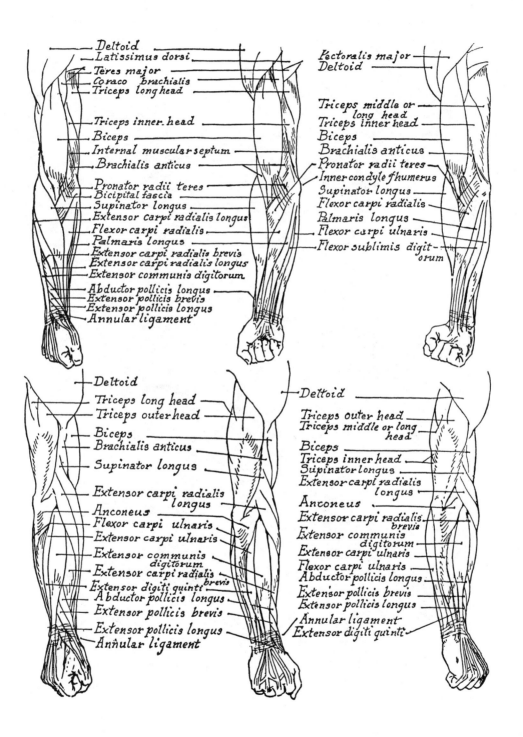

Deltoid
Latissimus dorsi
Teres major
Coraco brachialis
Triceps long head

Triceps inner head
Biceps
Internal muscular septum
Brachialis anticus

Pronator radii teres
Bicipital fascia
Supinator longus
Extensor carpi radialis longus
Flexor carpi radialis
Palmaris longus
Extensor carpi radialis brevis
Extensor carpi radialis longus
Extensor communis digitorum

Abductor pollicis longus
Extensor pollicis brevis
Extensor pollicis longus
Annular ligament

Pectoralis major
Deltoid

Triceps middle or
long head
Triceps inner head
Biceps
Brachialis anticus
Pronator radii teres
Inner condyle of humerus
Supinator longus
Flexor carpi radialis
Palmaris longus
Flexor carpi ulnaris
Flexor sublimis digit-
orum

Deltoid

Triceps long head
Triceps outer head

Biceps
Brachialis anticus

Supinator longus

Extensor carpi radialis
longus
Anconeus
Flexor carpi ulnaris
Extensor carpi ulnaris

Extensor communis
digitorum
Extensor carpi radialis
brevis
Extensor digiti quinti
Abductor pollicis longus
Extensor pollicis brevis

Extensor pollicis longus
Annular ligament

Deltoid

Triceps outer head
Triceps middle or long
head
Biceps
Triceps inner head
Supinator longus
Extensor carpi radialis
longus
Anconeus
Extensor carpi radialis
brevis
Extensor communis
digitorum
Extensor carpi ulnaris
Flexor carpi ulnaris
Abductor pollicis longus
Extensor pollicis brevis
Extensor pollicis longus
Annular ligament
Extensor digiti quinti

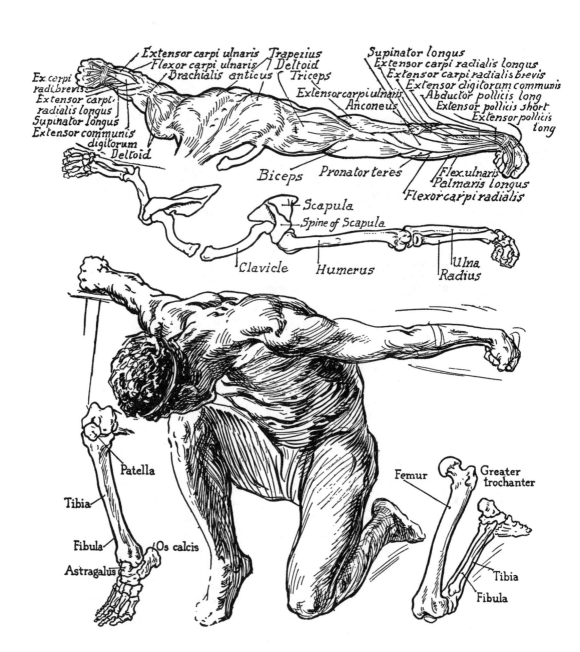

Extensor carpi ulnaris
Flexor carpi ulnaris
Brachialis anticus
Trapezius
Deltoid
Triceps

Ex. carpi
radi.brevis
Extensor carpi.
radialis longus
Supinator longus
Extensor communis
digitorum
Deltoid

Supinator longus
Extensor carpi radialis longus
Extensor carpi radialis brevis
Extensor digitorum communis
Abductor pollicis long
Extensor pollicis short
Extensor pollicis
long

Extensor carpi ulnaris
Anconeus

Biceps
Pronator teres
Flex. ulnaris
Palmaris longus
Flexor carpi radialis

Scapula
Spine of Scapula

Clavicle
Humerus
Ulna
Radius

Patella
Tibia
Fibula
Os calcis
Astragalus

Femur
Greater
trochanter

Tibia
Fibula

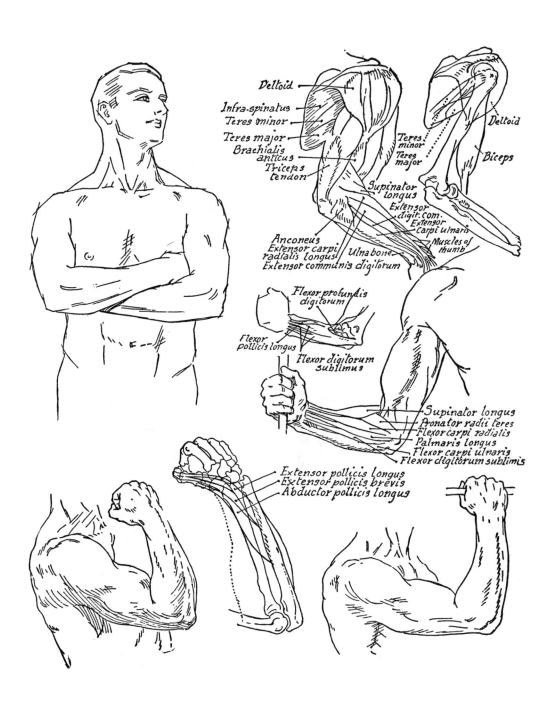

Deltoid

Infra-spinatus
Teres minor

Teres major
Brachialis
anticus
Triceps
tendon

Teres
minor
Teres
major

Deltoid

Biceps

Supinator
longus

Extensor
digit. com.
Extensor
Carpi ulnaris
Muscles of
thumb

Anconeus
Extensor carpi
radialis longus
Extensor communis digitorum

Ulna bone

Flexor profundis
digitorum

Flexor
pollicis longus

Flexor digitorum
sublimus

Supinator longus
Pronator radii teres
Flexor carpi radialis
Palmaris longus
Flexor carpi ulnaris
Flexor digitorum sublimis

Extensor pollicis longus
Extensor pollicis brevis
Abductor pollicis longus

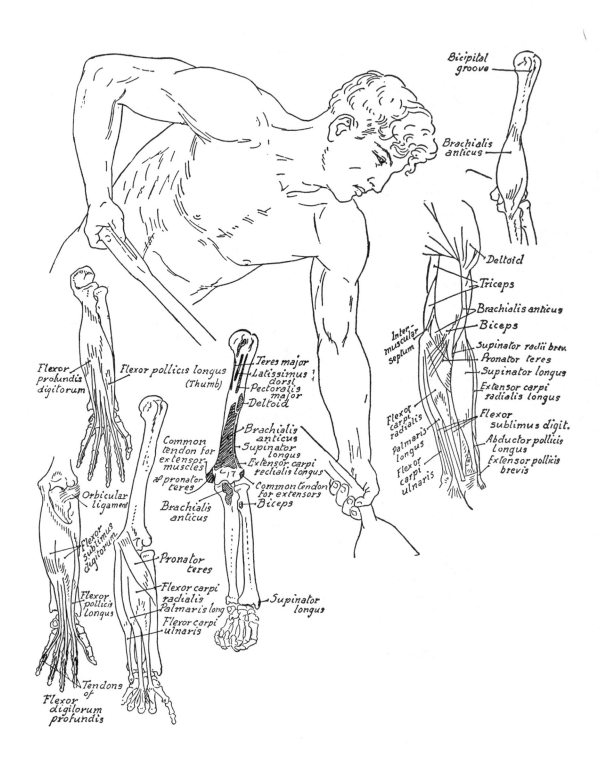

Bicipital groove

Brachialis anticus

Deltoid

Triceps

Brachialis anticus

Biceps

Supinator radii brev.

Pronator teres

Supinator longus

Extensor carpi radialis longus

Flexor sublimus digit.

Abductor pollicis longus

Extensor pollicis brevis

Inter-muscular septum

Flexor carpi radialis

Palmaris longus

Flexor carpi ulnaris

Flexor profundis digitorum

Flexor pollicis longus (Thumb)

Teres major

Latissimus dorsi

Pectoralis major

Deltoid

Brachialis anticus

Supinator longus

Extensor carpi radialis longus

Common tendon for extensor muscles

pronator teres

Common tendon for extensors

Biceps

Brachialis anticus

Orbicular ligament

Flexor sublimus digitorum

Pronator teres

Flexor pollicis longus

Flexor carpi radialis

Palmaris long

Flexor carpi ulnaris

Supinator longus

Tendons of Flexor digitorum profundis

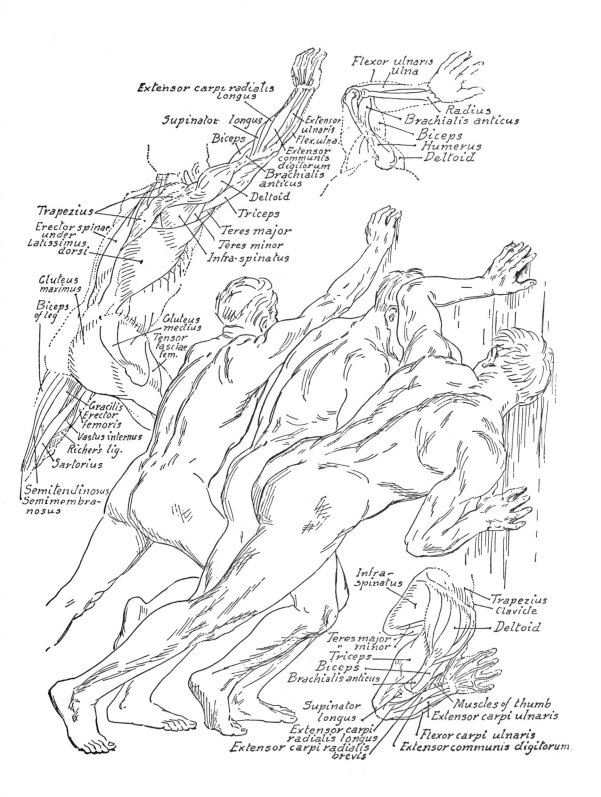

Extensor carpi radialis longus

Supinator longus

Biceps

Trapezius

Erector spinae under Latissimus dorsi

Gluteus maximus

Biceps of leg

Gracilis
Erector femoris
Vastus internus
Richer's lig.
Sartorius

Semitendinosus
Semimembranosus

Gluteus medius
Tensor fasciae fem.

Extensor ulnaris
Flex. ulna
Extensor communis digitorum
Brachialis anticus
Deltoid
Triceps
Teres major
Teres minor
Infra-spinatus

Flexor ulnaris
ulna

Radius
Brachialis anticus
Biceps
Humerus
Deltoid

Infra-spinatus

Teres major
" minor
Triceps
Biceps
Brachialis anticus

Supinator longus

Extensor carpi radialis longus
Extensor carpi radialis brevis

Trapezius
Clavicle
Deltoid

Muscles of thumb
Extensor carpi ulnaris

Flexor carpi ulnaris
Extensor communis digitorum

PART SIX

THE HAND

THE HAND

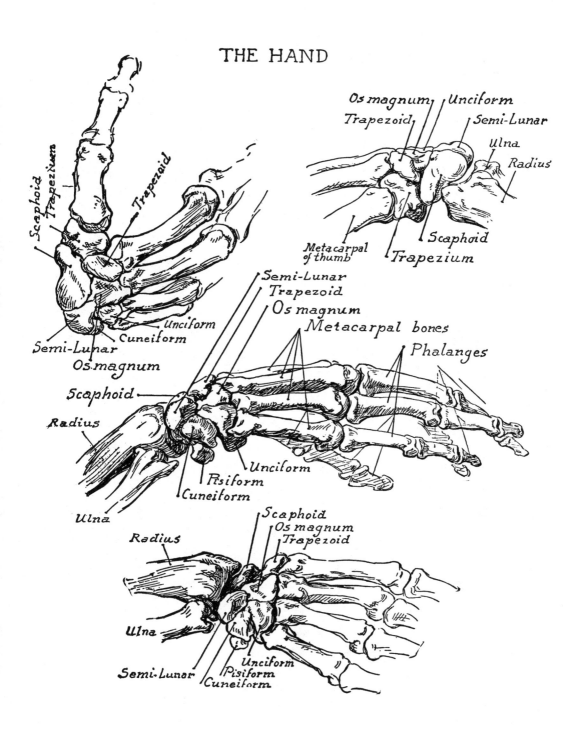

Scaphoid
Trapezium
Trapezoid
Semi-Lunar
Os magnum
Unciform
Cuneiform
Scaphoid

Os magnum Unciform
Trapezoid Semi-Lunar
 Ulna
 Radius
Metacarpal
of thumb
Scaphoid
Trapezium

Semi-Lunar
Trapezoid
Os magnum
Metacarpal bones
Phalanges
Scaphoid
Radius
Unciform
Pisiform
Cuneiform
Ulna

Scaphoid
Os magnum
Trapezoid
Radius
Ulna
Semi-Lunar
Unciform
Pisiform
Cuneiform

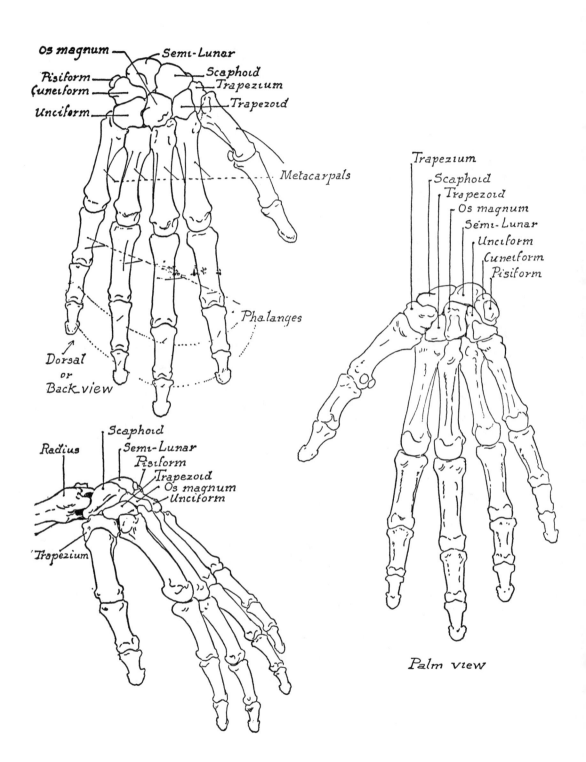

Os magnum — Semi-Lunar
Pisiform — Scaphoid
Cuneiform — Trapezium
Unciform — Trapezoid

Metacarpals

Phalanges

Dorsal
or
Back view

Radius — Scaphoid
Semi-Lunar
Pisiform
Trapezoid
Os magnum
Unciform

Trapezium

Trapezium
Scaphoid
Trapezoid
Os magnum
Semi-Lunar
Unciform
Cuneiform
Pisiform

Palm view

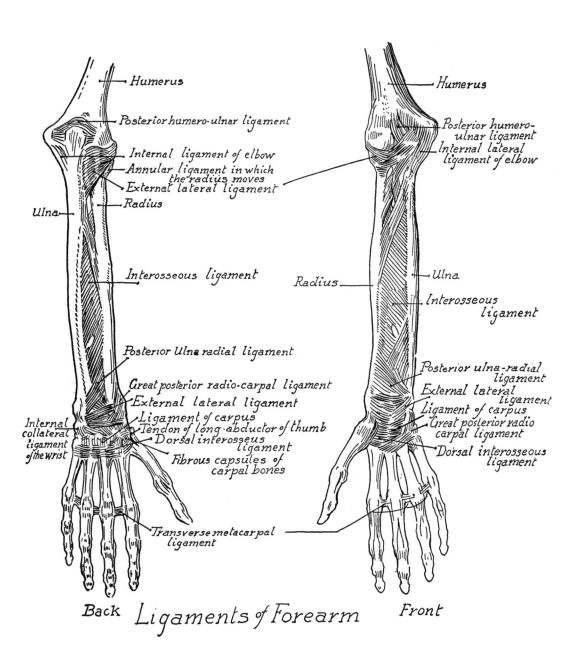

Humerus

Posterior humero-ulnar ligament

Internal ligament of elbow

Annular ligament in which the radius moves

External lateral ligament

Radius

Ulna

Interosseous ligament

Posterior Ulna radial ligament

Great posterior radio-carpal ligament

External lateral ligament

Ligament of carpus

Tendon of long abductor of thumb

Dorsal interosseus ligament

Fibrous capsules of carpal bones

Internal collateral ligament of the wrist

Transverse metacarpal ligament

Humerus

Posterior humero-ulnar ligament

Internal lateral ligament of elbow

Radius

Ulna

Interosseous ligament

Posterior ulna-radial ligament

External lateral ligament

Ligament of carpus

Great posterior radio carpal ligament

Dorsal interosseous ligament

Back Ligaments of Forearm Front

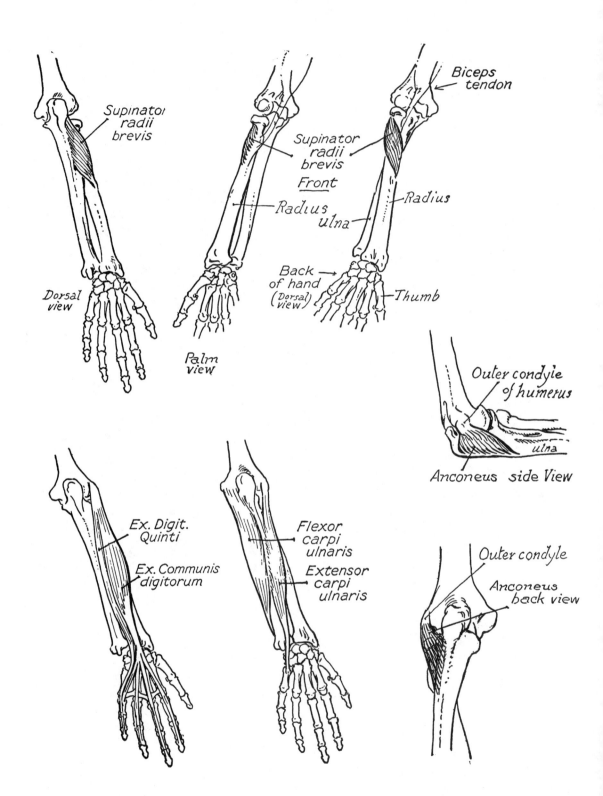

Supinator
radii
brevis

Dorsal
view

Supinator
radii
brevis
Front
Radius
ulna

Palm
view

Biceps
tendon

Radius

Back
of hand
(Dorsal)
view

Thumb

Outer condyle
of humerus

ulna

Anconeus side View

Ex. Digit.
Quinti

Ex. Communis
digitorum

Flexor
carpi
ulnaris

Extensor
carpi
ulnaris

Outer condyle

Anconeus
back view

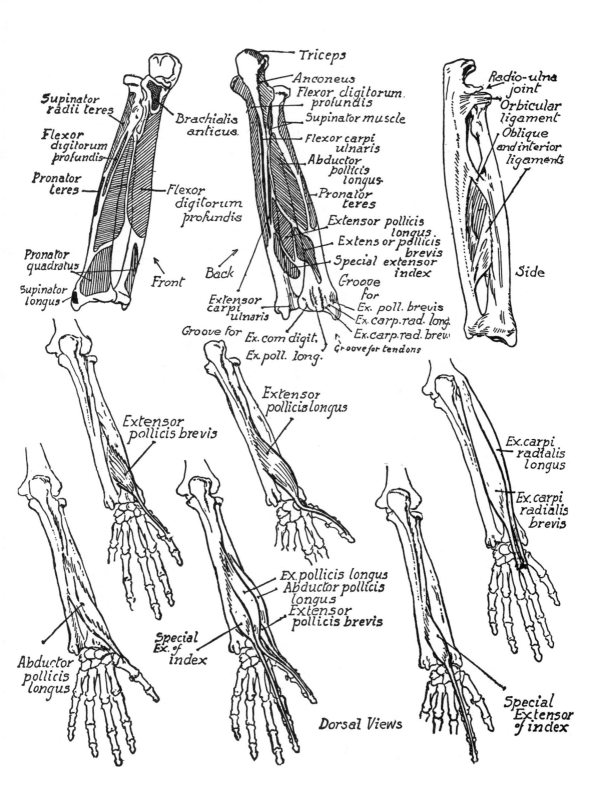

Supinator
radii teres

Flexor
digitorum
profundis

Pronator
teres

Brachialis
anticus

Flexor
digitorum
profundis

Pronator
quadratus

Supinator
longus

Front

Triceps

Anconeus

Flexor digitorum
profundis

Supinator muscle

Flexor carpi
ulnaris

Abductor
pollicis
longus

Pronator
teres

Extensor pollicis
longus

Extensor pollicis
brevis

Special extensor
index

Groove
for
Ex. poll. brevis

Ex. carp. rad. long

Ex.carp.rad. brev

Groove for tendons

Back

Extensor
carpi
ulnaris

Groove for

Ex. com digit.

Ex. poll. long.

Radio-ulna
joint

Orbicular
ligament

Oblique
and interior
ligaments

Side

Extensor
pollicis brevis

Extensor
pollicis longus

Ex. carpi
radialis
longus

Ex. carpi
radialis
brevis

Abductor
pollicis
longus

Special
Ex. of
index

Ex. pollicis longus
Abductor pollicis
longus
Extensor
pollicis brevis

Special
Extensor
of index

Dorsal Views

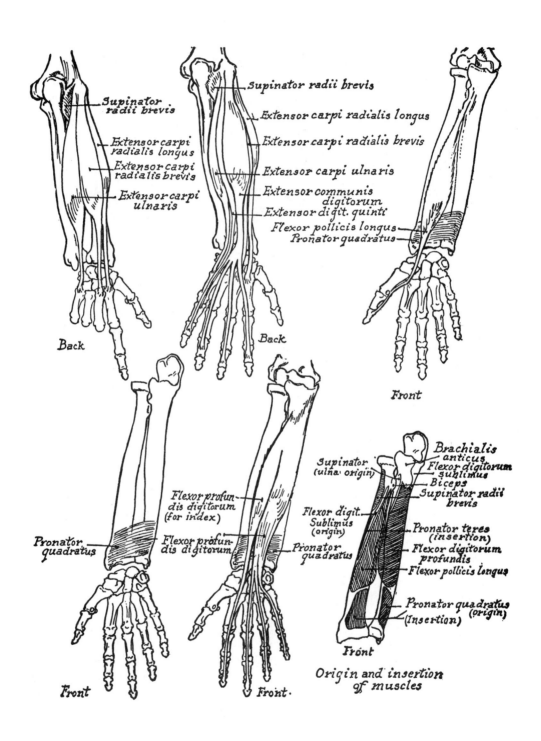

Supinator
radii brevis

Extensor carpi
radialis longus

Extensor carpi
radialis brevis

Extensor carpi
ulnaris

Back

Supinator radii brevis

Extensor carpi radialis longus

Extensor carpi radialis brevis

Extensor carpi ulnaris

Extensor communis
digitorum

Extensor digit. quinti

Flexor pollicis longus

Pronator quadratus

Back

Front

Flexor profun-
dis digitorum
(for index)

Flexor profun-
dis digitorum

Pronator
quadratus

Pronator
quadratus

Front

Front

Supinator
(ulna origin)

Flexor digit.
Sublimus
(origin)

Brachialis
anticus

Flexor digitorum
sublimus

Biceps

Supinator radii
brevis

Pronator teres
(insertion)

Flexor digitorum
profundis

Flexor pollicis longus

Pronator quadratus
(origin)

(Insertion)

Front

Origin and insertion
of muscles

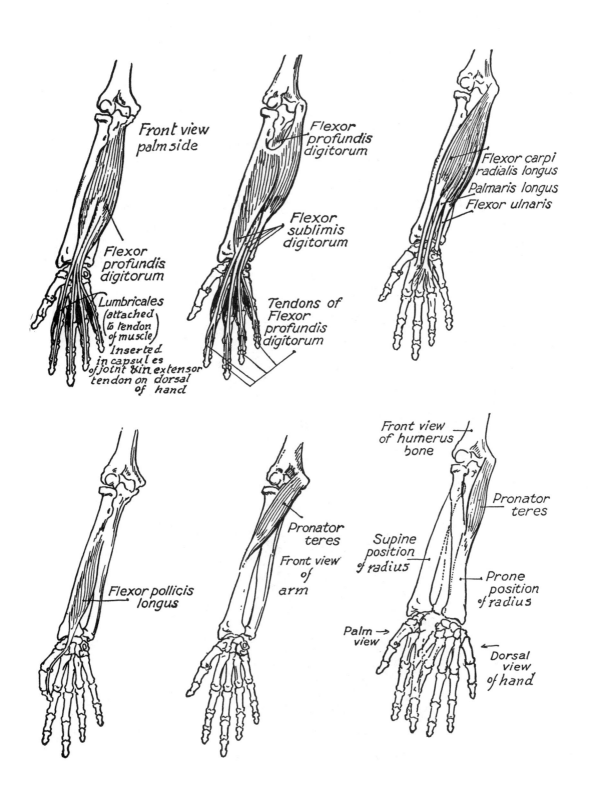

Front view
palm side

Flexor
profundis
digitorum

Lumbricales
(attached
to tendon
of muscle)
Inserted
in capsules
of joint & in extensor
tendon on dorsal
of hand

Flexor
profundis
digitorum

Flexor
sublimis
digitorum

Tendons of
Flexor
profundis
digitorum

Flexor carpi
radialis longus
Palmaris longus
Flexor ulnaris

Flexor pollicis
longus

Pronator
teres

Front view
of
arm

Front view
of humerus
bone

Pronator
teres

Supine
position
of radius

Prone
position
of radius

Palm →
view

Dorsal
view
of hand

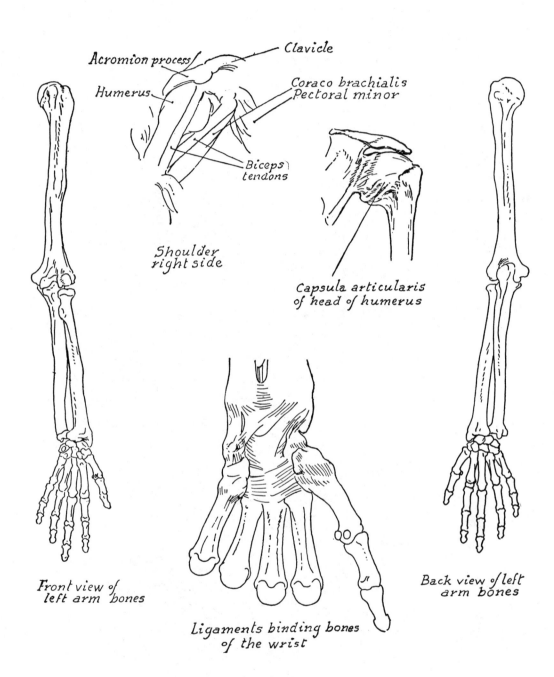

Acromion process

Clavicle

Humerus

Coraco brachialis
Pectoral minor

Biceps
tendons

Shoulder
right side

Capsula articularis
of head of humerus

Front view of
left arm bones

Ligaments binding bones
of the wrist

Back view of left
arm bones

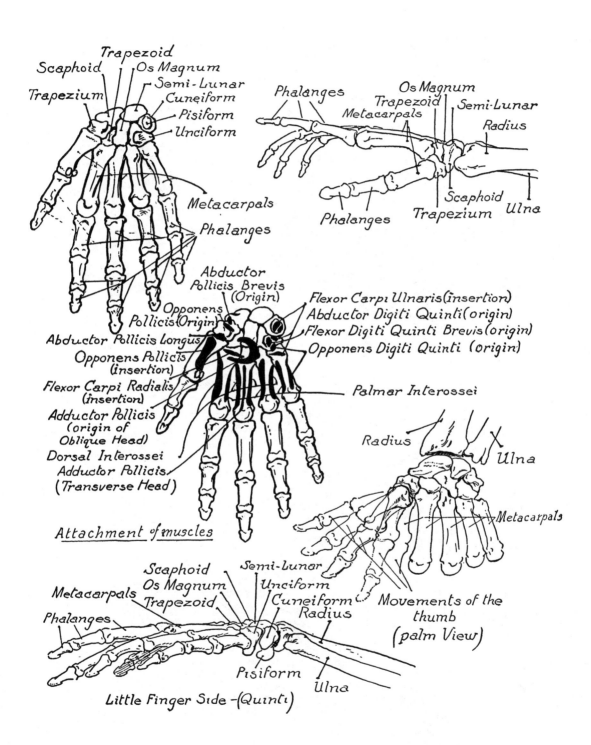

Trapezoid

Scaphoid

Os Magnum

Trapezium

Semi-Lunar

Cuneiform

Pisiform

Unciform

Phalanges

Os Magnum

Metacarpals

Trapezoid

Semi-Lunar

Radius

Metacarpals

Phalanges

Scaphoid

Phalanges

Trapezium

Ulna

Abductor
Pollicis Brevis
(Origin)

Opponens
Pollicis (Origin)

Flexor Carpi Ulnaris (insertion)

Abductor Digiti Quinti (origin)

Flexor Digiti Quinti Brevis (origin)

Opponens Digiti Quinti (origin)

Abductor Pollicis Longus

Opponens Pollicis
(insertion)

Flexor Carpi Radialis
(insertion)

Adductor Pollicis
(origin of
Oblique Head)

Dorsal Interossei

Adductor Pollicis
(Transverse Head)

Palmar Interossei

Radius

Ulna

Metacarpals

Attachment of muscles

Movements of the
thumb
(palm View)

Scaphoid

Os Magnum

Trapezoid

Metacarpals

Phalanges

Semi-Lunar

Unciform

Cuneiform

Radius

Pisiform

Ulna

Little Finger Side - (Quinti)

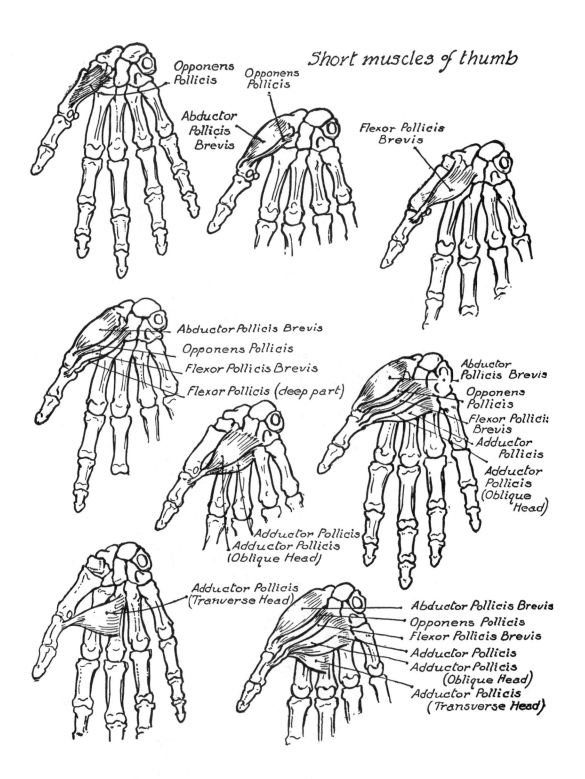

Short muscles of thumb

Opponens Pollicis

Opponens Pollicis

Abductor Pollicis Brevis

Flexor Pollicis Brevis

Abductor Pollicis Brevis
Opponens Pollicis
Flexor Pollicis Brevis
Flexor Pollicis (deep part)

Abductor Pollicis Brevis
Opponens Pollicis
Flexor Pollicis Brevis
Adductor Pollicis
Adductor Pollicis (Oblique Head)

Adductor Pollicis
Adductor Pollicis (Oblique Head)

Adductor Pollicis (Tranverse Head)

Abductor Pollicis Brevis
Opponens Pollicis
Flexor Pollicis Brevis
Adductor Pollicis
Adductor Pollicis (Oblique Head)
Adductor Pollicis (Transverse Head)

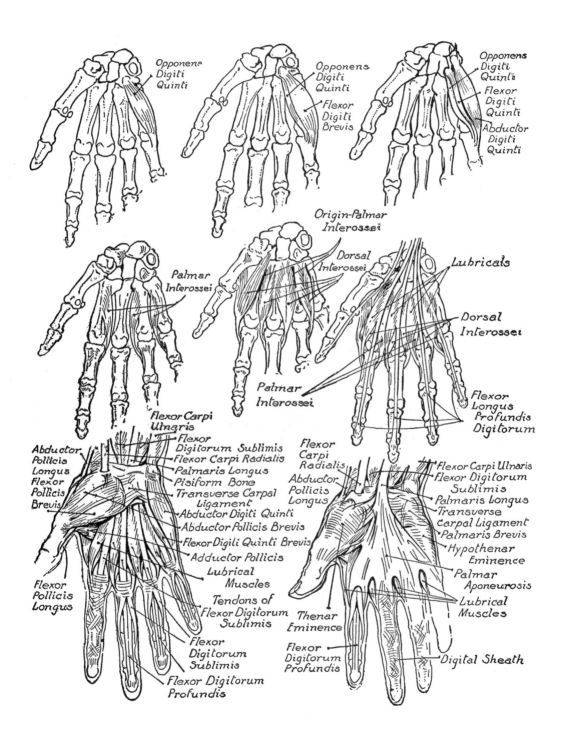

Opponens Digiti Quinti

Opponens Digiti Quinti

Flexor Digiti Brevis

Opponens Digiti Quinti

Flexor Digiti Quinti

Abductor Digiti Quinti

Origin-Palmar Interossei

Palmar Interossei

Dorsal Interossei

Lubricals

Palmar Interossei

Dorsal Interossei

Flexor Longus Profundis Digitorum

Flexor Carpi Ulnaris

Abductor Pollicis Longus Flexor Pollicis Brevis

Flexor Digitorum Sublimis
Flexor Carpi Radialis
Palmaris Longus
Pisiform Bone
Transverse Carpal Ligament
Abductor Digiti Quinti
Abductor Pollicis Brevis
Flexor Digiti Quinti Brevis
Adductor Pollicis
Lubrical Muscles
Tendons of Flexor Digitorum Sublimis

Flexor Pollicis Longus

Flexor Digitorum Sublimis

Flexor Digitorum Profundis

Flexor Carpi Radialis

Abductor Pollicis Longus

Flexor Carpi Ulnaris
Flexor Digitorum Sublimis
Palmaris Longus
Transverse Carpal Ligament
Palmaris Brevis
Hypothenar Eminence
Palmar Aponeurosis
Lubrical Muscles

Thenar Eminence

Flexor Digitorum Profundis

Digital Sheath

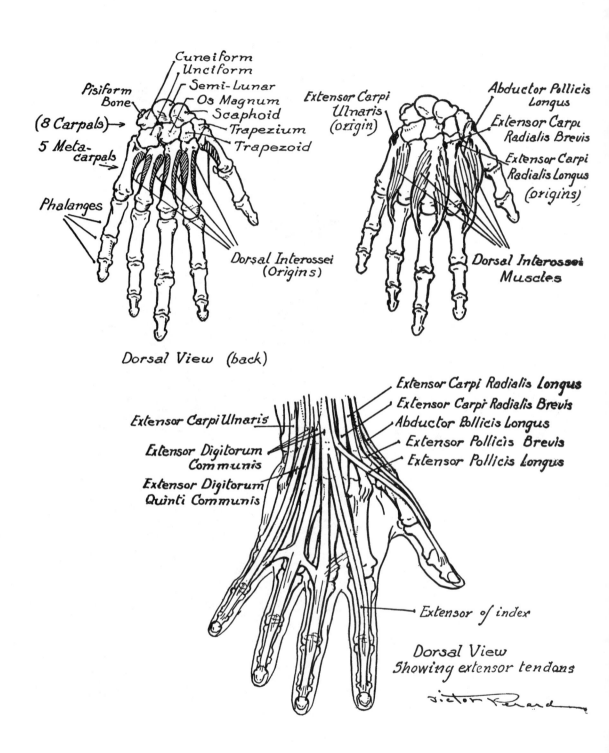

Cuneiform
Uncitform
Semi-Lunar
Os Magnum
Scaphoid
Trapezium
Trapezoid

Pisiform
Bone

(8 Carpals) →

5 Meta-
carpals →

Phalanges

Dorsal Interossei
(Origins)

Extensor Carpi
Ulnaris
(origin)

Abductor Pollicis
Longus

Extensor Carpi
Radialis Brevis

Extensor Carpi
Radialis Longus
(origins)

Dorsal Interossei
Muscles

Dorsal View (back)

Extensor Carpi Ulnaris

Extensor Digitorum
Communis

Extensor Digitorum
Quinti Communis

Extensor Carpi Radialis Longus
Extensor Carpi Radialis Brevis
Abductor Pollicis Longus
Extensor Pollicis Brevis
Extensor Pollicis Longus

Extensor of index

Dorsal View
Showing extensor tendons

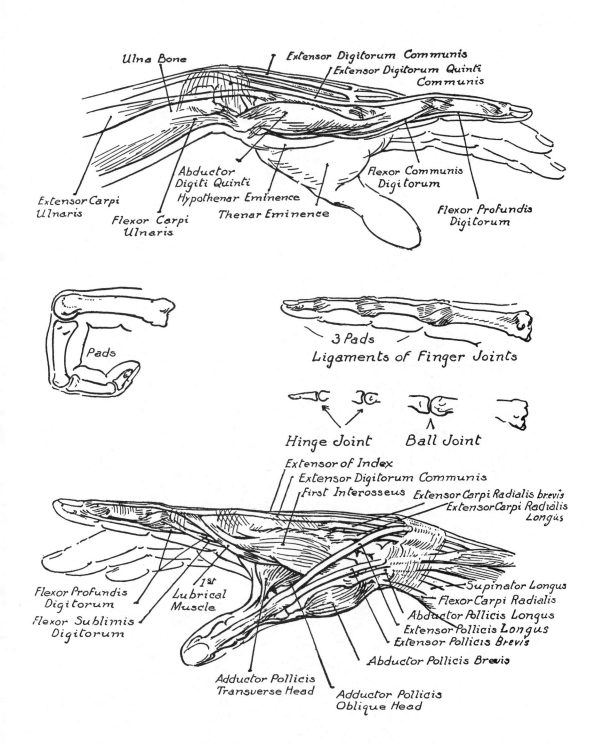

Ulna Bone

Extensor Digitorum Communis

Extensor Digitorum Quinti Communis

Abductor Digiti Quinti

Hypothenar Eminence

Thenar Eminence

Flexor Communis Digitorum

Flexor Profundis Digitorum

Extensor Carpi Ulnaris

Flexor Carpi Ulnaris

Pads

3 Pads

Ligaments of Finger Joints

Hinge Joint

Ball Joint

Extensor of Index

Extensor Digitorum Communis

First Interosseus

Extensor Carpi Radialis brevis

Extensor Carpi Radialis Longus

Flexor Profundis Digitorum

Flexor Sublimis Digitorum

1st Lubrical Muscle

Adductor Pollicis Transverse Head

Adductor Pollicis Oblique Head

Abductor Pollicis Brevis

Extensor Pollicis Brevis

Extensor Pollicis Longus

Abductor Pollicis Longus

Flexor Carpi Radialis

Supinator Longus

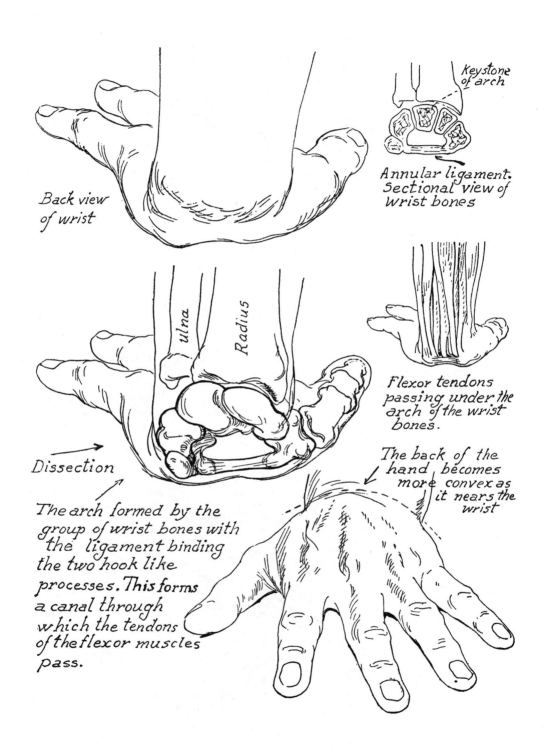

Back view
of wrist

Keystone
of arch

Annular ligament.
Sectional view of
wrist bones

ulna

Radius

Dissection

Flexor tendons
passing under the
arch of the wrist
bones.

The back of the
hand becomes
more convex as
it nears the
wrist

The arch formed by the
group of wrist bones with
the ligament binding
the two hook like
processes. This forms
a canal through
which the tendons
of the flexor muscles
pass.

The lengths of A and B together, equal the length of C

A B C

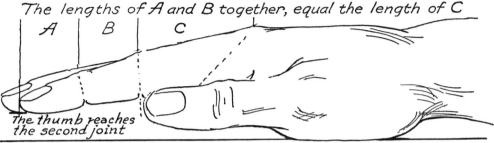

The thumb reaches
the second joint

When the hand is resting on a flat surface, the wrist
does not come in contact with that surface.

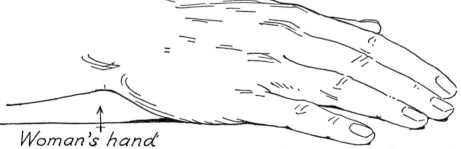

The wrist bones are grouped far into the wrist
forming the arch of the wrist.

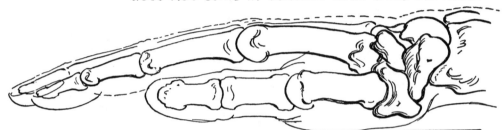

Woman's hand

Relative positions of the bones from the little finger side
when the hand is resting on a flat surface.

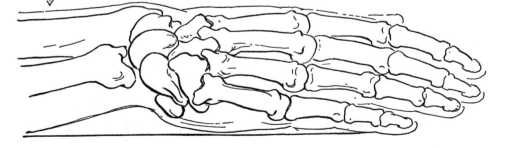

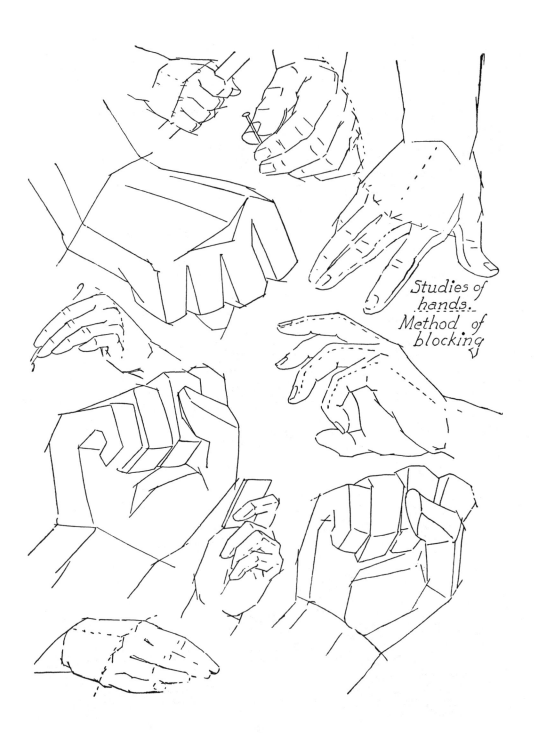

Studies of
hands.
Method of
blocking

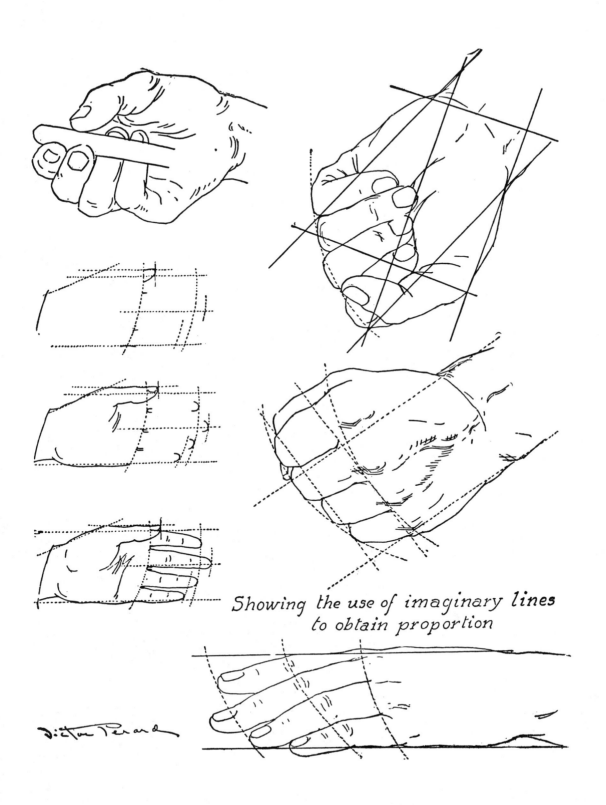

Showing the use of imaginary lines to obtain proportion

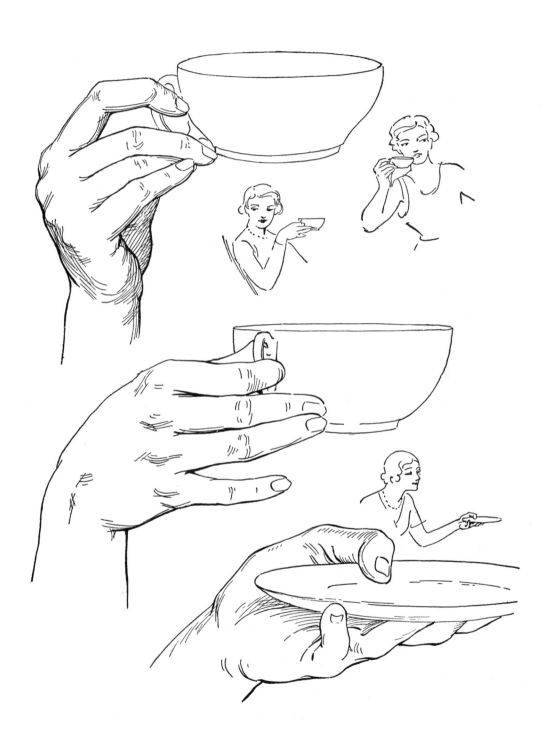

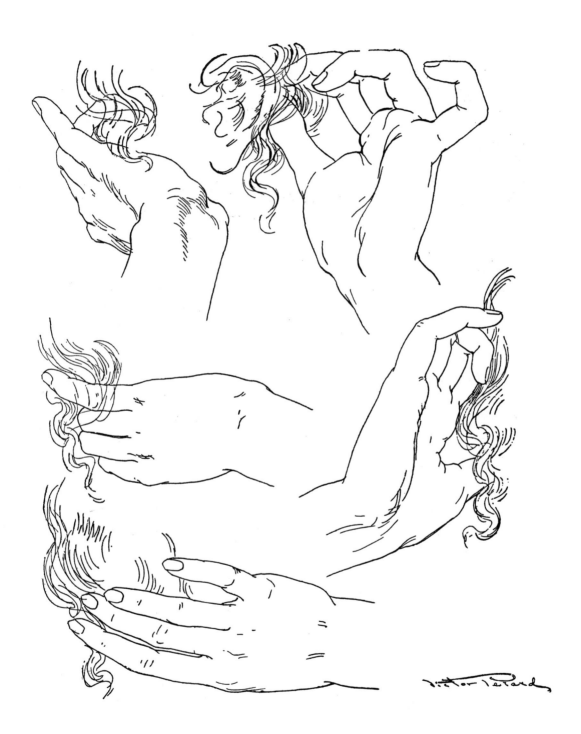

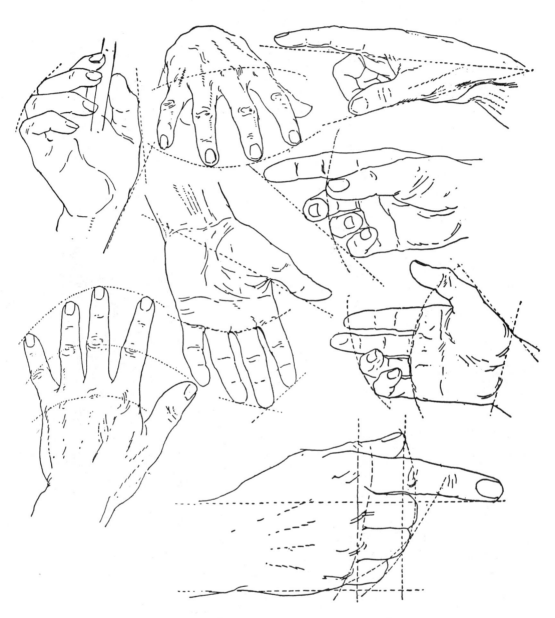

*Studies of hands with use of imaginary lines
for proportion*

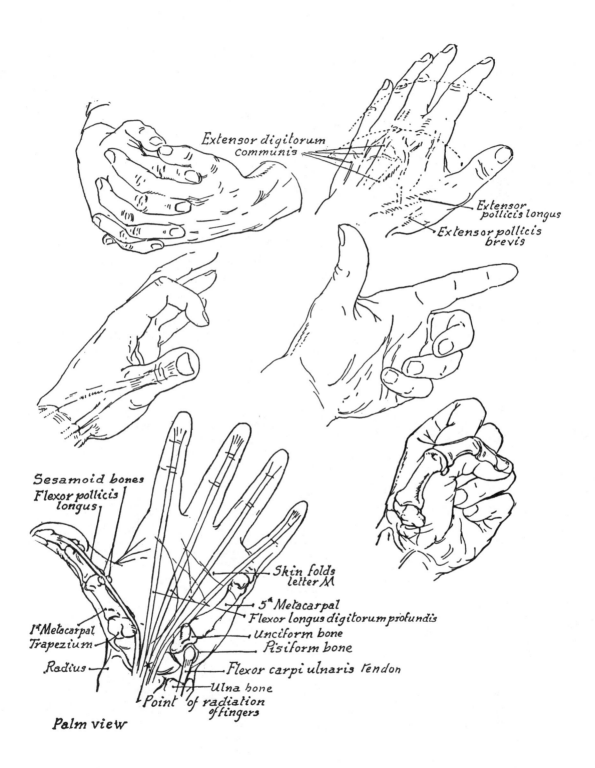

Extensor digitorum communis

Extensor pollicis longus

Extensor pollicis brevis

Sesamoid bones
Flexor pollicis longus

Skin folds letter M

5ᵗʰ Metacarpal
Flexor longus digitorum profundis

1ˢᵗ Metacarpal
Trapezium

Unciform bone
Pisiform bone

Radius

Flexor carpi ulnaris tendon

Ulna bone
Point of radiation of fingers

Palm view

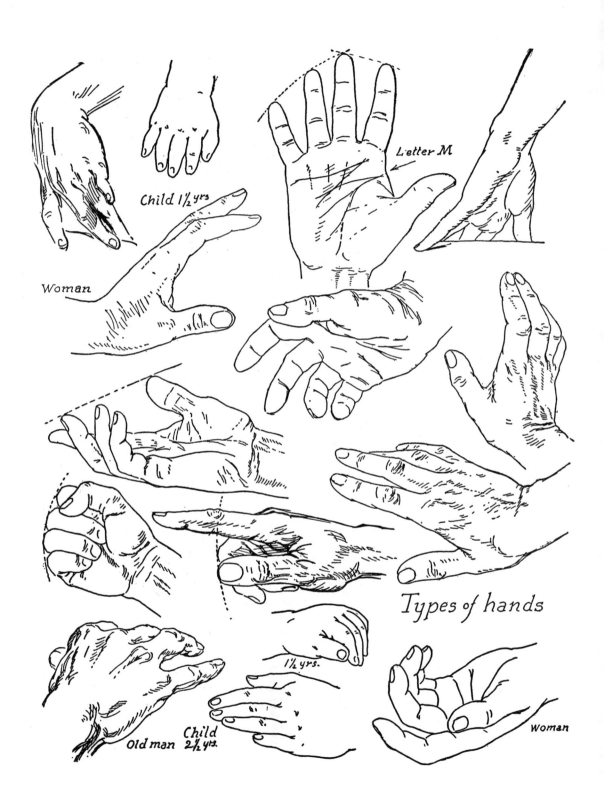

Child 1½ yrs

Woman

Letter M

Types of hands

Old man Child 2½ yrs.

1½ yrs.

Woman

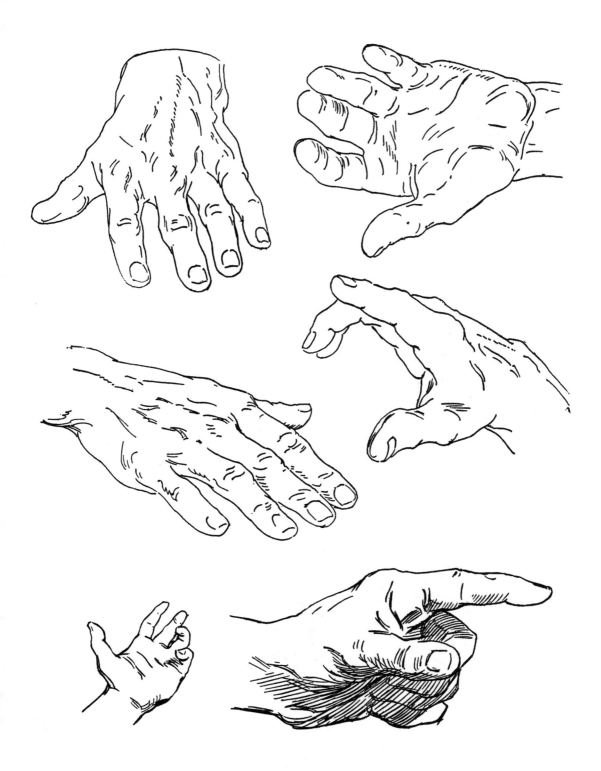

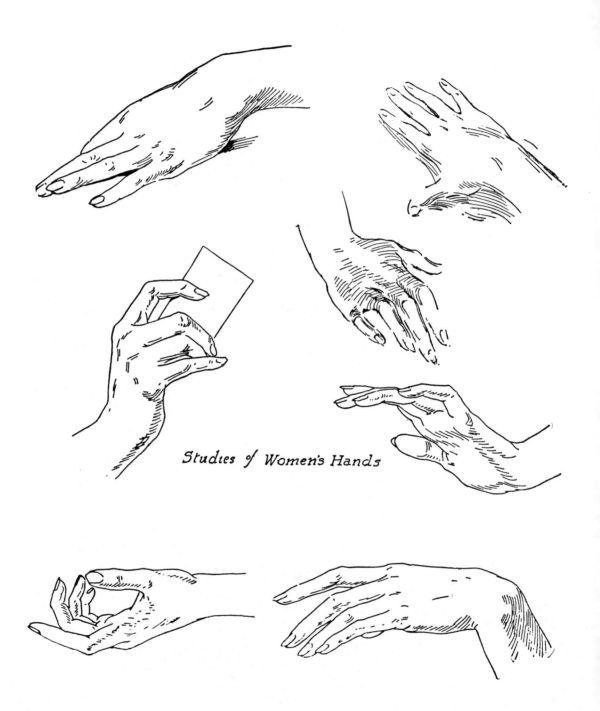

Studies of Women's Hands

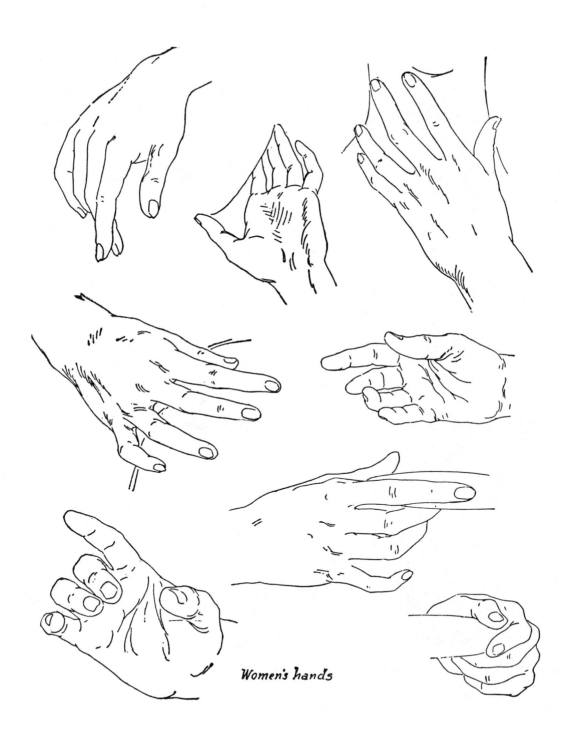

Women's hands

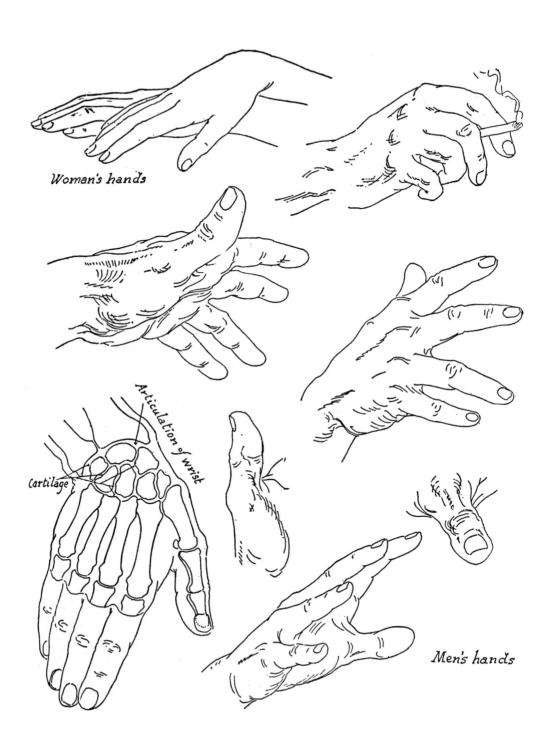

Woman's hands

Articulation of wrist

Cartilage

Men's hands

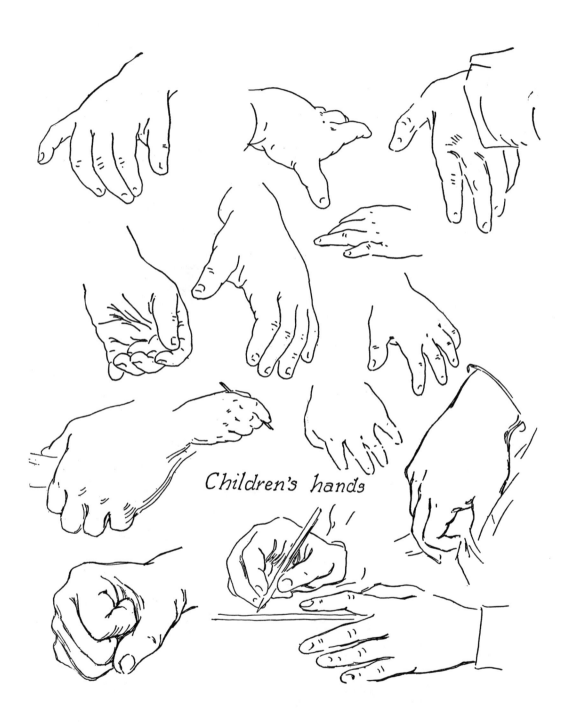

Children's hands

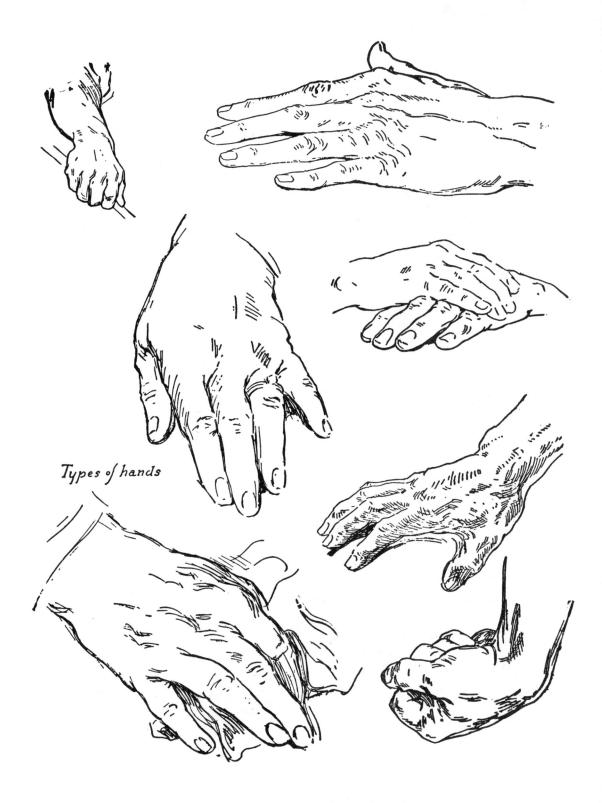

Types of hands

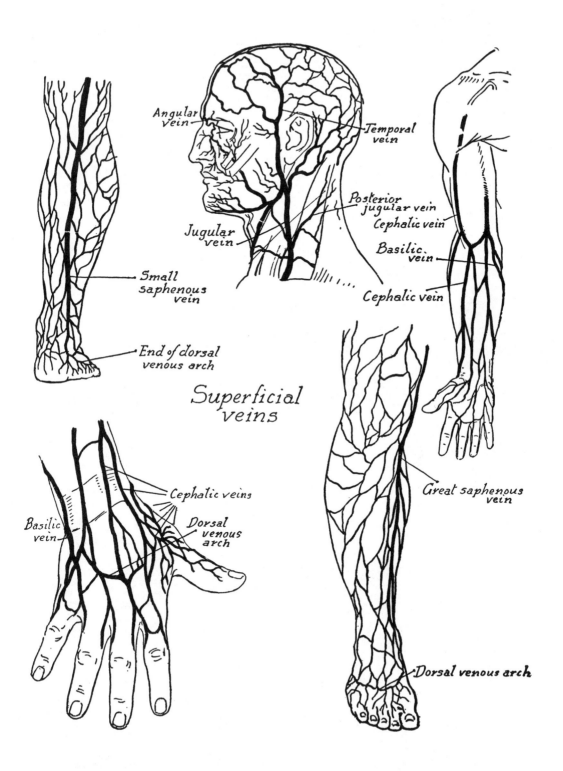

Angular
vein

Temporal
vein

Posterior
jugular vein

Cephalic vein

Basilic.
vein

Jugular
vein

Cephalic vein

Small
saphenous
vein

End of dorsal
venous arch

*Superficial
veins*

Cephalic veins

Dorsal
venous
arch

Basilic
vein

Great saphenous
vein

Dorsal venous arch

PART SEVEN

THE LEG

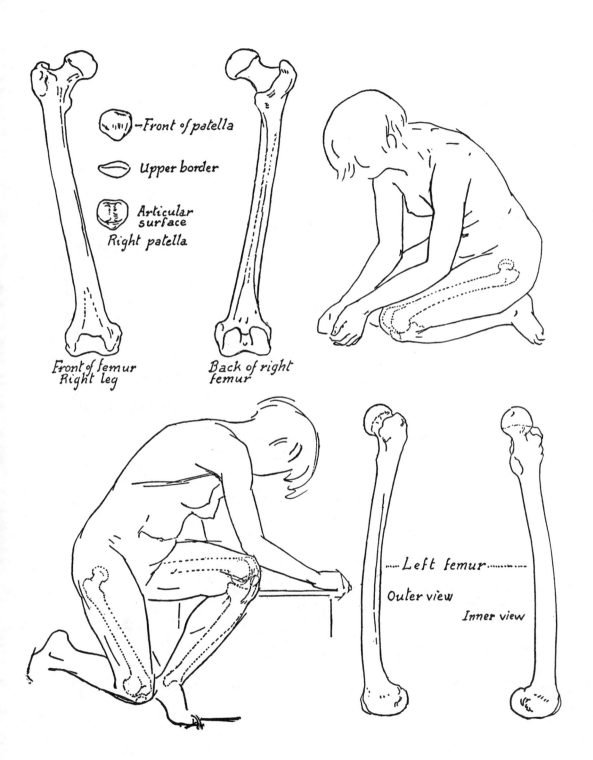

-Front of patella

Upper border

Articular surface

Right patella

Front of femur
Right leg

Back of right
femur

Left femur

Outer view

Inner view

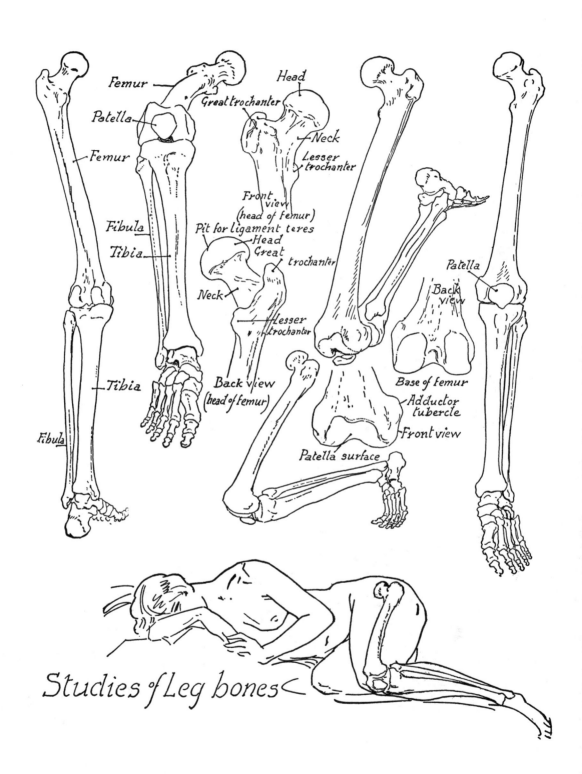

Femur

Patella

Femur

Fibula

Tibia

Tibia

Fibula

Great trochanter

Head

Neck

Lesser
trochanter

Front
view
(head of femur)

Pit for ligament teres

Head

Great

trochanter

Neck

Lesser
trochanter

Back view
(head of femur)

Patella surface

Base of femur

Adductor
tubercle

Front view

Patella

Back
view

Studies of Leg bones

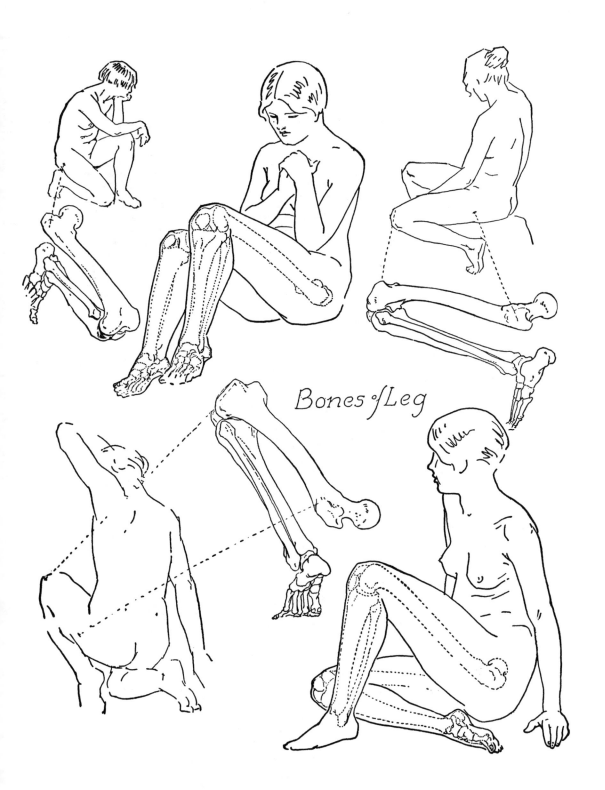

Bones of Leg

The Knee Joint

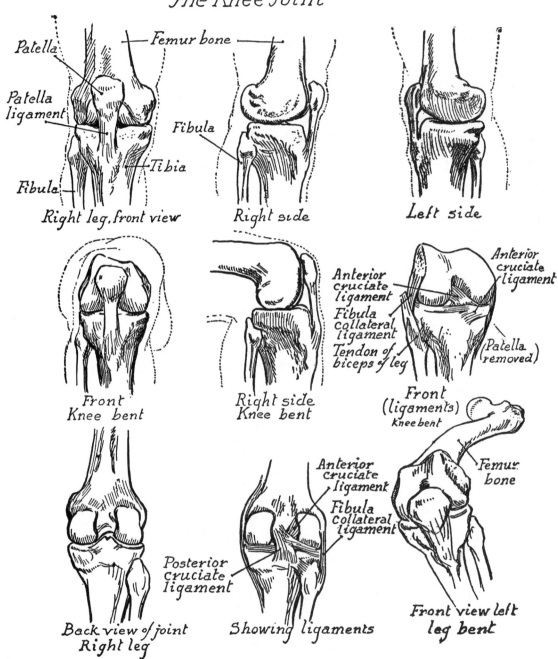

Patella

Femur bone

Patella ligament

Fibula

Tibia

Fibula

Right leg, front view

Right side

Left side

Front Knee bent

Right side Knee bent

Anterior cruciate ligament

Fibula collateral ligament

Tendon of biceps of leg

Anterior cruciate ligament

Patella (removed)

Front (ligaments) Knee bent

Back view of joint Right leg

Posterior cruciate ligament

Anterior cruciate ligament

Fibula collateral ligament

Showing ligaments

Femur bone

Front view left leg bent

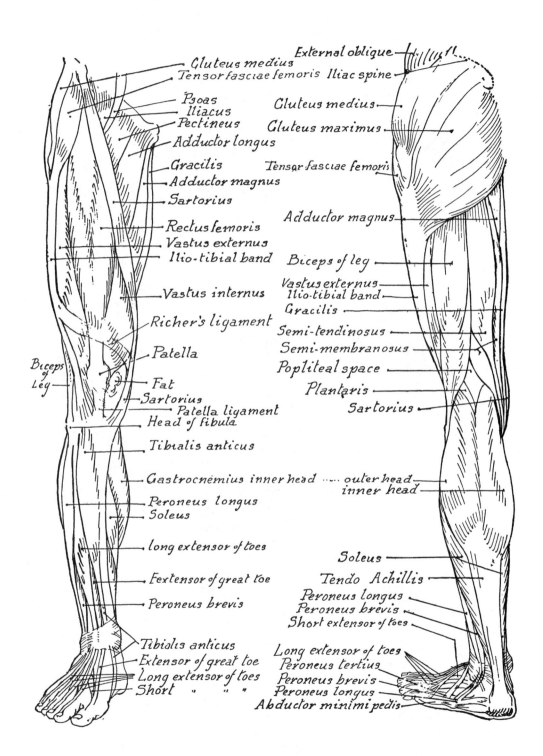

External oblique
Gluteus medius
Tensor fasciae femoris Iliac spine
Psoas
Iliacus
Pectineus
Adductor longus
Gracilis
Adductor magnus
Sartorius
Rectus femoris
Vastus externus
Ilio-tibial band
Vastus internus
Richer's ligament
Patella
Biceps of Leg
Fat
Sartorius
Patella ligament
Head of fibula
Tibialis anticus
Gastrocnemius inner head
Peroneus longus
Soleus
long extensor of toes
Extensor of great toe
Peroneus brevis
Tibialis anticus
Extensor of great toe
Long extensor of toes
Short " " "

Gluteus medius
Gluteus maximus
Tensor fasciae femoris
Adductor magnus
Biceps of leg
Vastus externus
Ilio-tibial band
Gracilis
Semi-tendinosus
Semi-membranosus
Popliteal space
Plantaris
Sartorius
outer head
inner head
Soleus
Tendo Achillis
Peroneus longus
Peroneus brevis
Short extensor of toes
Long extensor of toes
Peroneus tertius
Peroneus brevis
Peroneus longus
Abductor minimi pedis

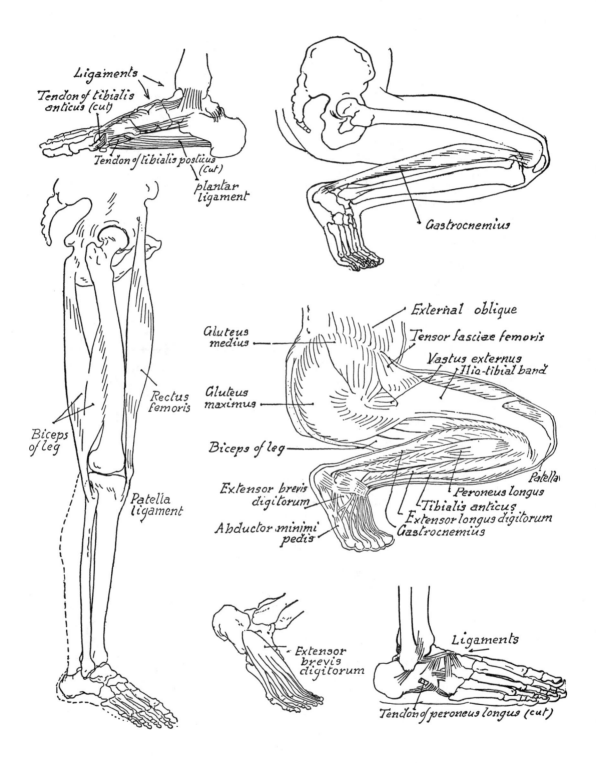

Ligaments

Tendon of tibialis
anticus (cut)

Tendon of tibialis posticus
(cut)

plantar
ligament

Gastrocnemius

Gluteus
medius

Gluteus
maximus

Rectus
femoris

Biceps
of leg

Patella
ligament

External oblique

Tensor fasciae femoris

Vastus externus
Ilio-tibial band

Biceps of leg

Extensor brevis
digitorum

Abductor minimi
pedis

Patella

Peroneus longus

Tibialis anticus
Extensor longus digitorum
Gastrocnemius

Extensor
brevis
digitorum

Ligaments

Tendon of peroneus longus (cut)

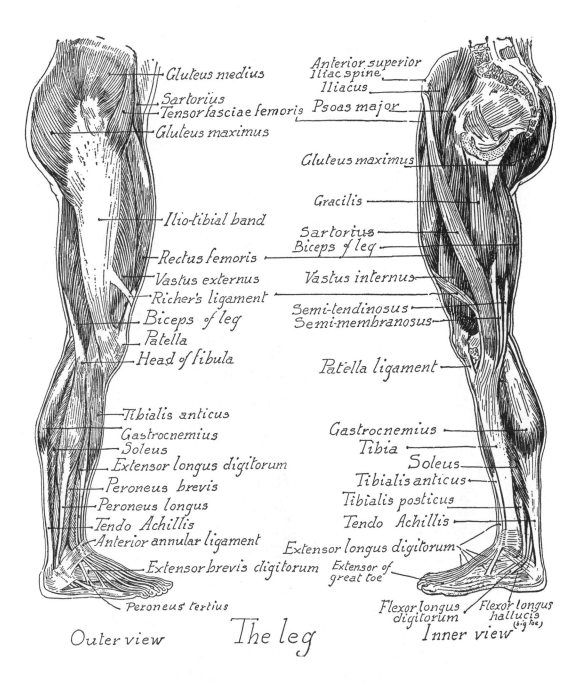

Gluteus medius

Sartorius
Tensor fasciae femoris
Gluteus maximus

Anterior superior
Iliac spine
Iliacus
Psoas major

Gluteus maximus

Gracilis

Sartorius
Biceps of leg

Ilio-tibial band

Rectus femoris
Vastus externus
Richer's ligament
Biceps of leg
Patella
Head of fibula

Vastus internus

Semi-tendinosus
Semi-membranosus

Patella ligament

Tibialis anticus
Gastrocnemius
Soleus
Extensor longus digitorum
Peroneus brevis
Peroneus longus
Tendo Achillis
Anterior annular ligament
Extensor brevis digitorum

Gastrocnemius
Tibia
Soleus
Tibialis anticus
Tibialis posticus
Tendo Achillis
Extensor longus digitorum
Extensor of
great toe

Peroneus tertius

Flexor longus
digitorum
Flexor longus
hallucis
(big toe)

Outer view

The leg

Inner view

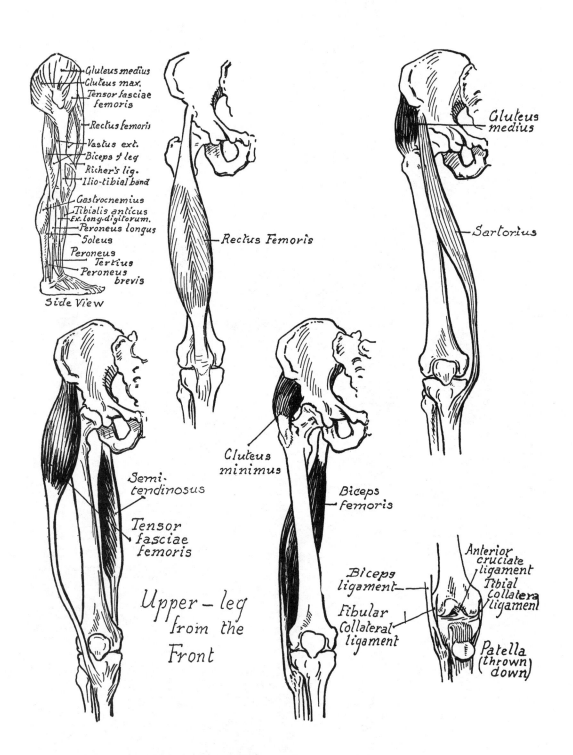

Gluteus medius
Gluteus max.
Tensor fasciae femoris

Rectus femoris

Vastus ext.
Biceps of leg
Richer's lig.
Ilio-tibial band

Gastrocnemius
Tibialis anticus
Ex. long. digitorum.
Peroneus longus
Soleus
Peroneus Tertius
Peroneus brevis

Side View

Rectus Femoris

Gluteus medius

Sartorius

Semi-tendinosus

Tensor fasciae femoris

Gluteus minimus

Biceps femoris

Upper-leg from the Front

Biceps ligament

Fibular Collateral ligament

Anterior cruciate ligament
Tibial Collateral ligament

Patella (thrown down)

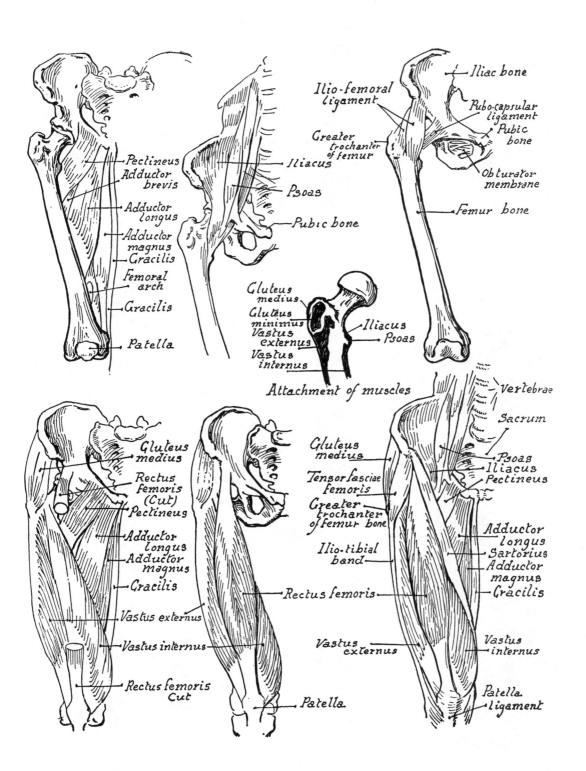

Pectineus
Adductor brevis
Adductor longus
Adductor magnus
Gracilis
Femoral arch
Gracilis
Patella

Ilio-femoral ligament
Greater trochanter of femur
Iliacus
Psoas
Pubic bone

Iliac bone
Pubo-capsular ligament
Pubic bone
Obturator membrane
Femur bone

Gluteus medius
Gluteus minimus
Vastus externus
Vastus internus
Iliacus
Psoas

Attachment of muscles

Gluteus medius
Rectus femoris (Cut)
Pectineus
Adductor longus
Adductor magnus
Gracilis
Vastus externus
Vastus internus
Rectus femoris Cut

Gluteus medius
Tensor fasciae femoris
Greater trochanter of femur bone
Ilio-tibial band
Rectus femoris
Vastus externus
Patella

Vertebrae
Sacrum
Psoas
Iliacus
Pectineus
Adductor longus
Sartorius
Adductor magnus
Gracilis
Vastus internus
Patella ligament

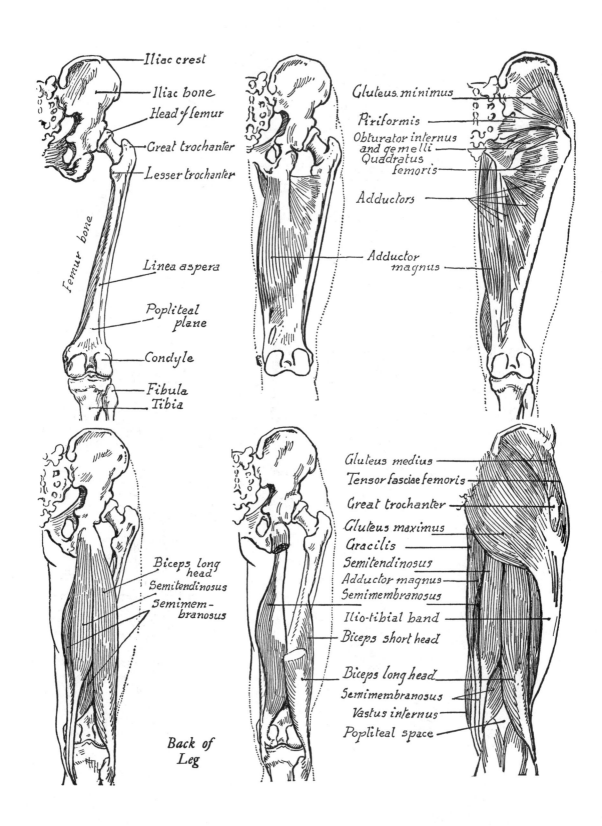

Iliac crest

Iliac bone

Head of femur

Great trochanter

Lesser trochanter

Femur bone

Linea aspera

Popliteal plane

Condyle

Fibula
Tibia

Gluteus minimus

Piriformis

Obturator internus
and gemelli

Quadratus
femoris

Adductors

Adductor
magnus

Biceps long
head

Semitendinosus

Semimem-
branosus

Back of
Leg

Gluteus medius

Tensor fasciae femoris

Great trochanter

Gluteus maximus

Gracilis

Semitendinosus

Adductor magnus

Semimembranosus

Ilio-tibial band

Biceps short head

Biceps long head

Semimembranosus

Vastus internus

Popliteal space

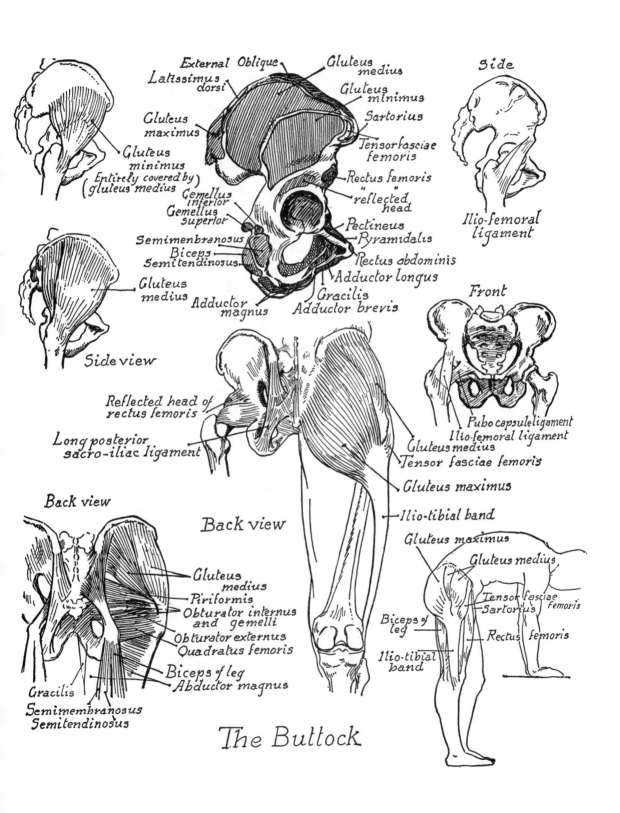

External Oblique
Gluteus medius
Latissimus dorsi
Gluteus minimus
Gluteus maximus
Sartorius
Gluteus minimus
Tensor fasciae femoris
Entirely covered by gluteus medius
Rectus femoris "reflected" head
Gemellus inferior
Gemellus superior
Pectineus
Semimembranosus
Pyramidalis
Biceps
Rectus abdominis
Semitendinosus
Adductor longus
Gluteus medius
Gracilis
Adductor magnus
Adductor brevis

Side

Ilio-femoral ligament

Side view

Front

Reflected head of rectus femoris

Long posterior sacro-iliac ligament

Pubo capsule ligament
Ilio-femoral ligament
Gluteus medius
Tensor fasciae femoris
Gluteus maximus
Ilio-tibial band

Back view

Back view

Gluteus maximus
Gluteus medius
Gluteus medius
Piriformis
Obturator internus and gemelli
Obturator externus
Quadratus femoris
Tensor fasciae femoris
Sartorius
Biceps of leg
Biceps of leg
Abductor magnus
Rectus femoris
Gracilis
Ilio-tibial band
Semimembranosus
Semitendinosus

The Buttock

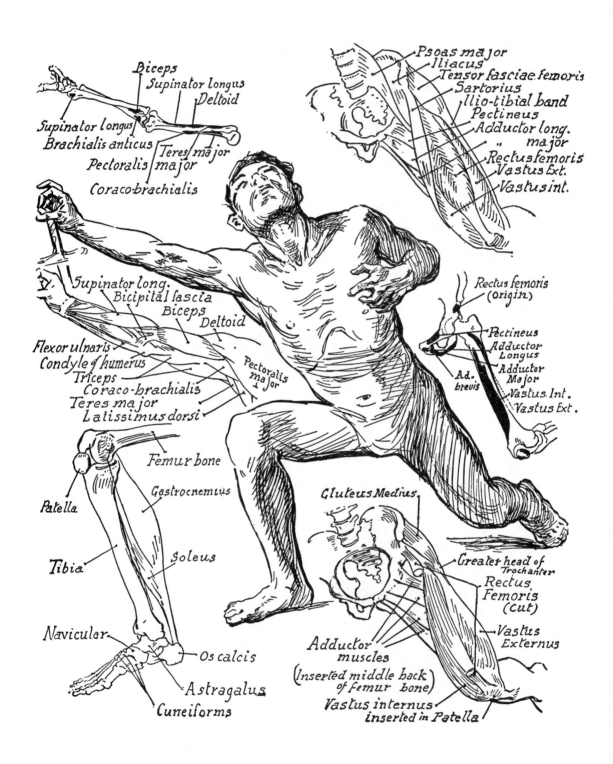

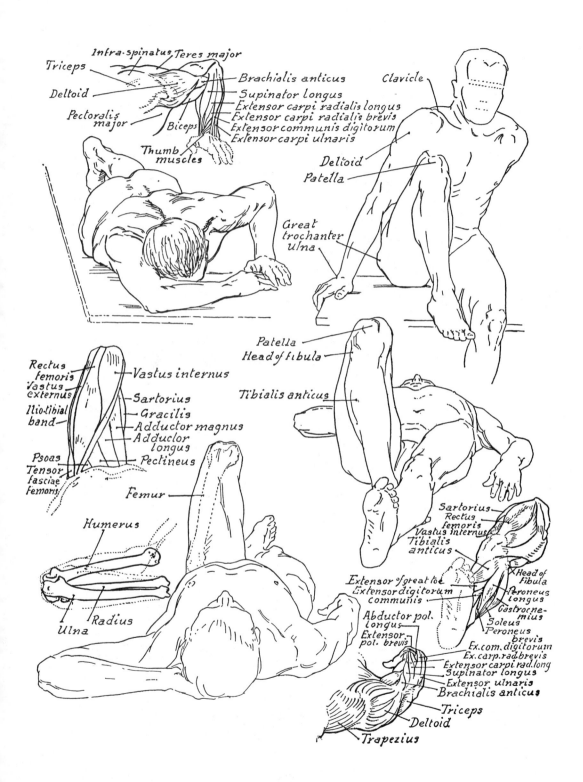

Triceps
Intra-spinatus Teres major
Deltoid
Brachialis anticus
Pectoralis major
Supinator longus
Extensor carpi radialis longus
Extensor carpi radialis brevis
Extensor communis digitorum
Biceps
Extensor carpi ulnaris
Thumb muscles

Clavicle

Deltoid
Patella

Great trochanter
Ulna

Rectus femoris
Vastus externus
Ilio-tibial band
Vastus internus
Sartorius
Gracilis
Adductor magnus
Adductor longus
Psoas
Tensor fasciae femoris
Pectineus

Patella
Head of fibula

Tibialis anticus

Femur

Humerus

Radius
Ulna

Sartorius
Rectus femoris
Vastus internus
Tibialis anticus
Head of fibula
Peroneus longus
Gastrocnemius
Soleus
Peroneus brevis
Extensor of great toe
Extensor digitorum communis
Abductor pol. longus
Extensor pol. brevis
Ex.com. digitorum
Ex. carp. rad. brevis
Extensor carpi rad. long
Supinator longus
Extensor ulnaris
Brachialis anticus
Triceps
Deltoid
Trapezius

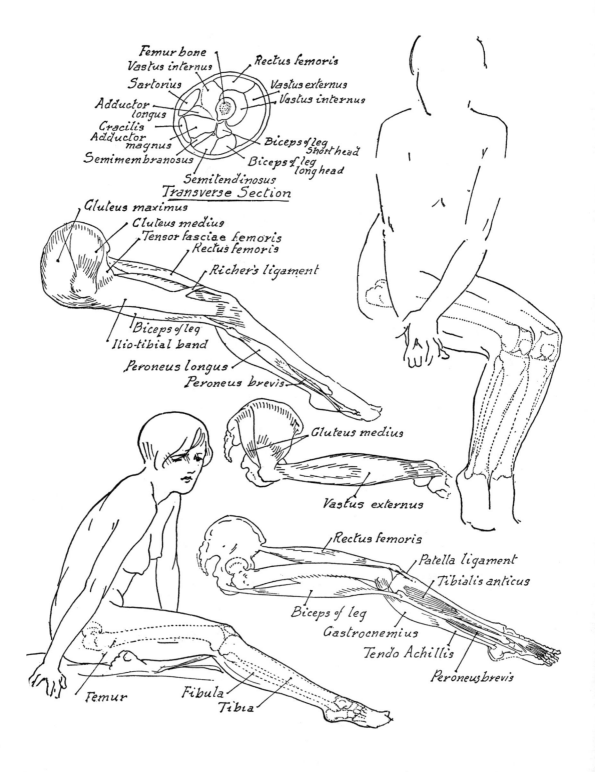

Femur bone

Vastus internus

Sartorius

Adductor longus

Gracilis

Adductor magnus

Semimembranosus

Semitendinosus

Rectus femoris

Vastus externus

Vastus internus

Biceps of leg Short head

Biceps of leg long head

Transverse Section

Gluteus maximus

Gluteus medius

Tensor fasciae femoris

Rectus femoris

Richer's ligament

Biceps of leg

Ilio-tibial band

Peroneus longus

Peroneus brevis

Gluteus medius

Vastus externus

Rectus femoris

Patella ligament

Tibialis anticus

Biceps of leg

Gastrocnemius

Tendo Achillis

Peroneus brevis

Femur

Fibula

Tibia

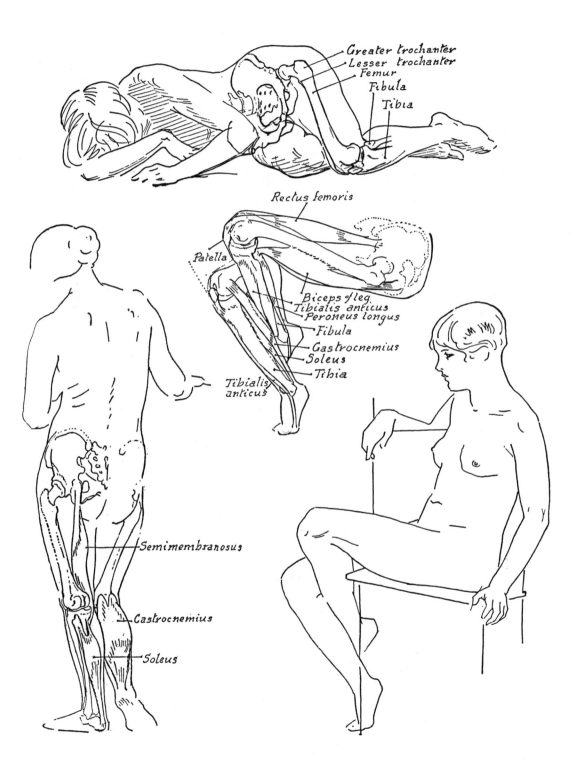

Greater trochanter
Lesser trochanter
Femur
Fibula
Tibia

Rectus femoris

Patella

Biceps of leg
Tibialis anticus
Peroneus longus
Fibula
Gastrocnemius
Soleus
Tibia

Tibialis
anticus

Semimembranosus

Gastrocnemius

Soleus

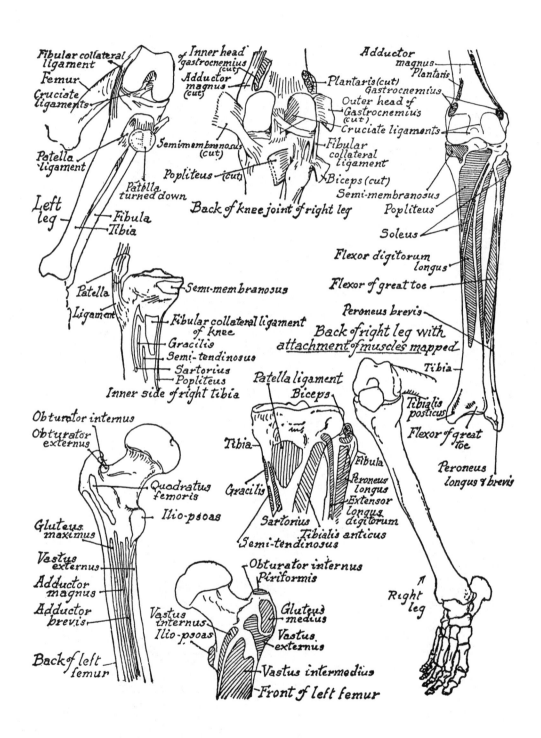

Fibular collateral ligament

Femur

Cruciate ligaments

Patella ligament

Left leg

Fibula

Tibia

Patella

Ligament

Inner side of right tibia

Inner head of gastrocnemius (cut)

Adductor magnus (cut)

Semimembranosus (cut)

Popliteus (cut)

Patella turned down

Back of knee joint of right leg

Semi-membranosus

Fibular collateral ligament of knee

Gracilis

Semi-tendinosus

Sartorius

Popliteus

Adductor magnus

Plantaris

Plantaris (cut)

Gastrocnemius

Outer head of Gastrocnemius (cut)

Cruciate ligaments

Fibular collateral ligament

Biceps (cut)

Semi-membranosus

Popliteus

Soleus

Flexor digitorum longus

Flexor of great toe

Peroneus brevis

Back of right leg with attachment of muscles mapped

Tibia

Tibialis posticus

Flexor of great toe

Peroneus longus & brevis

Obturator internus

Obturator externus

Quadratus femoris

Ilio-psoas

Gluteus maximus

Vastus externus

Adductor magnus

Adductor brevis

Back of left femur

Patella ligament

Biceps

Tibia

Gracilis

Sartorius

Semi-tendinosus

Fibula

Peroneus longus

Extensor longus digitorum

Tibialis anticus

Obturator internus

Piriformis

Gluteus medius

Vastus externus

Vastus internus

Ilio-psoas

Vastus intermedius

Front of left femur

Right leg

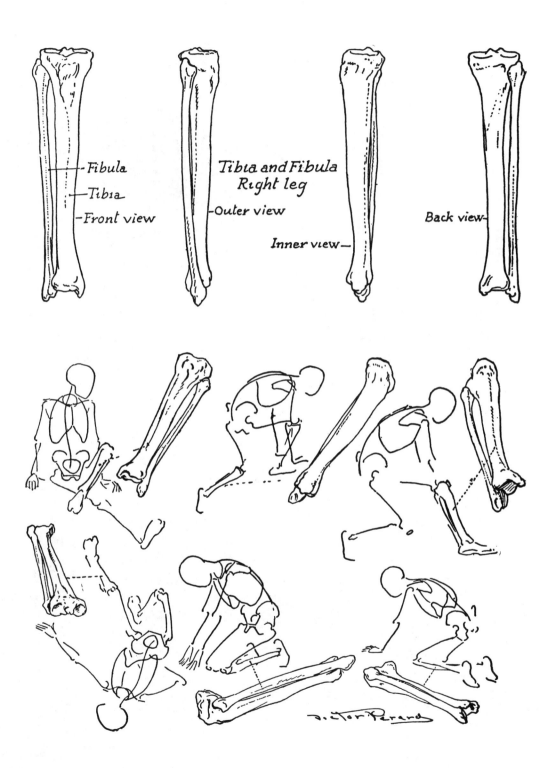

Fibula

Tibia

Front view

Tibia and Fibula
Right leg

Outer view

Inner view

Back view

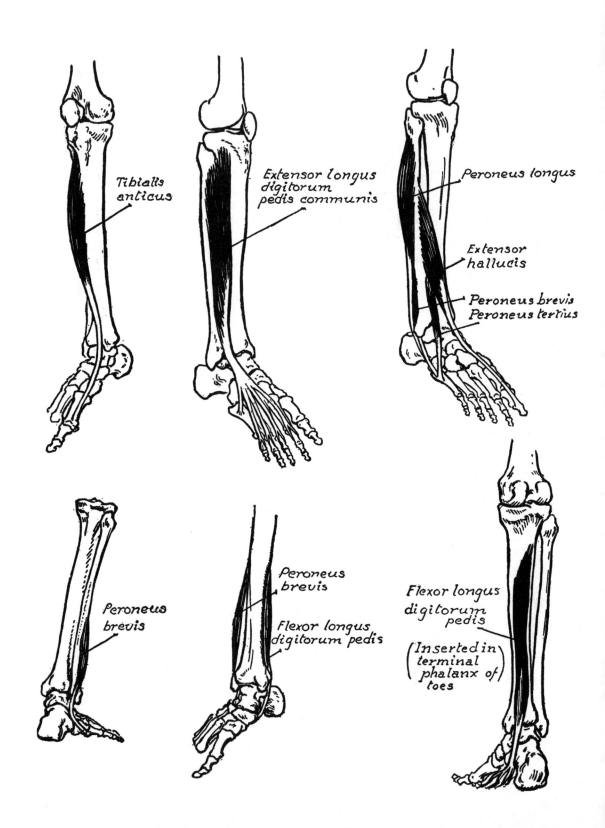

Tibialis anticus

Extensor longus digitorum pedis communis

Peroneus longus

Extensor hallucis

Peroneus brevis
Peroneus tertius

Peroneus brevis

Peroneus brevis

Flexor longus digitorum pedis

Flexor longus digitorum pedis

(Inserted in terminal phalanx of toes)

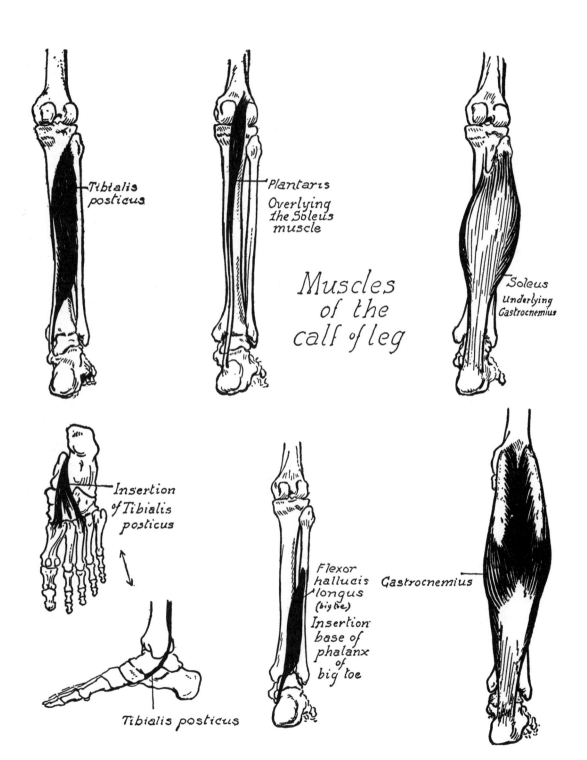

Tibialis posticus

Plantaris
Overlying
the Soleus
muscle

Muscles
of the
calf of leg

Soleus
Underlying
Gastrocnemius

Insertion
of Tibialis
posticus

Tibialis posticus

Flexor
hallucis
longus
(big toe)

Insertion
base of
phalanx
of
big toe

Gastrocnemius

PART EIGHT

THE FOOT

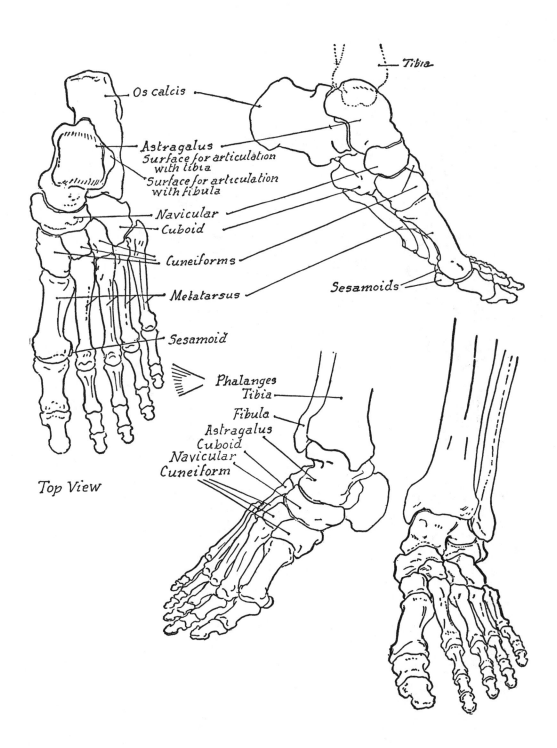

Os calcis

Astragalus
Surface for articulation
with tibia
Surface for articulation
with fibula

Navicular

Cuboid

Cuneiforms

Metatarsus

Sesamoid

Tibia

Sesamoids

Top View

Phalanges
Tibia
Fibula
Astragalus
Cuboid
Navicular
Cuneiform

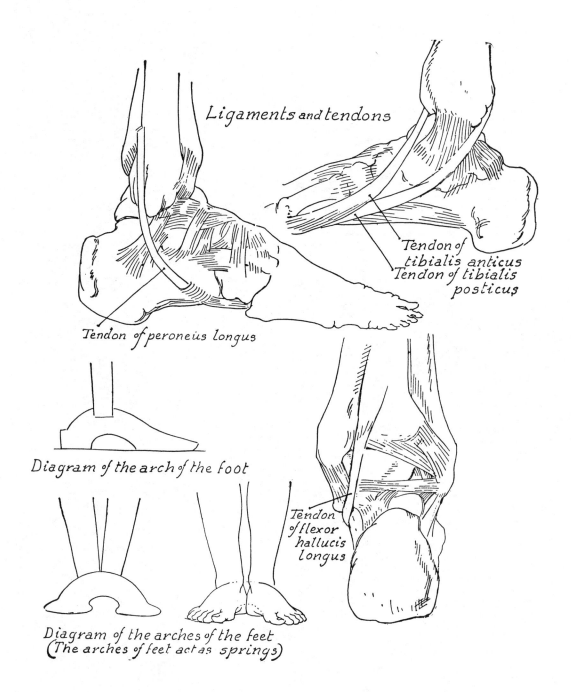

Ligaments and tendons

Tendon of
tibialis anticus
Tendon of tibialis
posticus

Tendon of peroneus longus

Diagram of the arch of the foot

Tendon
of flexor
hallucis
longus

Diagram of the arches of the feet
(The arches of feet act as springs)

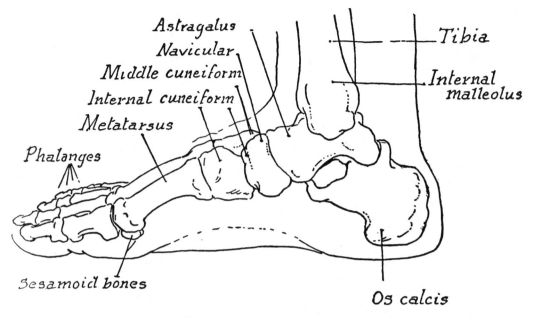

Astragalus
Navicular
Middle cuneiform
Internal cuneiform
Metatarsus
Phalanges
Tibia
Internal malleolus
Sesamoid bones
Os calcis

Inner view

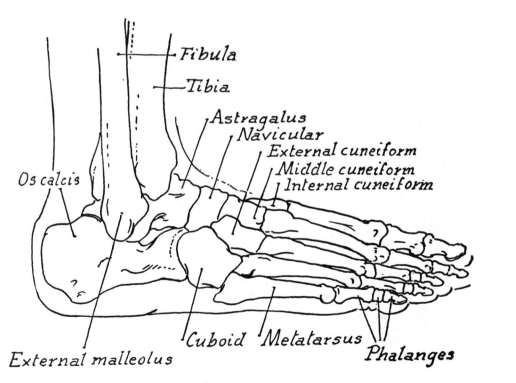

Fibula
Tibia
Astragalus
Navicular
External cuneiform
Middle cuneiform
Internal cuneiform
Os calcis
External malleolus
Cuboid
Metatarsus
Phalanges

Outer view

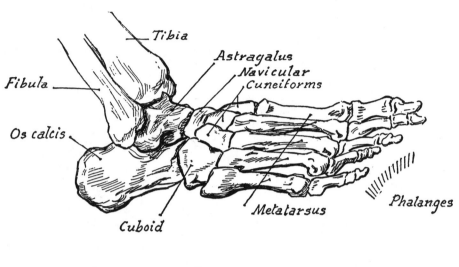

Tibia

Astragalus

Fibula

Navicular

Cuneiforms

Os calcis

Phalanges

Cuboid

Metatarsus

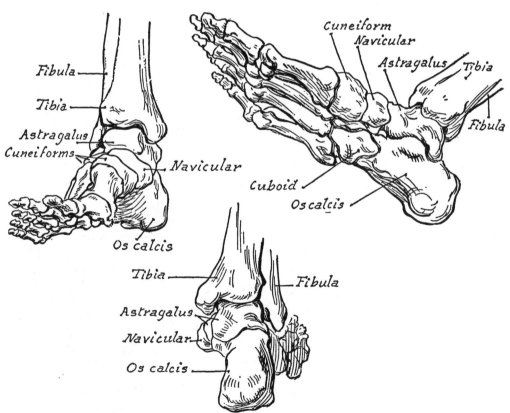

Fibula

Cuneiform

Navicular

Tibia

Astragalus

Tibia

Astragalus

Cuneiforms

Fibula

Navicular

Cuboid

Os calcis

Os calcis

Tibia

Fibula

Astragalus

Navicular

Os calcis

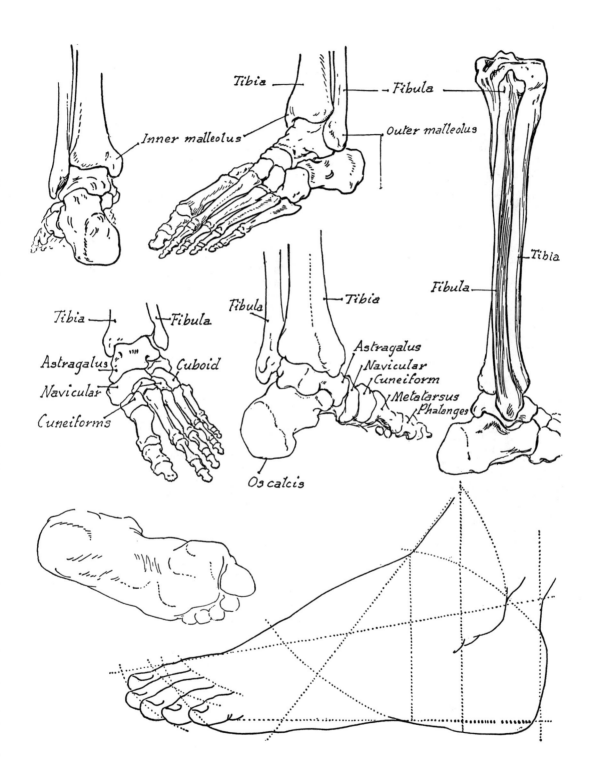

Tibia

Fibula

Inner malleolus

Outer malleolus

Tibia

Fibula

Tibia

Fibula

Astragalus

Cuboid

Navicular

Cuneiforms

Tibia

Fibula

Astragalus
Navicular
Cuneiform
Metatarsus
Phalanges

Os calcis

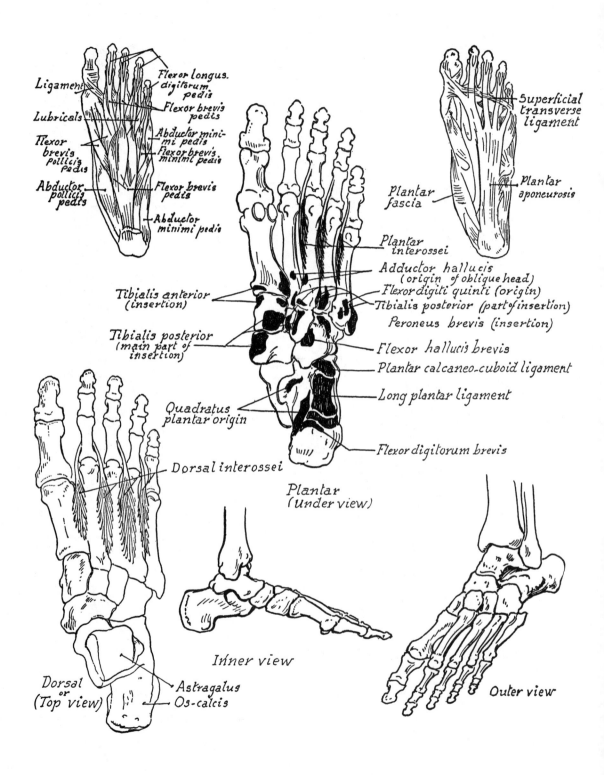

Ligament

Flexor longus.
digitorum
pedis

Lubricals

Flexor brevis
pedis

Flexor
brevis
pollicis
pedis

Abductor mini-
mi pedis

Flexor brevis.
minimi pedis

Abductor
pollicis
pedis

Flexor brevis
pedis

Abductor
minimi pedis

Superficial
transverse
ligament

Plantar
fascia

Plantar
aponeurosis

Plantar
interossei

Adductor hallucis
(origin of oblique head)

Flexor digiti quinti (origin)

Tibialis anterior
(insertion)

Tibialis posterior (part of insertion)

Peroneus brevis (insertion)

Tibialis posterior
(main part of
insertion)

Flexor hallucis brevis

Plantar calcaneo-cuboid ligament

Long plantar ligament

Quadratus
plantar origin

Flexor digitorum brevis

Dorsal interossei

Plantar
(Under view)

Dorsal
or
(Top view)

Astragalus

Os-calcis

Inner view

Outer view

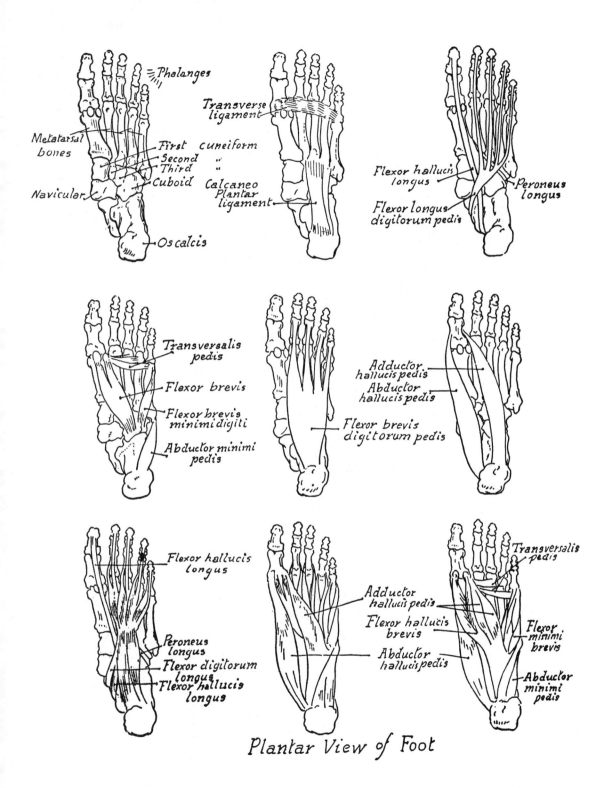

Phalanges

Transverse
ligament

Metatarsal
bones

First cuneiform
Second "
Third "
Cuboid

Calcaneo
Plantar
ligament

Navicular

Os calcis

Flexor hallucis
longus

Flexor longus
digitorum pedis

Peroneus
longus

Transversalis
pedis

Flexor brevis

Flexor brevis
minimi digiti

Abductor minimi
pedis

Flexor brevis
digitorum pedis

Adductor
hallucis pedis

Abductor
hallucis pedis

Flexor hallucis
longus

Peroneus
longus

Flexor digitorum
longus

Flexor hallucis
longus

Adductor
hallucis pedis

Flexor hallucis
brevis

Abductor
hallucis pedis

Transversalis
pedis

Flexor
minimi
brevis

Abductor
minimi
pedis

Plantar View of Foot

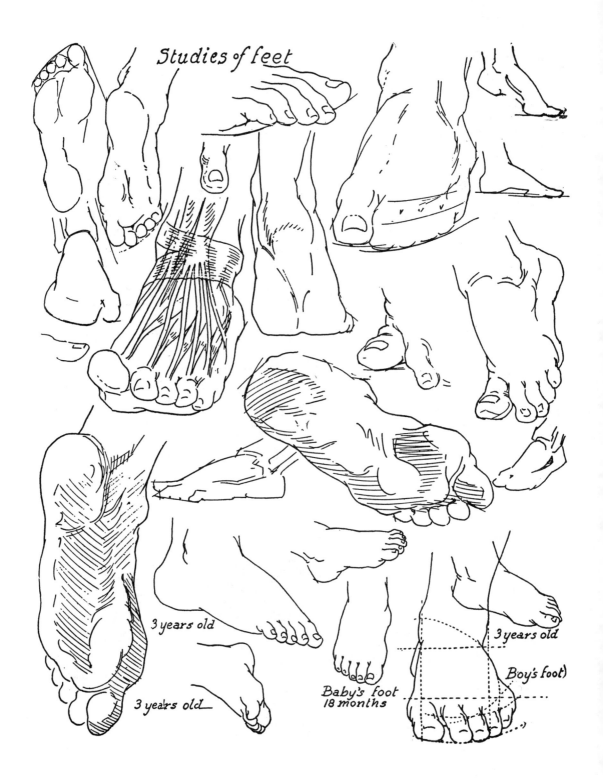

Studies of feet

3 years old

3 years old

Baby's foot
18 months

3 years old

Boy's foot)

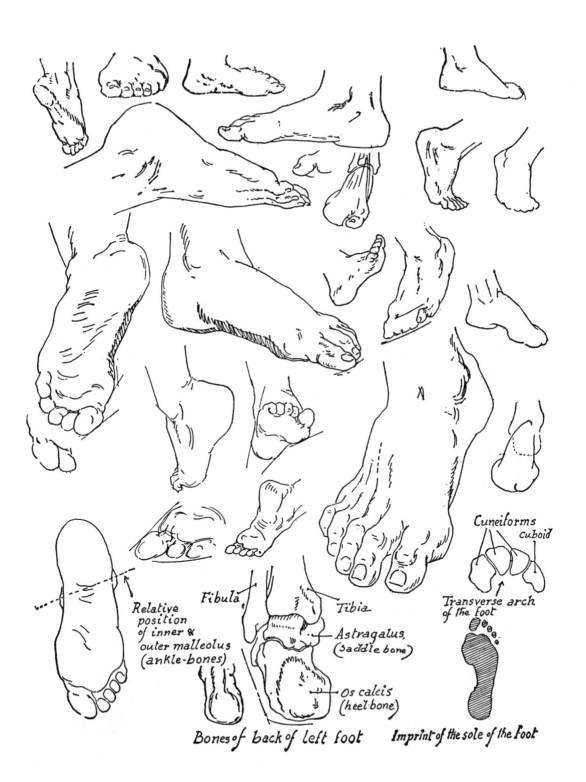

Relative
position
of inner &
outer malleolus
(ankle-bones)

Fibula

Tibia

Astragalus,
(saddle bone)

Os calcis
(heel·bone)

Bones of back of left foot

Cuneiforms
Cuboid

Transverse arch
of the foot

Imprint of the sole of the Foot

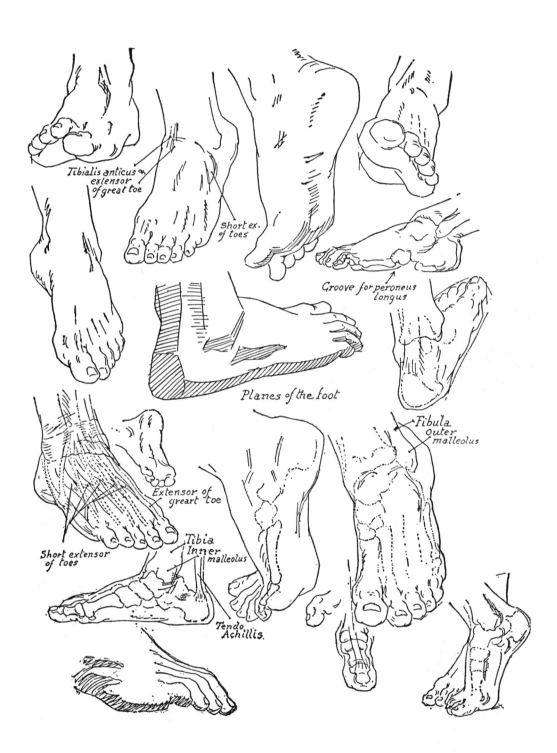

Tibialis anticus &
extensor
of great toe

Short ex.
of toes

Groove for peroneus
longus

Planes of the foot

Fibula
outer
malleolus

Extensor of
greart toe

Tibia
Inner
malleolus

Short extensor
of toes

Tendo
Achillis.

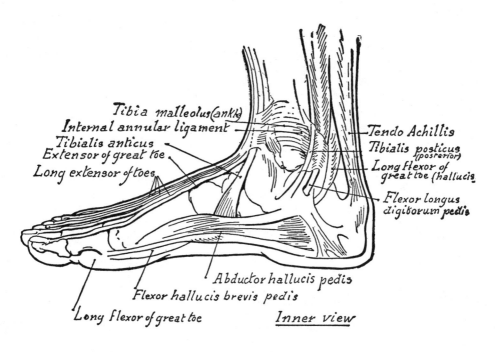

Tibia malleolus (ankle)
Internal annular ligament
Tibialis anticus
Extensor of great toe
Long extensor of toes

Tendo Achillis
Tibialis posticus (posterior)
Long flexor of great toe (hallucis)
Flexor longus digitorum pedis

Abductor hallucis pedis

Flexor hallucis brevis pedis

Long flexor of great toe

Inner view

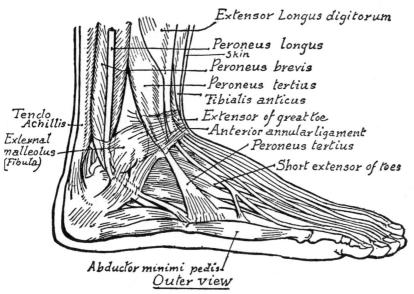

Extensor Longus digitorum
Peroneus longus
Skin
Peroneus brevis
Peroneus tertius
Tibialis anticus
Extensor of great toe
Anterior annular ligament
Peroneus tertius
Short extensor of toes

Tendo Achillis
External malleolus (Fibula)

Abductor minimi pedis
Outer view

PART NINE

THE ECORCHE
AND MUSCLES OF THE BODY

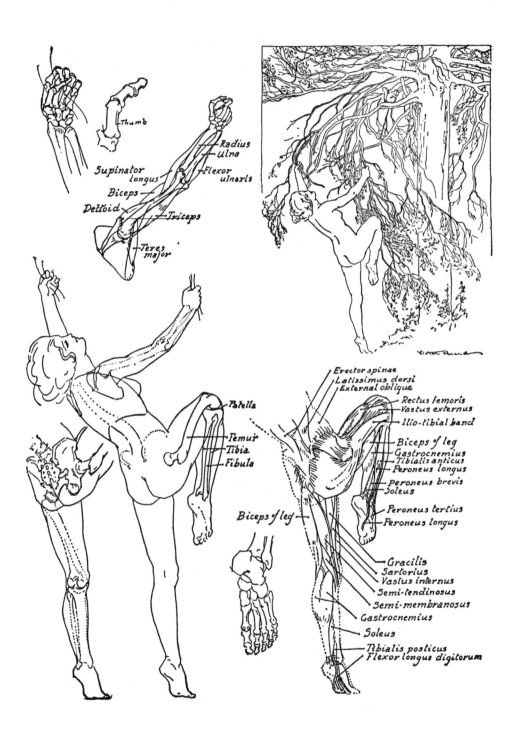

Thumb

Radius
Ulna
Supinator
longus
Flexor
ulnaris
Biceps
Deltoid
Triceps
Teres
major

Erector spinae
Latissimus dorsi
External oblique
Rectus femoris
Vastus externus
Ilio-tibial band
Patella
Biceps of leg
Gastrocnemius
Tibialis anticus
Peroneus longus
Femur
Tibia
Fibula
Peroneus brevis
Soleus
Peroneus tertius
Peroneus longus
Biceps of leg
Gracilis
Sartorius
Vastus internus
Semi-tendinosus
Semi-membranosus
Gastrocnemius
Soleus
Tibialis posticus
Flexor longus digitorum

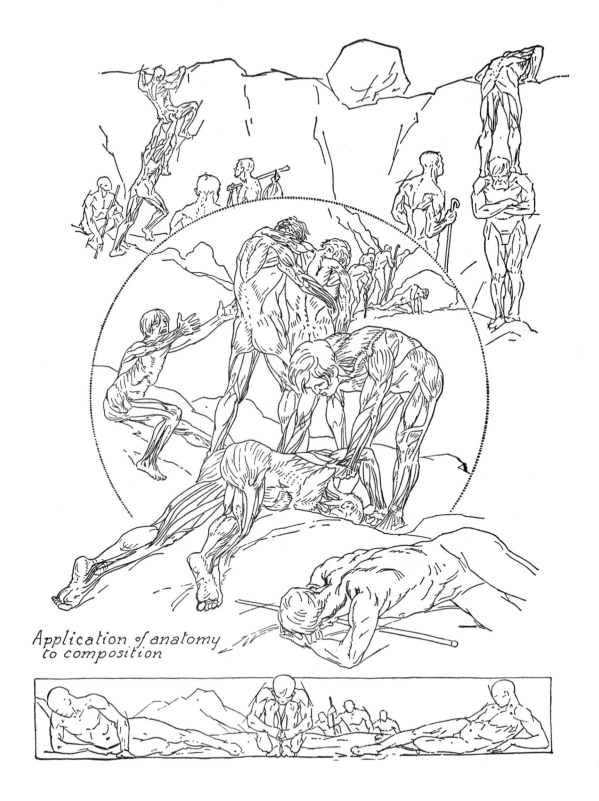

Application of anatomy to composition

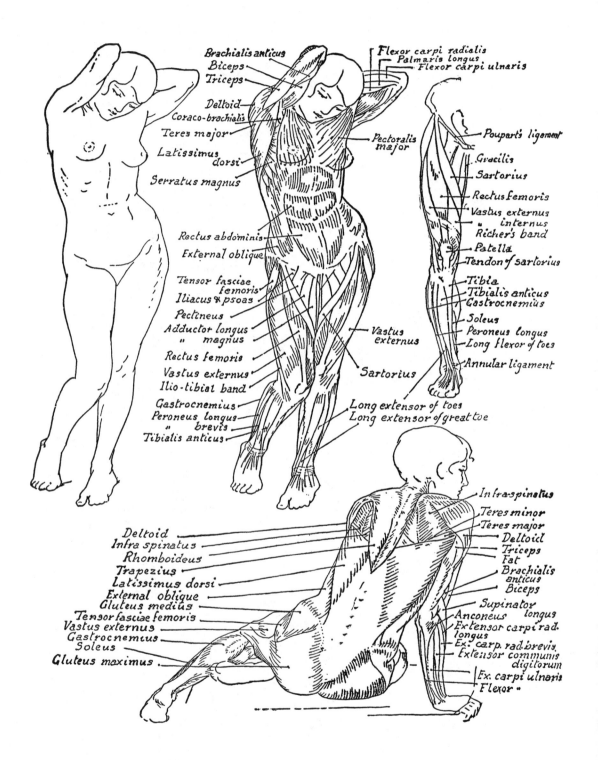

Brachialis anticus
Biceps
Triceps
Deltoid
Coraco-brachialis
Teres major
Latissimus dorsi
Serratus magnus

Flexor carpi radialis
Palmaris longus
Flexor carpi ulnaris

Pectoralis major

Rectus abdominis
External oblique

Tensor fasciae femoris
Iliacus & psoas
Pectineus
Adductor longus
 " magnus
Rectus femoris
Vastus externus
Ilio-tibial band
Gastrocnemius
Peroneus longus
 " brevis
Tibialis anticus

Vastus externus
Sartorius

Long extensor of toes
Long extensor of great toe

Poupart's ligament
Gracilis
Sartorius
Rectus femoris
Vastus externus
 " internus
Richer's band
Patella
Tendon of sartorius
Tibia
Tibialis anticus
Gastrocnemius
Soleus
Peroneus longus
Long flexor of toes
Annular ligament

Deltoid
Infra spinatus
Rhomboideus
Trapezius
Latissimus dorsi
External oblique
Gluteus medius
Tensor fasciae femoris
Vastus externus
Gastrocnemius
Soleus
Gluteus maximus

Infraspinatus
Teres minor
Teres major
Deltoid
Triceps
Fat
Brachialis anticus
Biceps
Supinator longus
Anconeus
Extensor carpi rad. longus
Ex. carp. rad. brevis
Extensor communis digitorum
Ex. carpi ulnaris
Flexor

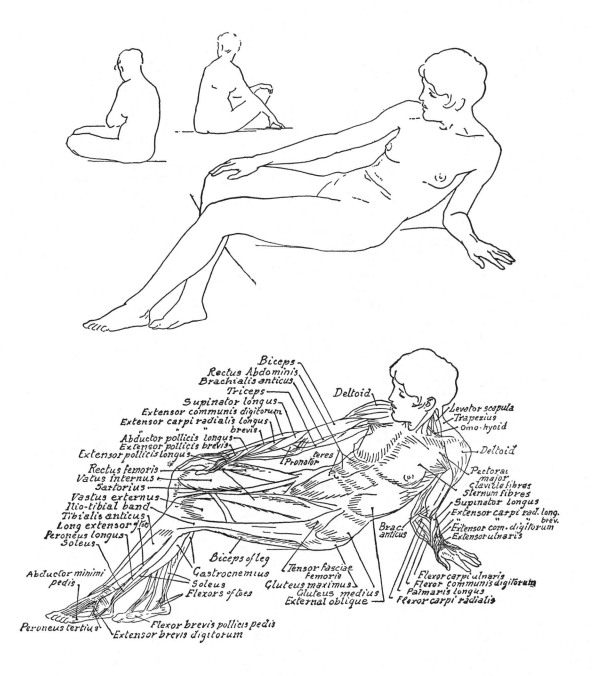

Biceps
Rectus Abdominis
Brachialis anticus
Triceps
Supinator longus
Extensor communis digitorum
Extensor carpi radialis longus
" " brevis
Abductor pollicis longus
Extensor pollicis brevis
Extensor pollicis longus
Rectus femoris
Vatus internus
Sartorius
Vastus externus
Ilio-tibial band
Tibialis anticus
Long extensor of toes
Peroneus longus
Soleus
Abductor minimi pedis
Peroneus tertius
Flexor brevis pollicis pedis
Extensor brevis digitorum
Gastrocnemius
Soleus
Flexors of toes
Biceps of leg
Tensor fasciae femoris
Gluteus maximus
Gluteus medius
External oblique
Pronator teres
Deltoid
Levator scapula
Trapezius
Omo-hyoid
Deltoid
Pectoral major
Clavicle fibres
Sternum fibres
Supinator longus
Extensor carpi rad. long.
" brev.
Extensor com. digitorum
Extensor ulnaris
Brach anticus
Flexor carpi ulnaris
Flexor communis digitorum
Palmaris longus
Flexor carpi radialis

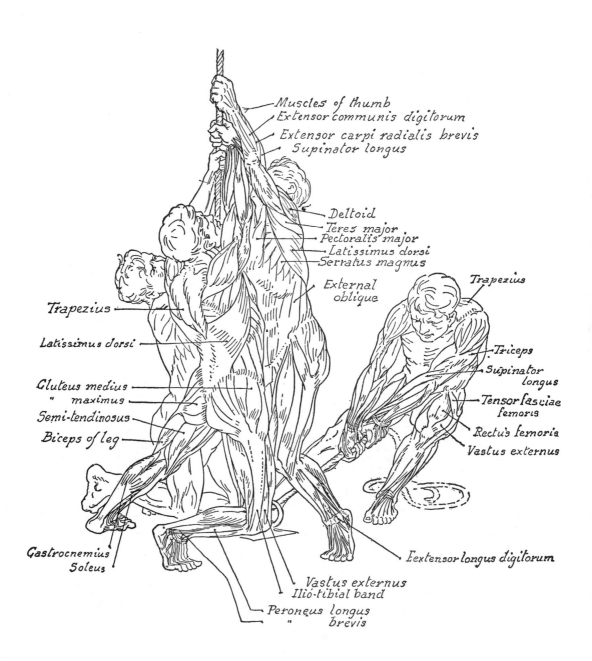

Muscles of thumb
Extensor communis digitorum
Extensor carpi radialis brevis
Supinator longus

Deltoid
Teres major
Pectoralis major
Latissimus dorsi
Serratus magnus

External oblique

Trapezius

Triceps

Supinator longus

Tensor fasciae femoris

Rectus femoris

Vastus externus

Trapezius

Latissimus dorsi

Gluteus medius
 " maximus
Semi-tendinosus
Biceps of leg

Gastrocnemius
Soleus

Eextensor longus digitorum

Vastus externus
Ilio-tibial band
Peroneus longus
 " brevis

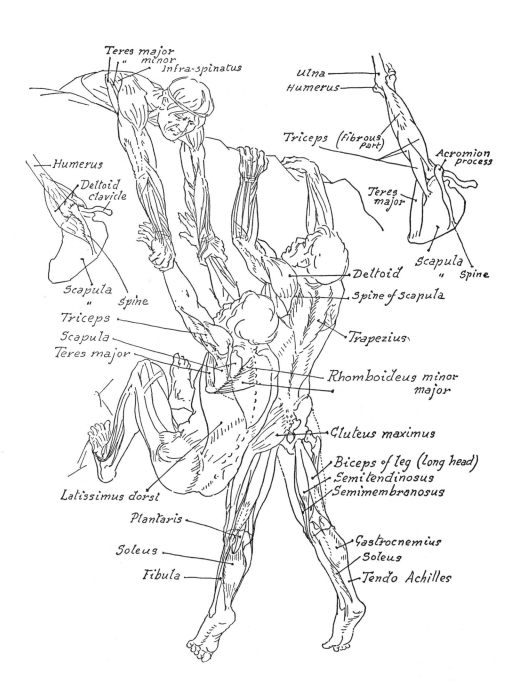

Teres major
 " minor
 Infra-spinatus

Ulna
Humerus

Triceps (fibrous part)

Acromion process

Teres major

Humerus

Deltoid
clavicle

Scapula
 " Spine

Scapula
 " spine

Deltoid

Spine of Scapula

Triceps

Scapula

Teres major

Trapezius

Rhomboideus minor
 major

Gluteus maximus

Biceps of leg (long head)
Semitendinosus
Semimembranosus

Latissimus dorsi

Plantaris

Soleus

Fibula

Gastrocnemius

Soleus

Tendo Achilles

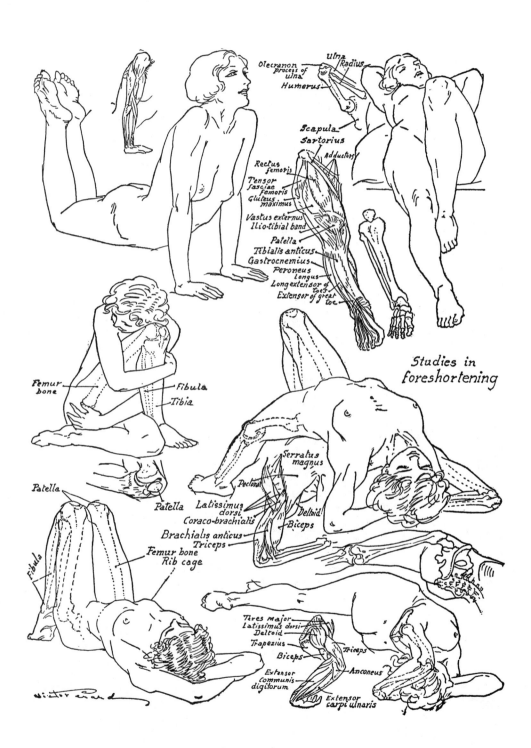

Olecranon
process of
ulna

ulna
Radius

Humerus

Scapula
Sartorius

Adductors

Rectus
femoris
Tensor
fasciae
femoris
Gluteus
maximus

Vastus externus
Ilio-tibial band

Patella
Tibialis anticus
Gastrocnemius
Peroneus
longus
Long extensor of
toes
Extensor of great
toe

Studies in
foreshortening

Femur
bone

Fibula
Tibia

Patella

Patella

Serratus
magnus

Pectoral

Fibula

Latissimus
dorsi
Coraco-brachialis
Brachialis anticus
Triceps
Femur bone
Rib cage

Deltoid
Biceps

Teres major
Latissimus dorsi
Deltoid
Trapezius

Biceps

Triceps

Anconeus

Extensor
communis
digitorum

Extensor
carpi ulnaris

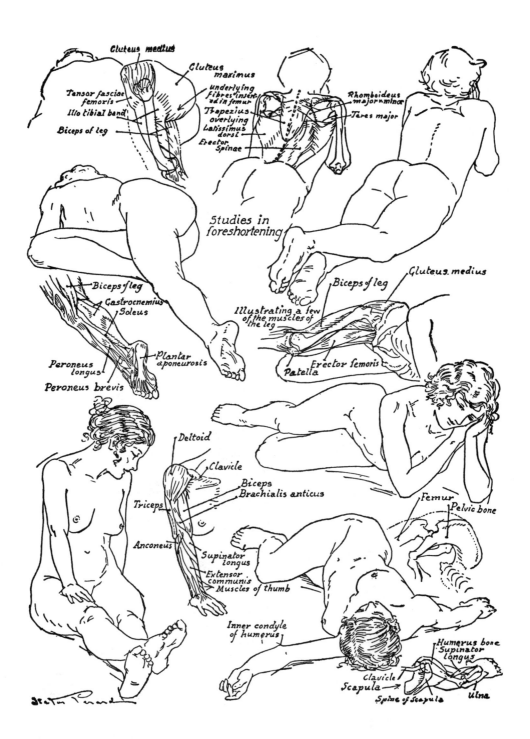

Gluteus medius

Gluteus maximus

Tensor fasciae femoris

Illio tibial band

Biceps of leg

underlying
Fibres insert-
ed in femur

Trapezius
overlying

Latissimus
dorsi

Erector
Spinae

Rhomboideus
major or minor

Teres major

Studies in
foreshortening

Biceps of leg

Gastrocnemius

Soleus

Biceps of leg

Gluteus medius

Illustrating a few
of the muscles of
the leg

Peroneus
longus

Plantar
aponeurosis

Peroneus brevis

Erector femoris

Patella

Deltoid

Clavicle

Biceps
Brachialis anticus

Triceps

Femur

Pelvic bone

Anconeus

Supinator
longus

Extensor
communis

Muscles of thumb

Inner condyle
of humerus

Humerus bone
Supinator
longus

Clavicle

Scapula

Spine of Scapula

Ulna

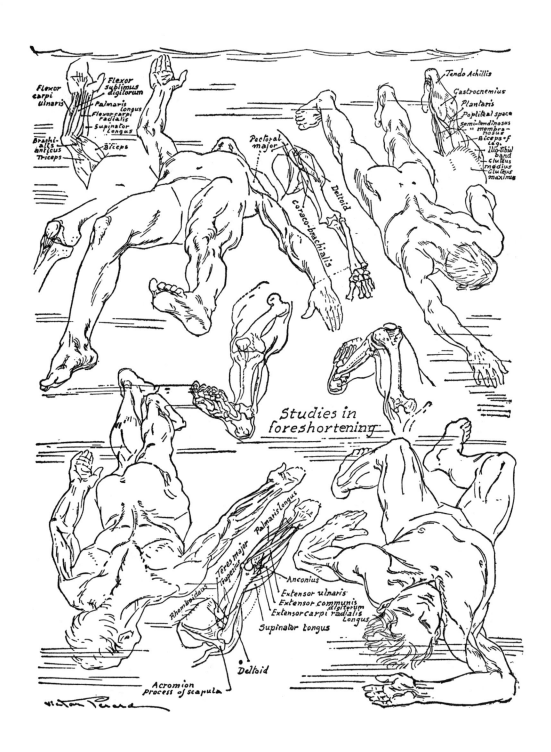

Flexor carpi ulnaris
Flexor sublimus digitorum
Palmaris Longus
Flexor carpi radialis
Supinator Longus
Brachialis anticus
Triceps
Biceps

Pectoral major
Deltoid
coraco-brachialis

Tendo Achillis
Gastrocnemius
Plantaris
Poplital space
semi-tendinosus
" membranosus
Biceps of Leg
Ilio-tibial band
Gluteus medius
Gluteus maximus

Studies in foreshortening

Teres major
Trapezius
Rhomboideus
Palmaris longus
Anconius
Extensor ulnaris
Extensor communis digitorum
Extensorcarpi radialis Longus
Supinator Longus
Deltoid
Acromion Process of scapula

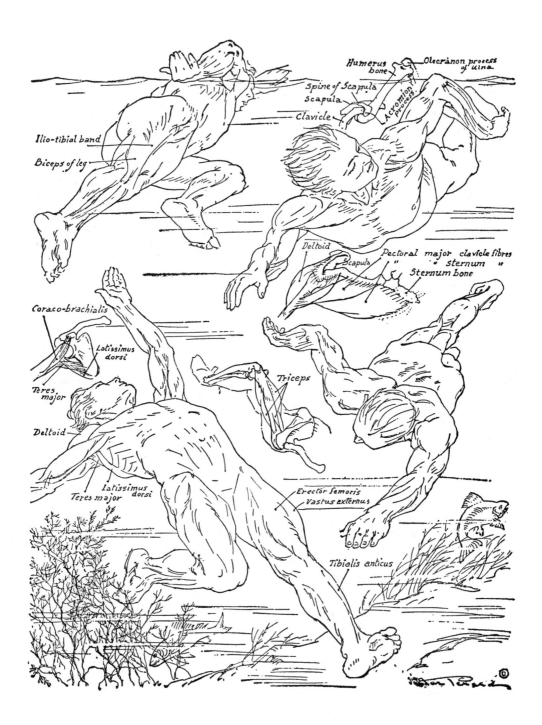

Humerus bone

Olecranon process of ulna

Spine of Scapula

Scapula

Acromion process

Clavicle

Ilio-tibial band

Biceps of leg

Deltoid

Scapula

Pectoral major clavicle fibres

" " sternum "

Sternum bone

Coraco-brachialis

Latissimus dorsi

Teres major

Deltoid

Triceps

Teres major

Latissimus dorsi

Erector femoris

Vastus externus

Tibialis anticus

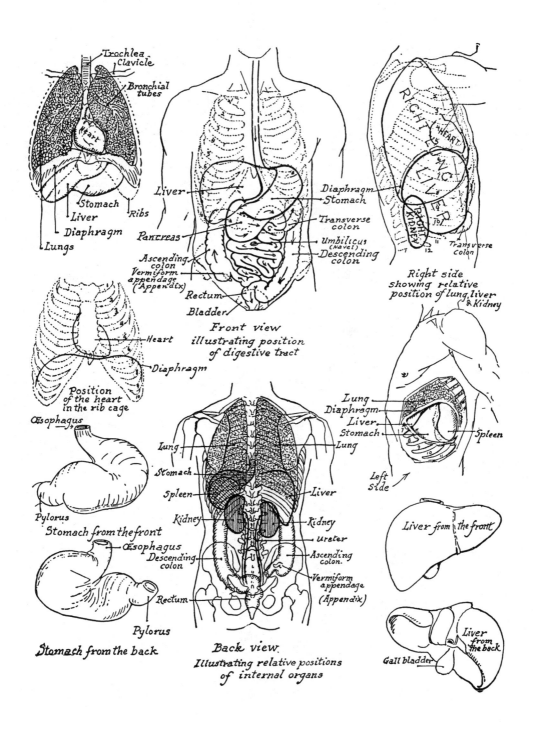

Trochlea
Clavicle
Bronchial tubes

Heart

Stomach
Liver
Diaphragm
Lungs
Ribs

Liver
Pancreas
Ascending colon
Vermiform appendage (Appendix)
Rectum
Bladder

Diaphragm
Stomach
Transverse colon
Umbilicus (Navel)
Descending colon

Front view
illustrating position
of digestive tract

RICHTER'S LIVER
HEART
RIGHT KIDNEY
Transverse colon

Right side
showing relative
position of lung, liver
& Kidney

Heart
Diaphragm

Position
of the heart
in the rib cage

Œsophagus

Pylorus

Stomach from the front

Œsophagus
Descending colon
Rectum

Pylorus

Stomach from the back

Lung
Stomach
Spleen
Kidney
Descending colon

Lung
Liver
Kidney
Ureter
Ascending colon
Vermiform appendage (Appendix)

Back view.
Illustrating relative positions
of internal organs

Lung
Diaphragm
Liver
Stomach
Spleen

Left
Side

Liver from the front

Liver
from
the back

Gall bladder

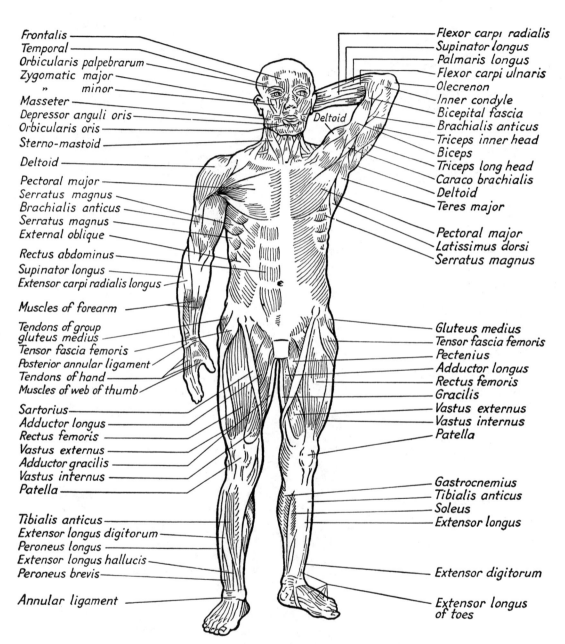

Frontalis
Temporal
Orbicularis palpebrarum
Zygomatic major
 „ minor
Masseter
Depressor anguli oris
Orbicularis oris
Sterno-mastoid

Deltoid

Pectoral major
Serratus magnus
Brachialis anticus
Serratus magnus
External oblique

Rectus abdominus

Supinator longus
Extensor carpi radialis longus

Muscles of forearm

Tendons of group
gluteus medius
Tensor fascia femoris
Posterior annular ligament
Tendons of hand
Muscles of web of thumb

Sartorius
Adductor longus
Rectus femoris
Vastus externus
Adductor gracilis
Vastus internus
Patella

Tibialis anticus
Extensor longus digitorum
Peroneus longus
Extensor longus hallucis
Peroneus brevis

Annular ligament

Deltoid

Flexor carpi radialis
Supinator longus
Palmaris longus
Flexor carpi ulnaris
Olecrenon
Inner condyle
Bicepital fascia
Brachialis anticus
Triceps inner head
Biceps
Triceps long head
Caraco brachialis
Deltoid
Teres major

Pectoral major
Latissimus dorsi
Serratus magnus

Gluteus medius
Tensor fascia femoris
Pectenius
Adductor longus
Rectus femoris
Gracilis
Vastus externus
Vastus internus
Patella

Gastrocnemius
Tibialis anticus
Soleus
Extensor longus

Extensor digitorum

Extensor longus
of toes

MUSCLES OF BODY (front view)

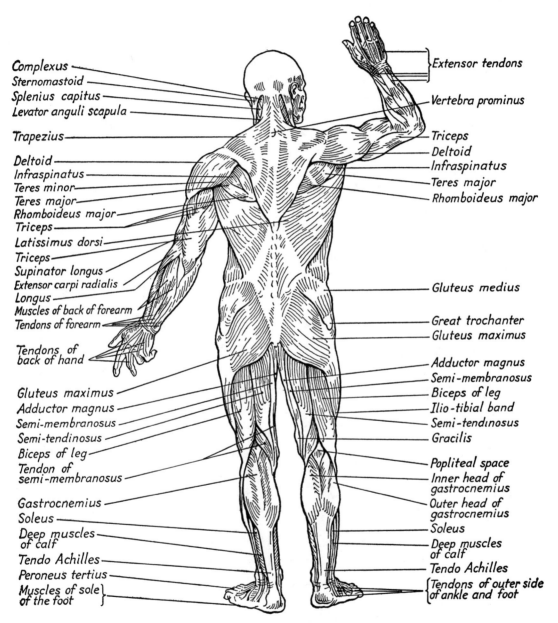

Complexus
Sternomastoid
Splenius capitus
Levator anguli scapula

Trapezius

Deltoid
Infraspinatus
Teres minor
Teres major
Rhomboideus major
Triceps
Latissimus dorsi
Triceps
Supinator longus
Extensor carpi radialis
Longus
Muscles of back of forearm
Tendons of forearm

Tendons of
back of hand

Gluteus maximus
Adductor magnus
Semi-membranosus
Semi-tendinosus
Biceps of leg
Tendon of
semi-membranosus

Gastrocnemius
Soleus
Deep muscles
of calf
Tendo Achilles
Peroneus tertius
Muscles of sole
of the foot

Extensor tendons

Vertebra prominus

Triceps
Deltoid
Infraspinatus
Teres major
Rhomboideus major

Gluteus medius

Great trochanter
Gluteus maximus

Adductor magnus
Semi-membranosus
Biceps of leg
Ilio-tibial band
Semi-tendinosus
Gracilis

Popliteal space
Inner head of
gastrocnemius
Outer head of
gastrocnemius
Soleus
Deep muscles
of calf
Tendo Achilles
Tendons of outer side
of ankle and foot

MUSCLES OF BODY (back view)

Compend of Anatomy Muscles of the head, face and neck

NAME OF MUSCLE	ORIGIN	INSERTION	ACTION
Auricular Posterior and superior	Aponeurosis	Helix of ear	Moves scalp
Buccinator	Processes of both maxillary bones	Orbicular muscle of mouth	Presses cheek against teeth
Complexus	Transverse process of first three dorsals and articular processes of last three cervical vertebrae	Occipital below curved line	Draws head backwards
Compressor naris	Superior maxilla	Opposite muscle	Narrows nostrils
Depressor anguli oris	External oblique line of lower maxilla	Angle of mouth	Draws down angle of mouth
Depressor labii inferior	External oblique line at lower maxillary	Lower lip	Draws lower lip downward
Digastric anterior and posterior	Posterior surface of lower jaw and the mastoid process	Hyoid bone	Depresses jaw raises hyoid bone and tongue
External rectus	Two heads from outer margin of optic foramen	Sclerotic coat	Turns eyeball outward
Frontalis	Nasal and internal angular process of frontal bone	Aponeurosis scalp over bone of forehead	Wrinkles forehead and raises eyebrows
Inferior constrictor	Cricoid and thyroid cartilage	Posterior medium line	Contracts caliber of pharynx
Levator menti	Mandible	Integument of chin	Raises the chin
Levator palpebrarum superioris	Lesser wing of sphenoid	Upper tarsal cartilage	Lifts upper lid of eye
Levator scapula	Transverse process of 4 upper cervical vertebrae	Border of scapula below upper angle	Raises upper angle of scapula
Levator labii superioris	Nasal process of upper maxillary	Nasal cartilage and lip	Draws up lip and opens nostrils
Levator labii superioris alaeque nasi	Root of nose and frontalis muscle	Wing of nose and upper lip	Dilates nostril and lifts upper lip
Levator orbicularis oris	Lower margin of orbit	Upper lip	Raises lip
Longus capitis	Occipital bone	3rd., 4th., 5th., 6th., 7th., cervical vertebrae	Draws head to the side
Longus colli	Base of skull	Upper four thoracic vertebrae	Draws head back
Masseter	Zygomatic arch	Ramus and angle of jaw	Brings molar teeth together
Middle constrictor	Both horns of hyoid stylo-hyoid and ligament	Posterior median line	Contracts caliber of pharynx
Mylo-hyoid	Mylo-hyoid ridge of lower jaw	Body of hyoid and middle line	Draws hyoid up and forward
Occipital	Superior curved line of occiput	Aponeurosis of scalp	Moves scalp
Omo-hyoid	Upper border of scapula	Body of hyoid	Draws hyoid bone downward
Orbicularis palpebrarum (eye)	Internal margin of orbit	Outer margin of orbit	Closes eyelids
Orbicularis oris (mouth)	Nasal septum and bone below lower maxillary	Forms bulk of lip	Closes the mouth

Muscles of head, face and neck (continued)

NAME OF MUSCLE	ORIGIN	INSERTION	ACTION
Oblique inferior	Orbital plate of upper maxillary	Sclerotic coat	Rotates eyeball
Oblique superior	Above optic foramen	Sclerotic coat	Rotates eyeball
Platysma myoides	Clavicle, acromion and fascia	Jaw beneath oblique	Wrinkles skin draws mouth down
Pyramidalis	Frontal bone	Compressor of nose	Draws down eye brow
Rectus inferior	Lower margin of optic foramen	Sclerotic coat	Turns eyeball downward
Rectus lateralis	Two heads from outer margin of optic foramen	Sclerotic coat	Turns eyeball outward
Rectus superior	Upper margin of optic foramen	Sclerotic coat	Turns eyeball upward
Risorius	Fascia over masseter	Angle of mouth	Draws out angle of mouth
Scalenus anterior	Tubercle of first rib	Transverse process of third, seventh cervical vertebrae	Bends neck to side
Scalenus medius and posterior	First rib and second rib	Transverse process of three lower cervical vertebrae	Bends neck to side
Semispinalis	Articular process of lower cervicals	Spinous process of upper cervicals	Keeps neck erect
Splenius capitus of neck	Half of ligament of nape and spinous process of six upper dorsal vertebrae	Occiput and mastoid transverse process of the four upper cervical vertebrae	Draws head back keeps neck erect
Sterno-hyoid	Clavicle and first piece of sternum bone	Body of hyoid bone	Draws down hyoid bone
Sterno-mastoid	Sternum and inner end of clavicle	Mastoid process	Bends head down and rotates it
Sterno-thyroid	First piece of sternum	Side of thyroid cartilage	Draws down larynx
Stylo-hyoid	Styloid process of temporal	Body of hyoid	Draws hyoid up and back
Temporal	Temporal fossa and fascia	Coronoid process of jaw	Brings teeth together
Trapezius	Superior line of occipital, all spinous processes to twelfth dorsal	Clavicle and spine of scapula	Draws head back and shoulders together
Thyro-hyoid	Side of thyroid cartilage	Body of great horn of hyoid	Raises larynx
Zygomatic major	Malar bone	Angle of mouth	Raises and draws outward the upper lip
Zygomatic minor	Malar bone	Angle of mouth	Raises and draws outward the upper lip

The muscles of the face are muscles of expression whose duty is to cause such motion of the eyelids, nose, and mouth, and to produce such wrinkles in the integument that the mental emotions may be exhibited. About the mouth a number of small muscles are inserted into a large one, and, as it relaxes, pull it in various directions.
The mouth is, therefore a most expressive feature.

Muscles of arm and hand

NAME OF MUSCLE	ORIGIN	INSERTION	ACTION
Abductor pollicis longus	Radius and ulna	Head of metacarpal of thumb	Extends thumb
Abductor pollicis brevis	Trapezium	First phalanx of thumb	Draws thumb away from hand
Abductor digiti quinti (fifth)	Pisiform bone	First phalanx of little finger	Draws finger away from the rest
Adductor pollicis oblique head	Carpals and first and second metacarpals	First metacarpal of thumb	Draws thumb to oppose fingers
Adductor pollicis transverse head	Third metacarpal	First phalanx	Draws thumb to oppose fingers
Anconeus	Posterior surface of external condyle of humerus bone	Olecanon and posterior part of ulna	Extends forearm
Annular ligament posterior and anterior	Surrounds wrist	Holds tendons down	Keeps extensor and flexor tendons in place
Biceps	Coracoid process and top of glenoid cavity	Back of tuberosity of radius bone	Flexes and supinates forearm
Brachialis anticus	Lower part of front of humerus	Base of coronoid process of ulna	Flexes forearm
Coraco-brachialis	Coracoid process of scapula	Inside of shaft of humerus	Draws arm forward and inward
Deltoid	Clavicle and acromion process and spine of scapula	Outside of shaft of humerus bone	Raises arm to side back and front
Dorsal interossei (four)	Sides of metacarpal bones	Back of phalanges	Abducts fingers from middle line of middle finger
Extensor carpi radialis brevis	Outer condyle of humerus	Inner side of metacarpal bone of middle finger	Extends and lifts hand up
Extensor carpi radialis longus	External condyloid ridge of humerus	Base of second metacarpal	Extends wrist
Extensor carpi ulnaris	External condyle of humerus	Base of metacarpal of little finger	Extends hand toward ulnar side
Extensor communis digitorum	Outer condyle of humerus	Last phalanges of four fingers	Extends fingers
Extensor digitorum quinti communis	External condyle of humerus	Phalanx of little finger	Extends little finger
Extensor of index	Lower third of ulna	End of phalanx of index	Extends index
Extensor pollicis brevis	Back of ulna and interosseous membrane	Base of second phalanx of thumb	Extends thumb
Extensor pollicis longus	Back of radius	Base of metacarpal of thumb	Extends thumb
Extensor radialis brevis	External condyle ridge of humerus	Base of third metacarpal (middle finger)	Extends wrist
Flexor carpi ulnaris	Internal condyle of humerus	Base of metacarpal and pisiform bone	Flexes wrist
Flexor carpi radialis longus	Inner condyle of humerus	Metacarpal bone of index finger	Flexes wrist and bends hand up
Flexor policis brevis	Trapezium and os magnus and three metacarpals	First phalanx	Flexes thumb
Flexor policis longus	Shaft of upper half of radius	Last phalanx of thumb	Flexes thumb

Muscles of arm and hand (continued)

NAME OF MUSCLE	ORIGIN	INSERTION	ACTION
Flexor profundis digitorum	Upper section of ulna and radius	End of four phalanges of fingers	Flexes fingers
Flexor digitorum sublimus	Inner condyle of humerus and shaft of radius	Side of second phalanx	Flexes finger and also the hand
Flexor digiti quinti brevis	Unciform bone	First phalanx of little finger	Flexes little finger
Infra spinatus	Infraspinatus fossa	Great tuberosity of humerus	External rotator
Lubricals (four)	Tendon of deep flexor	Back of phalanges	Flex first phalanges
Opponens digiti quinti	Unciform bone of carpal group	Metacarpal of little finger	Pulls little finger away from center of hand
Opponens pollicis	Trapezium	Metacarpel of thumb	Draws thumb up and inward
Palmaris brevis	Annular ligament and palmar facia	Skin of palm	Wrinkles skin and helps to close hand
Palmaris longus	Inner condyle of humerus	Dense facia of the palm of hand	Flexes wrist and hand
Palmar aponeurosi	Tendon of palmaris longus	Tendon sheaths of fingers	Protects structures of blood vessels and nerves
Palmar interossei	Palmar surface of metacarpals	Side of phalanges	Adducts fingers toward middle of hand
Pronator radii teres	Internal condyle of humerus	Outside of shaft of radius	Pronates hand
Pronator quadratus	Lower part of ulna	Lower part of radius	Pronates hand
Subscapularis	Subscapular fossa	Lesser tuberosity of humerus	Internal rotator of arm
Supinator longus	External condyloid ridge of humerus	Styloid process of radius	Supinates hand and flexes elbow
Supinator radii teres	External condyle of humerus and back of ulna	Neck and back of radius	Supinates hand
Supinator radii brevis	Side of upper half of radius	Upper part of ulna	Brings hand to supine position
Supra spinatus	Supraspinatus fossa	Great tuberosity of humerus	Holds head of humerus in socket of scapula
Teres major	Inferior angle of scapula	Posterior bicepital ridge of humerus	Draws arm down and back
Teres minor	Auxiliary border of scapula	Great tuberosity of humerus	External rotator
Transverse carpal ligament	Attached to navicular and multangular (carpals)	Pisiform and os hamatum (carpals)	Binds down flexor tendons of fingers
Triceps outer head___ Humerus middle head__ Scapula inner head_ __ Humerus		Olecranan of ulna	Extends the forearm

The shoulder girdle comprising the collar bone (clavicle) and shoulder blade (scapula) plays a large part in the form and action of the upper arm. The study of the humerus articulating with the scapula is most interesting.

Muscles of leg and foot

NAME OF MUSCLE	ORIGIN	INSERTION	ACTION
Abductor pollicis pedis (big toe)	Inner tubercle of os calcis	First phalanx of big toe	Draws big toe away from others
Abductor minimi pedis (little toe)	Outer tubercle of os calcis	First phalanx of little toe	Draws toe away from others
Adductor brevis	Ramus of pubes	Upper part of rough line of femur	Flexes and draws thigh inward
Adductor hallucis oblique head (big toe)	Os calcis	Second phalanx of big toe	Draws big toes toward the others
Adductor longus	Front of pubes	Middle of rough line of femur	Flexes and draws thigh inward
Adductor magnus	Ramus of pubes and of ischium	Entire length of rough line of femur	Draws thigh inward
Biceps of leg long and short head	Tuberosity of ischium outer bifurcation of rough line of femur	Head of fibula	Flexes leg and rotates it outward
Extensor of big toe (Hallucis)	Middle of shaft of fibula	Last phalanx of great toe	Extends toe
Extensor brevis digitorum pedis	Outer side of os calcis	First phalanx of big toe and tendons of long extensors	Extends toes
Extensor longus digitorum communis	Head of tibia and shaft of fibula	Second and third phalanges of toes	Extends toes
Flexor brevis digitorum pedis	Inner tubercle of os calcis and plantar fascia	Second phalanges of toes	Flexes toes
Flexor brevis pollicis pedis (big toe)	Cuboid	Base of first phalanx of big toe	Flexes big toe
Flexor brevis minimi digiti	Base of 5th. metatarsal	Base of first phalanx of little toe	Flexes little toe
Flexor longus digitorum pedis	Shaft of tibia	Last phalanges of toes	Flexes toes
Flexor hallucis brevis (big toe)	Cuboid	Base of first phalanx of big toe	Flexes big toe
Flexor longus hallucis (big toe)	Shaft of fibula	Last phalanx of big toe	Flexes toes
Gastrocnemius inner and outer head	Two heads above condyles of femur	Os calcis	Extends foot
Gemellus superior gracilis	Spine and tuberosity of ischium and ramus of pubes	Great trochanter upper and inner part of tibia	Flexes and draws leg inward
Gluteus maximus	Back of illium behind superior line of sacrum and coccyx	Fascia and below great trochanter	Extends and draws thigh outward
Gluteus medius " minimus	Ilium between superior and middle lines	Oblique line of great trochanter	Draws thigh outward and rotates leg
Ilio-tibial band	Conjoined flattened tendon of gluteus maximus tensor fascia femoris	External tuberosity of tibia	Supports knee joint in extension
Iliacus	Iliac fossa and base of sacrum	Below lesser trochanter	Flexes and rotates thigh outward
Ilio-psoas	Radius and transverse process of last dorsal and all lumbar vertebra	Lesser trochanter of femur	Flexes and rotates thigh outward
Lubricals (four)	Tendons of long flexor	Base of first phalanges	Flexes toes and gathers them together
Obturator externus and gemelli	Outside of obturator membrane and bony margin	Digital fossa of femur	External rotator of thigh

Muscles of leg and foot (continued)

NAME OF MUSCLE	ORIGIN	INSERTION	ACTION
Obturator internus	Inside of obturator membrane and bony margin	Top of great trochanter	External rotator of thigh
Pectineus	Ilio-pectineal line and body of pubes	Below lesser trochanter	Flexes thigh on pelvis and rotates outward
Peroneus brevis	Outside of shaft of fibula	Base of fifth metatarsal	Extends ankle
Peroneus longus	Head and outside of shaft of fibula	Base of metatarsus of big toe	Extends ankle
Peroneus tertius	Outside of shaft of fibula	Base of fifth metatarsal	Extends ankle
Piriformis	Front of sacrum through great sciatic notch	Top of great trochanter	Extends and rotates thigh
Plantar interossei (three)	Under surface of metatarsal	Back of first phalanges	Draws toe toward middle line of 2nd. toe
Plantaris	Above outer condyle of femur	Os-calcis	Extends foot with tendons of Achilles
Popliteus	Outside of external condyle of femur	Tibia above oblique line	Flexes leg
Psoas major	Bodies and transverse processes of last dorsal and all lumbar vertebrae	Lesser trochanter of femur	Flexes and rotates thigh outward
Psoas minor	Bodies of last dorsal and first lumbar vertebrae	Iliac fascia	Flexes and rotates thigh outward
Quadratus femoris	Tuberosity of ischium	Quadrate line of femur	Extends and rotates thigh
Rectus femoris	Anterior inferior spine and top of acetabulum	Patella	Extensor of leg
Sartorius	Anterior superior spine of ilium	Upper and inner part of tibia	Flexes and crosses legs
Semi-tendinosus	Tuberosity of ischium	Upper and inner part of tibia	Flexes leg
Semi-membranosus	Tuberosity of ischium	Back of inner tuberosity of tibia	Flexes leg, rotates inward
Soleus	Shaft of fibula and oblique line of tibia	Os-calcis	Extends foot with tendon of Achilles
Superior gemellus and inferior	Spine of ischium	Great trochanter	External rotator of thigh
Tendo Achilles	Tendon of the muscle of the calf	Os-calcis	Lifts heel in walking
Tensor fascia femoris	Anterior extremity of iliac crest	Front of great trochanter of femur	Helps lift leg outward
Tibialis anticus	Outside of head and shaft of tibia	Internal cuneiform and first metatarsal	Flexes ankle and inverts foot
Tibialis posterior	Back of tibia and fibula	Sole of foot, navicular, cuneiform and metatarsal bones	Extends foot
Transversalis pedis	Head of metatarsal	First phalanx of great toe	Brings great toe towards middle line
Vastus externus	External lip of rough line of femur and base of great trochanter	Patella	Extends leg
Vastus internus	Back and inner side of tibia	Patella	Extends leg

Muscles of the torso

NAME OF MUSCLE	ORIGIN	INSERTION	ACTION
Erector spinae	Crest of ilium, back of sacrum and six lower ribs	Transverse process of four cervical and six upper thoracic ribs	Straightens spine and draws head back
External oblique	Eight lower ribs	Middle line and crest of ilium and pourparts ligament	Compresses viscera and flexes thorax
Infra spinatus	Infraspinous fossa	Great tuberosity of humerus	External rotator of humerus
Intercostal and two external intercostal	Inner lip of lower border of ribs, and outer lip second of ribs	Upper border of ribs	Draws ribs together when exhaling two when inhaling
Internal oblique	Pourparts ligament crest of ilium and lumbar fascia	Middle line and crest of pubes plus four lower ribs	Compresses viscera and flexes thorax
Latissimus dorsi	Spinal processes of six lower dorsal, lumbar vertebrae and crest of ilium	Bicepital groove of humerus	Draws arm back and down
Levator scapula	Transverse processes of four upper cervical vertebrae	Border of scapula below upper angle	Raises upper angle of scapula
Ligamentum Nuchae	Spinous processes of spine	Base of skull	By its elasticity it braces the spine
Pectoralis major	Clavicle sternum and costal cartilage	Anterior bicepital ridge of humerus	Draws arm down and across the chest
Pectoralis minor	Third, fourth and fifth rib	Coracoid process of scapula	Depresses point of shoulder
Rectus abdominis	Crest of pubis bone	Cartilage of fifth, sixth and seventh rib	Bends chest forward
Rhomboideus major	Spinal processes of five upper dorsal vertebrae	Border of scapula to lower angle	Draws scapula forward
Rhomboideus minor	Spinal process of last cervical and first dorsal	Border of scapula at lower margin	Draws scapula forward
Serratus magnus	Eight upper ribs	Posterior border of scapula	Draws shoulder blade and arm forward
Serratus posticus inferior	Spinal process of last two dorsal and first two lumbar vertebrae	Four lower ribs	Depresses ribs in expiration
Supra spinatus	Supra-spinous fossa of scapula	Great tuberosity of humerus	Holds head of humerus in socket
Teres major	Inferior angle of scapula	Posterior bicepital ridge of humerus	Draws arm down and back
Teres minor	Axillary border of scapula	Great tuberosity of humerus	Rotates laterally
Transversus abdominis	Pourparts ligament crest of ilium and six lower ribs	Middle line and crest of pubic bone	Compresses viscera and flexes thorax
Trapezius	Superior line of occipital, all spinous processes to twelfth dorsal vertebra	Clavicle and spine of scapula	Draws head back and shoulders together

The Spine. The amount of movement between the vertebrae is very limited yet the total range of movement reached is considerable. Flexion forward and backward is freer and most of the action occurs in the neck and the lumbar region. The lumbar vertebrae are larger than the others and have more space between them thus allowing freer movement.